Nature's Extremes

INSIDE THE GREAT NATURAL DISASTERS
THAT SHAPE LIFE ON EARTH

Nature's Extremes

EDITOR	Kelly Knauer
ART DIRECTOR	Anthony Wing Kosner
PICTURE EDITOR	Patricia Cadley
WRITER/RESEARCHER	Matthew McCann Fenton
GRAPHICS	Lon Tweeten
COPY EDITOR	Bruce Christopher Carr
INDEX	Marilyn Rowland

TIME INC. HOME ENTERTAINMENT

PUBLISHER	Richard Fraiman
EXECUTIVE DIRECTOR, MARKETING SERVICES	Carol Pittard
DIRECTOR, RETAIL & SPECIAL SALES	Tom Mifsud
MARKETING DIRECTOR, BRANDED BUSINESSES	Swati Rao
ASSISTANT GENERAL COUNSEL	Dasha Smith Dwin
DIRECTOR, NEW PRODUCT DEVELOPMENT	Peter Harper
FINANCIAL DIRECTOR	Steven Sandonato
PREPRESS MANAGER	Emily Rabin
BOOK PRODUCTION MANAGER	Jonathan Polsky
MARKETING MANAGER	Kristin Treadway
ASSOCIATE PREPRESS MANAGER	Anne-Michelle Gallero

SPECIAL THANKS TO

Bozena Bannett, Alexandra Bliss, Glenn Buonocore, Brian Fellows, Suzanne Janso,
Robert Marasco, Brooke McGuire, Chavaughn Raines, Ilene Schreider, Adriana Tierno, Britney Williams

Copyright 2006 Time Inc. Home Entertainment
Published by TIME Books
Time Inc. • 1271 Avenue of the Americas • New York, NY 10020

ISBN: 1-933405-04-X
Library of Congress Control Number: 2006900124

TIME Books is a trademark of Time Inc.

We welcome your comments and suggestions about TIME Books. Please write to us at
TIME Books • Attention: Book Editors • PO Box 11016 • Des Moines, IA 50336-1016

If you would like to order any of our hardcover Collector's Edition books, please call us at 1-800-327-6388
(Monday through Friday, 7 a.m.–8 p.m., or Saturday, 7 a.m.–6 p.m., Central time).

PRINTED IN THE UNITED STATES OF AMERICA

COVER PHOTOGRAPHY CREDITS

Main image: Hurricane Katrina, Aug. 28, 2005: Courtesy NOAA.
Insets: Volcano: Otto Hahn—Peter Arnold Inc.; Wave: Bob Barbour—Minden Pictures;
Lightning: © Warren Faidley—Weatherstock.com; Tornado: Eric Nguyen—Jim Reed Photography/Corbis

Back cover, softcover edition only:
Tui De Roy—Minden Pictures

Nature's Extremes

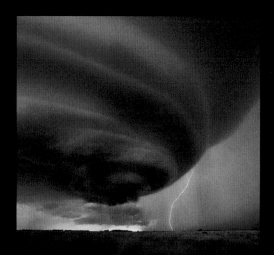

INSIDE THE GREAT NATURAL DISASTERS THAT SHAPE LIFE ON EARTH

CONTENTS

REUNION ISLAND, 2002
The volcano Piton de la Fournaise, whose eruptions built this rocky island in the Indian Ocean, put on a fiery show in January 2002

Our Extreme Planet

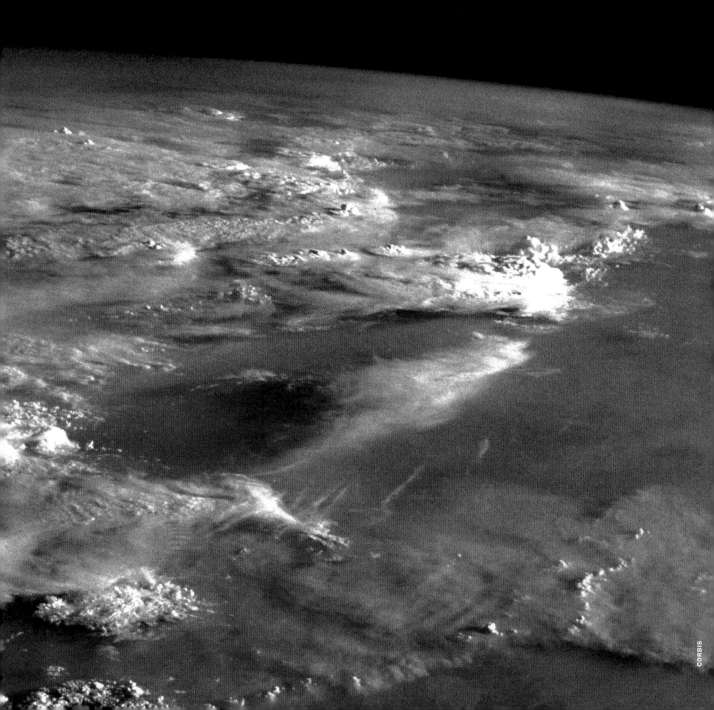

GADFLY GENIUS BUCKMINSTER FULLER SEIZED our imaginations back in the 1960s when he described our planet as Spaceship Earth. Along with NASA pictures that showed us for the first time the planet in its entirety, hanging resplendent in space, Fuller's fanciful notion marked the dawn of global consciousness, the sense that the earth is a single entity, however distinct its many environments. Fuller's metaphor spoke to a *Star Trek* era, however, and today it seems more up to date to express the interdependence of natural phenomena as a sort of world wide web, a skein of interwoven connections.

One of the scientists featured in this book, Cristian Samper of the Smithsonian's National Museum of Natural History, makes just that comparison. Speaking of tropical rain forests, he says, "We are taught to think of food as a chain, with microbes at the bottom, plants and animals in the middle and human beings at the top. But it's really much more like a web, where every strand supports and relies upon every other strand. If you put stress on any segment, it will be felt all across the web. Take away even one strand, and the whole web gets weaker. If you take away more than a few, the entire web may collapse." Samper was speaking of forest food chains, but his metaphor applies to the entire planet.

That sense of interconnectedness is everywhere in this book. Consider the picture below, which shows giant sandstorms sweeping across the African desert. For local shepherds, that storm may be a calamity. Yet in the past few years we have learned that such storms also carry essential minerals across the ocean all the way to the Amazon forests of South America, enriching the soil. And the plants that grow in those biological hothouses, in turn, can be the source of wonder-working drugs that help mankind fight disease.

Nature's global web is awe-inspiring indeed, but it evokes terror as well as wonder, as recent events have reminded us. In 2004 two tectonic plates twitched below the Indian Ocean and more than 229,000 people died. In 2005 Hurricane Katrina simply swamped one of America's most historic cities. In exploring these planetary disasters, this book follows the fine phrase of British Renaissance man Francis Bacon: "Nature best reveals her secrets when tormented." These pages fully document nature's torments, and the many sorrows they afflict upon mankind. Like Fuller's metaphor, they remind us that we are all passengers on this orb, bit players on a stage whose proportions are so vast as to leave us humbled. —*By Kelly Knauer*

NORTHERN AFRICA, 1992
A photo from outer space shows a giant sandstorm, the light brown clouds at left, rushing across the deserts of Libya and Algeria

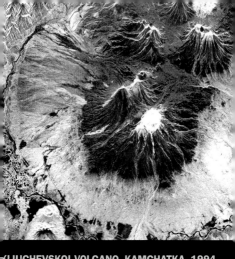

KLIUCHEVSKOI VOLCANO, KAMCHATKA, 1994
A camera aboard space shuttle *Endeavor* took
his false-color radar image of the volcano—
he dark blue triangle at center—erupting on
)ct. 5. The dark red areas are snow cover.

Planet Earth is restless, unsettled, a work in progress. The processes that drive its **CONSTANT CHANGE** challenge our comprehension: planetary time is measured in millions of years, space in thousands of miles. Even the most basic facts of nature defy common sense. Can it be that the ground under our feet isn't always solid? Yes, for **EARTHQUAKE** survivors report seeing the landscape transformed into a mass of churning waves resembling the ocean's tides. Can it be, as scientists assure us, that the interior of our world is composed of two **CORES**, one liquid and one solid, zones of intense heat? Yes, for we receive occasional postcards from the planet's interior in the form of the hot, deadly lava expelled by **VOLCANOES**. Can it be that the familiar continents of the globe slowly move, as the giant **TECTONIC PLATES** they float upon grind against one another, giving birth to the Himalayas and **DEEP CHASMS** beneath the sea? Yes, for it is precisely at these seams in the skin of the planet that we see the deadly proof of its dynamics. On Dec. 26, 2004, two plates shifted their position deep under the Pacific Ocean. By the planet's yardstick, it was a minor event, a shrug, a tectonic fender-bender. But within 12 hours, more than 229,000 humans lay dead, victims of the giant **TSUNAMI** unleashed by the quake. Mother Nature's message for man: be humble—and be wary.

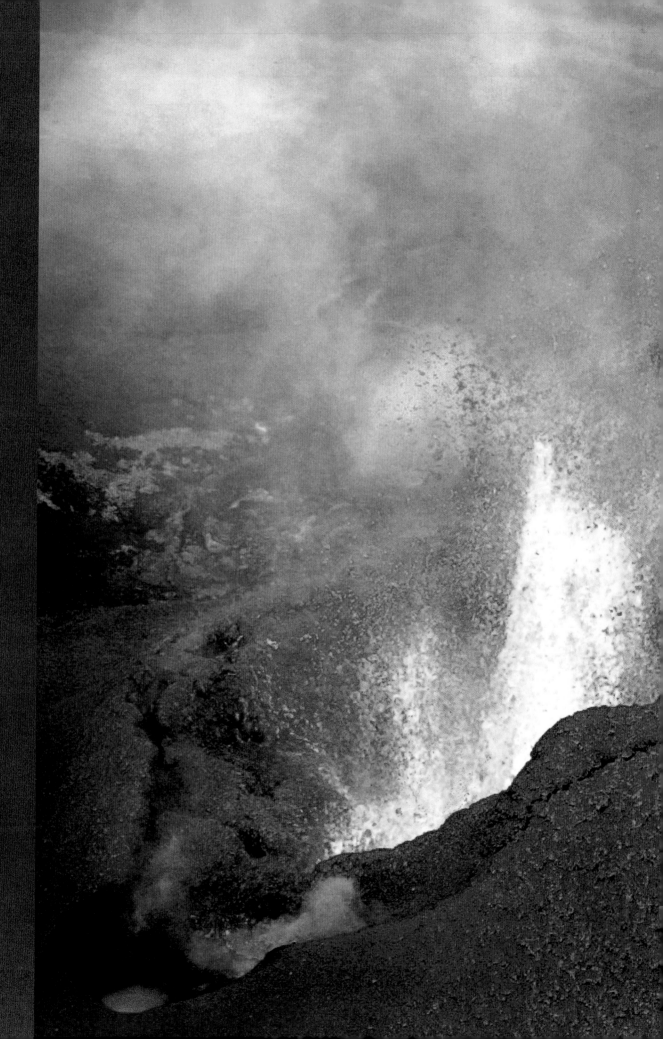

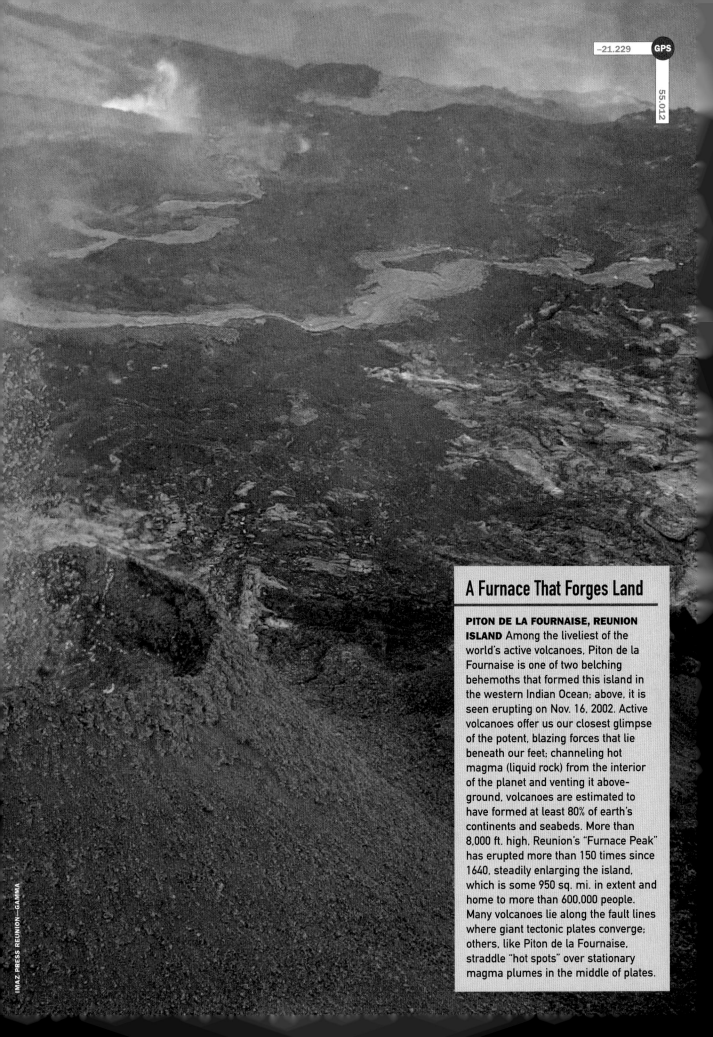

A Furnace That Forges Land

PITON DE LA FOURNAISE, REUNION ISLAND Among the liveliest of the world's active volcanoes, Piton de la Fournaise is one of two belching behemoths that formed this island in the western Indian Ocean; above, it is seen erupting on Nov. 16, 2002. Active volcanoes offer us our closest glimpse of the potent, blazing forces that lie beneath our feet; channeling hot magma (liquid rock) from the interior of the planet and venting it above-ground, volcanoes are estimated to have formed at least 80% of earth's continents and seabeds. More than 8,000 ft. high, Reunion's "Furnace Peak" has erupted more than 150 times since 1640, steadily enlarging the island, which is some 950 sq. mi. in extent and home to more than 600,000 people. Many volcanoes lie along the fault lines where giant tectonic plates converge; others, like Piton de la Fournaise, straddle "hot spots" over stationary magma plumes in the middle of plates.

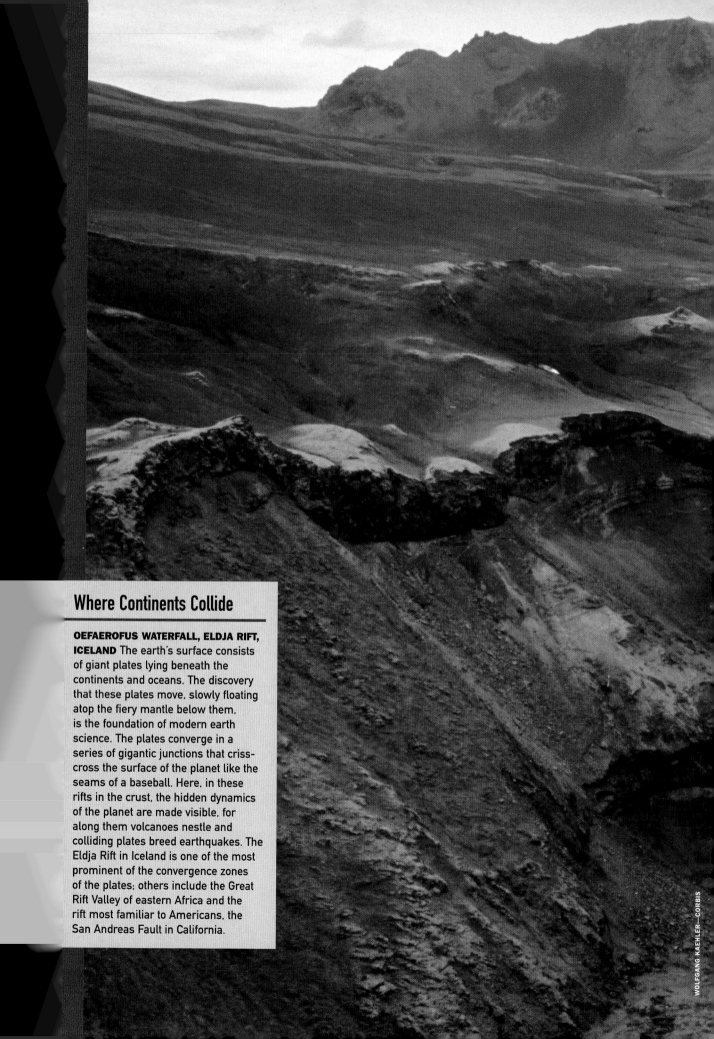

Where Continents Collide

OEFAEROFUS WATERFALL, ELDJA RIFT, ICELAND The earth's surface consists of giant plates lying beneath the continents and oceans. The discovery that these plates move, slowly floating atop the fiery mantle below them, is the foundation of modern earth science. The plates converge in a series of gigantic junctions that criss-cross the surface of the planet like the seams of a baseball. Here, in these rifts in the crust, the hidden dynamics of the planet are made visible, for along them volcanoes nestle and colliding plates breed earthquakes. The Eldja Rift in Iceland is one of the most prominent of the convergence zones of the plates; others include the Great Rift Valley of eastern Africa and the rift most familiar to Americans, the San Andreas Fault in California.

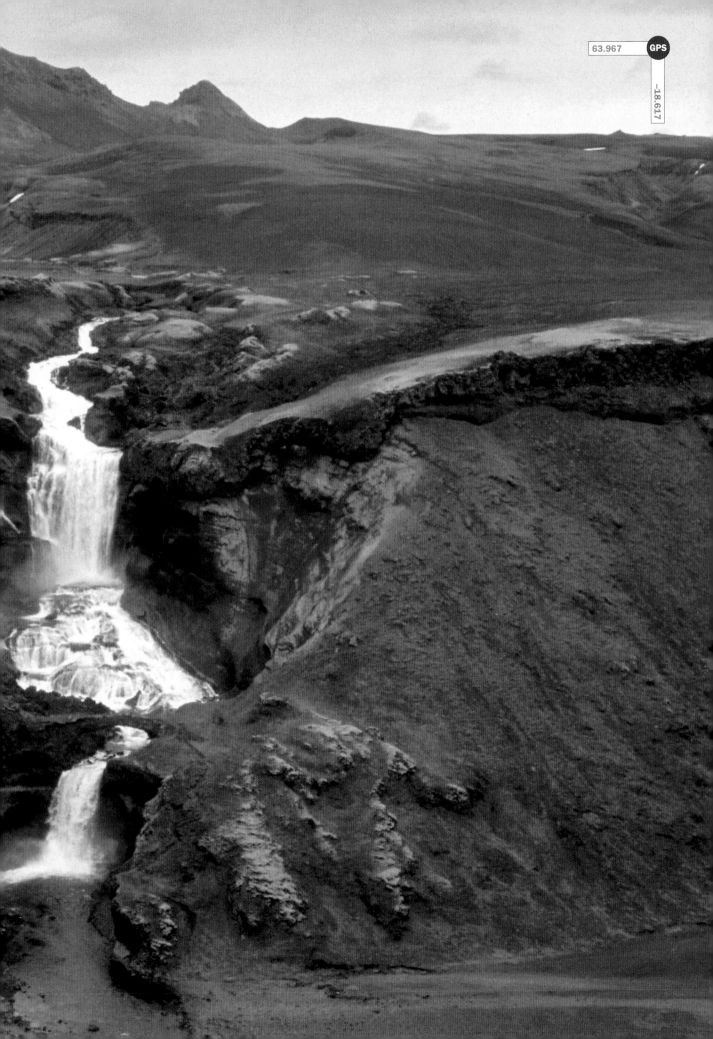

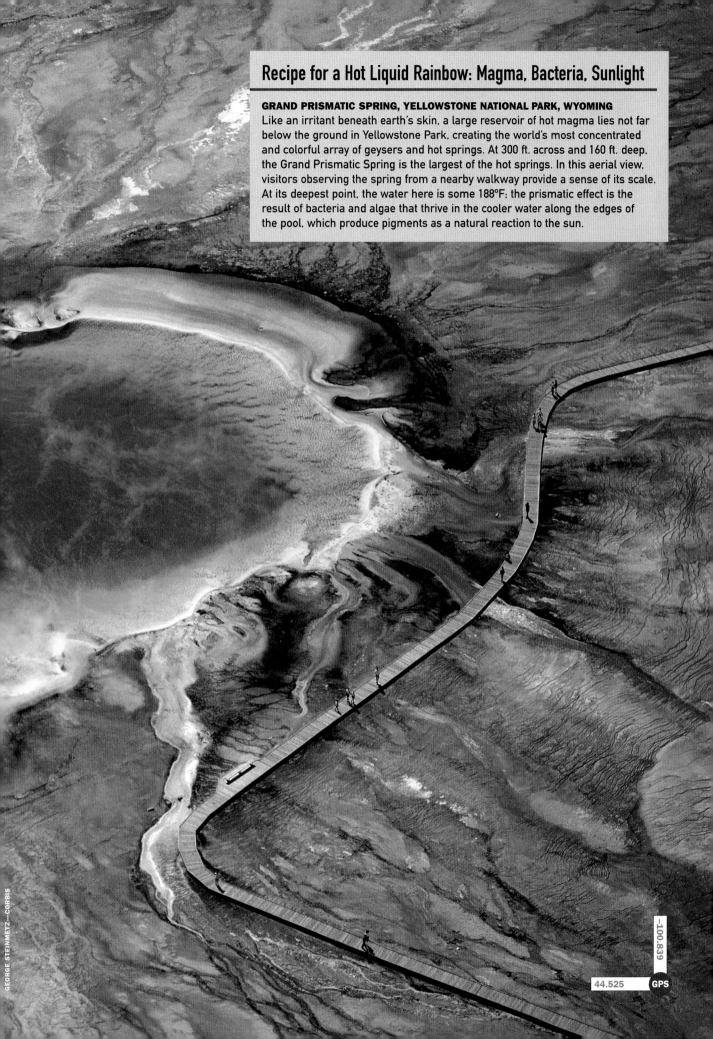

Recipe for a Hot Liquid Rainbow: Magma, Bacteria, Sunlight

GRAND PRISMATIC SPRING, YELLOWSTONE NATIONAL PARK, WYOMING
Like an irritant beneath earth's skin, a large reservoir of hot magma lies not far below the ground in Yellowstone Park, creating the world's most concentrated and colorful array of geysers and hot springs. At 300 ft. across and 160 ft. deep, the Grand Prismatic Spring is the largest of the hot springs. In this aerial view, visitors observing the spring from a nearby walkway provide a sense of its scale. At its deepest point, the water here is some 188°F; the prismatic effect is the result of bacteria and algae that thrive in the cooler water along the edges of the pool, which produce pigments as a natural reaction to the sun.

-100.839

44.525 GPS

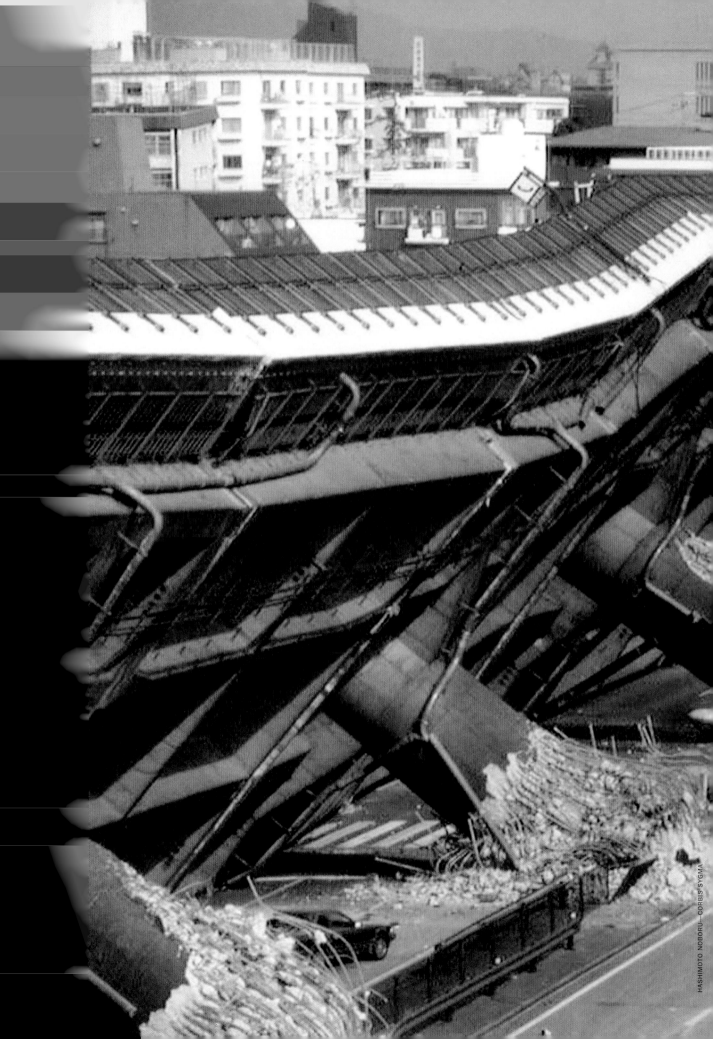

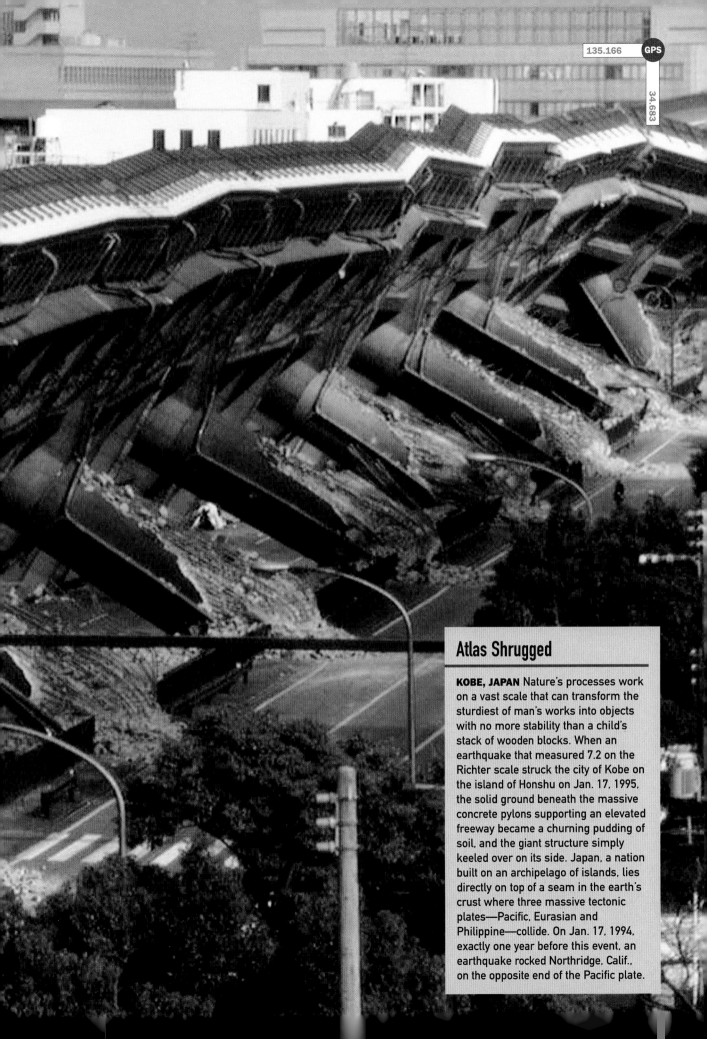

Atlas Shrugged

KOBE, JAPAN Nature's processes work on a vast scale that can transform the sturdiest of man's works into objects with no more stability than a child's stack of wooden blocks. When an earthquake that measured 7.2 on the Richter scale struck the city of Kobe on the island of Honshu on Jan. 17, 1995, the solid ground beneath the massive concrete pylons supporting an elevated freeway became a churning pudding of soil, and the giant structure simply keeled over on its side. Japan, a nation built on an archipelago of islands, lies directly on top of a seam in the earth's crust where three massive tectonic plates—Pacific, Eurasian and Philippine—collide. On Jan. 17, 1994, exactly one year before this event, an earthquake rocked Northridge, Calif., on the opposite end of the Pacific plate.

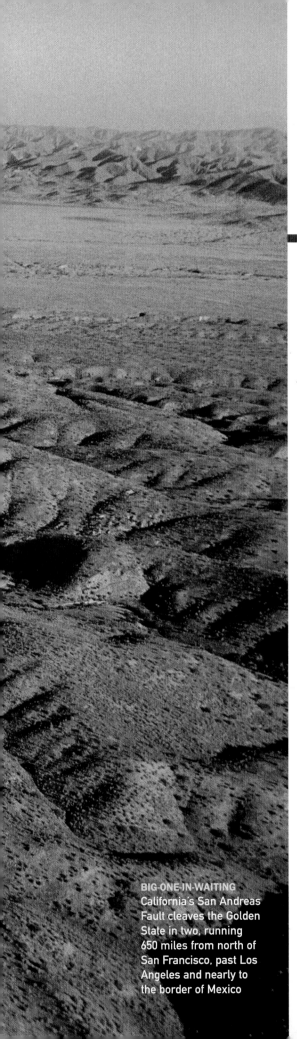

GETTING THE DRIFT

The bold theory of plate tectonics unites nature's deadly extremes

S TRANGE AS IT MAY SEEM," PHYSICIST Richard Feynman wrote in his 1985 book *Six Easy Pieces*, "we understand the distribution of matter in the interior of the sun far better than we understand the interior of the earth." That curious neglect of the world we know (or ought to know) in favor of the firmament that once seemed unknowable seems hard-wired into our DNA: a concern with the world below our feet somehow seems, well, beneath us.

Human beings have gazed skyward and speculated about the stars for ages, yet we have known that the earth is not flat for only about one-tenth of 1% of human history. Indeed, human beings have been able to fly machines above the ground for longer than we have had an inkling that there is anything below that ground other than solid rock. Even in the geography of mythology, people of widely different cultures have always believed instinctively that the skies belong to the gods, and the realms beneath the ground are the property of darker forces. And tidings from the Underworld—chiefly in the form of volcanoes and earthquakes—were almost invariably bad.

It was the search for worldly riches—gold , diamonds, oil and coal—that first prompted men to probe ever so slightly beneath the surface of our planet. What they found, usually a layer of soil or sand followed by solid rock, was assumed until the 20th century to represent the entire nature of the earth's interior. But in the past 100 years, mankind's knowledge of the world that lies beneath the surface has increased considerably, thanks to a handful of visionary scientists. Today we understand that many of the seemingly disparate natural disasters treated in this book—earthquakes and volcanoes, landslides and tsunamis—are all linked, each phenomenon the reflection of a planetary architecture whose forces are vast enough to move continents, raise mountain ranges and drain oceans dry.

The first of these revolutionary earth scientists was a German meteorologist, Alfred Wegener, who was only 30 when he wrote to his fiancé in 1910: "Doesn't the east coast of South America fit exactly against the west coast of Africa, as if they had once been joined? This is an idea I'll have to pursue." And he did, researching geologic and fossil records in university libraries all over Europe. Some of his findings amazed him: remains of *Cyognathus*, a 9-ft.-long Triassic-era land reptile, had been

BIG-ONE-IN-WAITING
California's San Andreas Fault cleaves the Golden State in two, running 650 miles from north of San Francisco, past Los Angeles and nearly to the border of Mexico

discovered in two narrow strips of land, one in South America, the other in central Africa. When these continents were fitted together, like jigsaw pieces, the two strips lined up perfectly. Another set of bands, in which fossils of the freshwater reptile *Mesosaurus* had been found, seemed to connect seamlessly across the lower latitudes of South American and Africa. A third dinosaur, *Lystrosaurus*, was found only in three strips traversing Africa, India and Antarctica, and these bands formed a single brushstroke when the shapes of those continents were linked.

For Wegener, the conclusion was as clear as it was revolutionary: all the world's continents had once been joined in a single land mass, which he called Pangea, Greek for "All Earth." That giant landmass, he posited, had gradually broken apart, in a process he called "continental drift." Of course, the fossil evidence that Wegener used to support his theory had not gone unnoticed by other scientists. In an example of how tenaciously mainstream scholars will cling to orthodoxy, geologists and paleontologists had explained these anomalies by hypothesizing a series of "land bridges," causeways that once linked continents across the world's oceans. The fact that there was little evidence that aside from a few well-known examples such bridges had ever existed seemed to bother no one.

What did bother nearly everyone, though, was the prospect that a young outsider—a mere weatherman, no less!—could upend the finely wrought theory of land bridges. "Utter, damned rot!" howled the president of the American Philosophical Society. Any person who "valued his reputation for scientific sanity" would dismiss such a theory out of hand, agreed a leading British geologist. When Wegener died, on an expedition to Greenland in 1930, his theories about Pangea and continental drift commanded roughly the same level of academic respect that speculation about the Bermuda Triangle does today.

PANGEA: ONE WORLD

All the planet's landmasses were once concentrated in a single supercontinent, Pangea (Greek for "whole earth"), which began breaking up around 225 million years ago

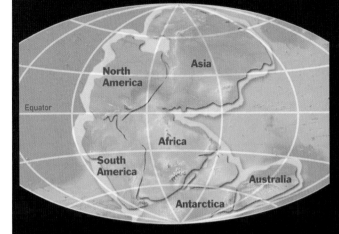

ONCE UNITED ... As of 200 million years ago, there were two continents: Lauraisa and Gondwanaland. Around 130 million years ago, Lauraisa cleaved into North America, Europe and Asia. About 70 million years later, Gondwanaland calved into South America, Africa, Australia and Antarctica

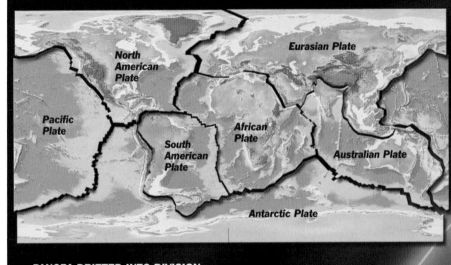

... PANGEA DRIFTED INTO DIVISION
Terra firma is a figment of the human imagination: the seemingly solid surface of the earth is made up of more than a dozen vast plates floating above the liquid rock of the planet's interior and butting up against one another at tectonic convergence zones

O NE REASON WEGENER COULD BE IGNORED WAS THAT he offered no theory as to how or why continents could move, like plows in a field, through the apparently solid surface of the planet. The explanation would have to await Harry Hess, a Princeton geologist who served as the commanding officer of a naval transport during World War II. Hess's ship was equipped with an early version of sonar, and Hess ordered that the equipment never be turned off. He thus compiled thousands of detailed readings about the contours of the sea floor. Among his first discoveries was the Mid-Atlantic Ridge, a vast mountain range that bisects the ocean, reaching almost from pole to pole. Hess and his collaborators would later discover that this ridge is one small part of a global chain of mountain ranges, mostly undersea, that stretch around the earth like seams on a baseball, and that many of these ranges consist of extinct or currently active volcanoes.

Taking core samples from these volcanic ranges, geologists found that the rocks on top of the mountains were relatively young, just a few million years old, whereas rocks found on the slopes were older by tens of millions of years, and stones recovered far from the peaks were geologic senior citizens, hundreds of millions of years old. Their conclusion: new rock was continually bubbling up from somewhere inside the earth and was being ejected and pushed outward in the form of volcanic lava all along this line of ridges. The planet's surface, they reasoned, is actually composed of a series of giant plates that are continually spreading apart, bearing the continents away from one another.

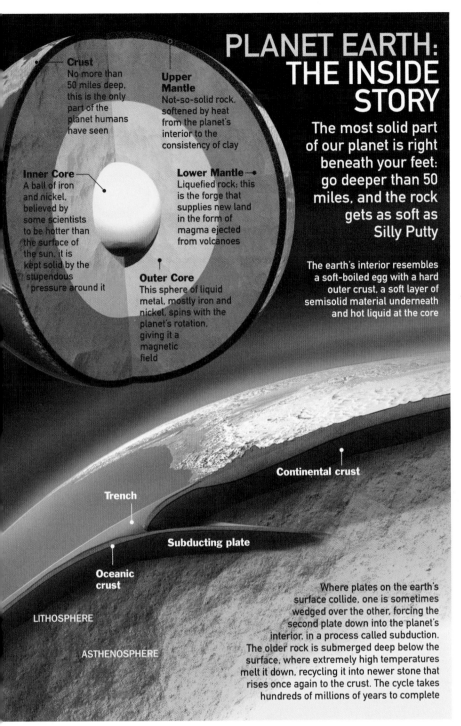

PLANET EARTH: THE INSIDE STORY

Crust
No more than 50 miles deep, this is the only part of the planet humans have seen

Upper Mantle
Not-so-solid rock, softened by heat from the planet's interior to the consistency of clay

Inner Core
A ball of iron and nickel, believed by some scientists to be hotter than the surface of the sun, it is kept solid by the stupendous pressure around it

Lower Mantle
Liquefied rock; this is the forge that supplies new land in the form of magma ejected from volcanoes

Outer Core
This sphere of liquid metal, mostly iron and nickel, spins with the planet's rotation, giving it a magnetic field

The most solid part of our planet is right beneath your feet: go deeper than 50 miles, and the rock gets as soft as Silly Putty

The earth's interior resembles a soft-boiled egg with a hard outer crust, a soft layer of semisolid material underneath and hot liquid at the core

Continental crust

Trench

Subducting plate

Oceanic crust

LITHOSPHERE

ASTHENOSPHERE

Where plates on the earth's surface collide, one is sometimes wedged over the other, forcing the second plate down into the planet's interior, in a process called subduction. The older rock is submerged deep below the surface, where extremely high temperatures melt it down, recycling it into newer stone that rises once again to the crust. The cycle takes hundreds of millions of years to complete

ON THE MOVE The late seismologist Bruce Bolt once quipped, "In 30 million years, Los Angeles will become a new suburb of San Francisco"

of the planet's jigsaw skin is the San Andreas Fault, which gashes California for 650 miles. The two plates are moving so inexorably in opposite directions that the state's late well-known seismologist Bruce Bolt once quipped, "In 30 million years, Los Angeles will become a new suburb of San Francisco."

As new rock is pushed out of the volcanic ranges that circle the world, older material from the earth's crust is continually being pulled into the planet's interior, in "subduction zones," where one plate forces another (or both push each other) downward.

THE NEXT UNKNOWN: WHAT LIES under the plates? Exploration of this final interior frontier began in 1936, when Danish seismologist Inge Lehmann used seismographic readings to deduce that earth's center consists of two concentric cores: a 1,300-mile-thick liquid outer core and a solid, inner core, about 750 miles in diameter. Both sections are composed mostly of iron and nickel, and it is these two nested spheres (especially the liquid outer core, which spins with the earth's rotation) that give the planet its magnetic field.

Lehmann built on earlier seismograph readings indicating that surrounding the core is a "mantle" layer of rock, 1,800 miles thick, that is softened by the heat from the earth's core. The mantle begins immediately beneath the 20- to 50-mile-thick crust, earth's outermost layer. The mantle is the source of new volcanic rock, which causes ocean floors to spread, continents to drift and tectonic plates to collide. It is also the destination for older rock that is sucked back into the deepest part of the mantle, closest to the hot core, where it is melted and in effect "recycled" into new rock that bubbles back toward the surface. In a rotation that takes hundreds of millions of years to complete, the reconstituted rock is then ejected back through the crust by volcanic activity. Mankind's home planet, it seems, is bulimic.

By the late 1960s, Wegener was vindicated. Yet it remains a challenge that humans, who have walked on the moon and sent probes beyond the solar system, have never ventured more than a few miles beneath the surface of their home planet. Twenty years on, Feynman's words still ring true: if our world were an apple, we have yet to pierce its skin. ∎

Today scientists believe the earth's crust is made up of 11 major segments, vast and solid, along with about 20 much smaller pieces, that float on a layer of molten rock that has the consistency of Silly Putty. The plates are called tectonic, from the Greek root meaning "to build," because they are continually building and reshaping the planet's surface while constantly jostling against one another like rafts crowded into a small pond. Along the boundaries where they meet, earthquakes and volcanoes are especially common.

When tectonic plates collide, one of three things occurs: they push each other upward to form mountain ranges like the Himalayas; they push each other downward (that is how ocean trenches are formed); or they grind against each other, creating regions of instability. That is what is happening where the two largest plates in the world, the Pacific and the North American, meet. The line that joins these two pieces

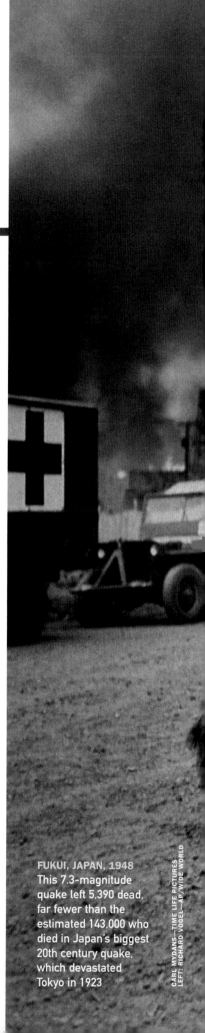

CRACKS IN THE CRUST

When the planet's skin shakes, rattles and rolls, humans have few defenses

WHEN WE DESCRIBE ANOTHER PERSON as "grounded," we are saluting their stability: after all, what could be more solid than the good old terra firma beneath our feet? But as any earth scientist will tell you, when it comes to terra, little is firma.

For proof, look at the picture at right, taken by veteran LIFE photographer Carl Mydans in Fukui, Japan, on June 28, 1948, when an earthquake simply opened up the ground beneath the feet of citizens who moments before were peacefully going about their daily business.

Or consider a more recent, far deadlier example: on the morning of Oct. 8, 2005, violence returned to the war-torn region of Kashmir, which India and Pakistan have been fighting over since 1947. On the Indian side of the Line of Control, Mussadiq Hussain Manhas, 54, heard a deep cracking inside the earth and thought, "The war has started again." On the Pakistani side of the border, Ihsanullah Khan, the mayor of Batagram, looked across a valley and saw "houses on the ridge … exploding, one by one." Below him, on the shores of the Indus River, a tribal elder, Mohammed, observed that the river "looked like water boiling inside a tea kettle."

In retrospect, an outbreak of fighting between India and Pakistan might have been less destructive than the calamity that was taking place: the Himalayan region of Kashmir had been hit by a 7.6-magnitude earthquake. As the ground "bounced," Manhas recalled, "it was clear this was not the work of men. I threw myself onto the ground, but the walls began toppling on me. So I ran to a walnut tree and clung to it. It was swinging like a pendulum in a clock. I could see walls and houses falling all around me, and cracks were appearing in the earth beneath my feet. Rocks were breaking off the mountains and crashing down." Said Khan: "I thought it was doomsday, that the earth would open and swallow me up."

The quake, which killed more than 30,000 people in a matter of hours, was triggered by the same forces that created the Himalayas themselves. Some 6.2 miles beneath the planet's surface, the Indian Plate of the earth's crust is moving north at around 2 in. per year, driving against the Eurasian Plate. But these huge masses don't slide past

PAKISTAN, 2005 A woman left homeless by the Oct. 8 quake scavenges supplies

FUKUI, JAPAN, 1948 This 7.3-magnitude quake left 5,390 dead, far fewer than the estimated 143,000 who died in Japan's biggest 20th century quake, which devastated Tokyo in 1923

CARL MYDANS—TIME LIFE PICTURES
LEFT: RICHARD VOGEL—AP/WIDE WORLD

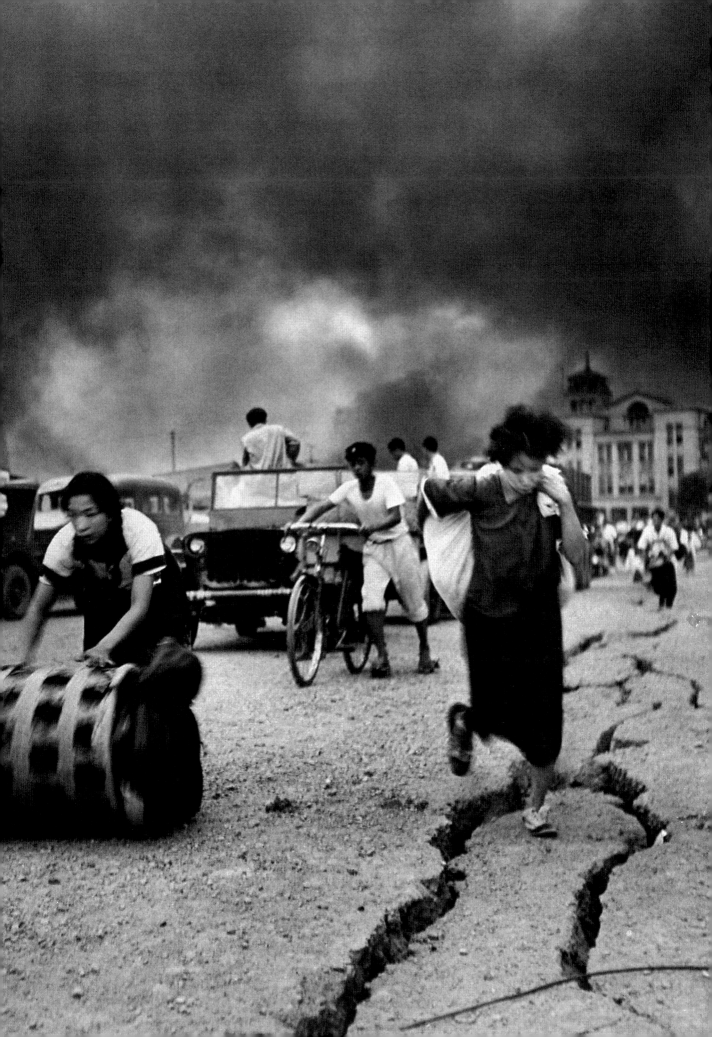

each other very smoothly. Like two giant sheets of sandpaper, they often get stuck, sometimes for hundreds of years. The pressure keeps building until something—often a juncture just a few miles below ground—snaps, and the ground begins to heave and lurch like Jell-O on springs.

Because of those movements, regions like southern Asia that are perched atop tectonic convergence zones experience cataclysmic earthquakes with grim, if unpredictable, regularity. In December 2003, a magnitude-6.4 temblor devastated Bam, Iran, killing more than 26,000 people. In January 2001, 13,000 people died in the Gujarat state in India when a magnitude-7.9 quake hit. Another 10,000 were killed in Latur, India, in 1993, on top of 50,000 fatalities in the northwestern corner of Iran in 1990.

SINCE PREHISTORIC TIMES, UPHEAVALS OF THE EARTH have stunned humans and ravaged their handiwork: some scholars believe the ancient Minoan civilization and the biblical cities of Sodom and Gomorrah were wiped out by quakes. Other historians theorize that a string of earthquakes clustered within 50 years of 1200 B.C. may explain the mysterious, violent end—both sudden and simultaneous—of all the Bronze Age civilizations of the eastern Mediterranean, including the city of Troy. A devastating quake in 373 B.C. destroyed Helike, a major Greek city on the Gulf of Corinth. Because Helike was also submerged by the tsunami unleashed by this quake, some see in it the origin for the legend of Atlantis, although there is no lack of contenders for this distinction.

However much terror earthquakes held for ancient humans, a new threshold of destruction was crossed in 1556, when the ground shook in Shensi province of north-central China and more than 800,000 people died. The huge death toll was the result of a large population of laborers who had created rudimentary homes for themselves by digging caves, called *yaodongs*, into the soft clay of the cliffs that overlook the Loess Plateau. These unstable shelters collapsed by the tens of thousands, burying as much as 60% of the region's population alive.

With hindsight, the Shensi quake was a discouraging but accurate portent of the future. For earthquakes are a mythic plague whose effects have grown worse with the rise of modern civilization. The advent of buildings that disappear into the clouds and the massive population growth of cities like San Francisco and Tokyo, which are built near convergence zones, have exponentially multiplied the potential

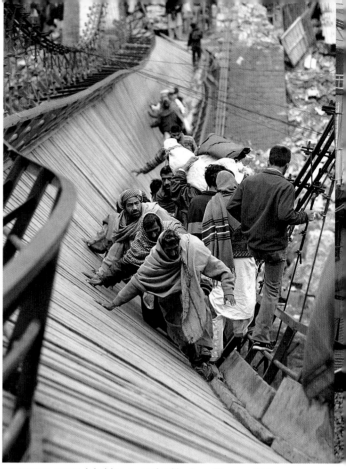

PAKISTAN, 2005 A bridge over the Neelum River wobbles

havoc earthquakes can create, making their effects ever deadlier and more dangerous.

Earthquakes have much in common with tornadoes: they are capricious beasts, ruled by what physicists refer to as nonlinear dynamics, which means precise forecasting of when and where they will occur may forever remain impossible. In theory, major earthquakes should be preceded by smaller shocks. They usually are, but the earliest foreshocks are often so weak that they are hard to distinguish from seismic background "noise." And for every small tremor that is followed by a big quake, others are answered by nothing much at all. On an average day, there are more than 2,500 earthquakes worldwide, almost all of them so slight that they cannot be detected without sensitive instruments.

As a result, predicting earthquakes is, at best, an inexact

EARTHQUAKES 101

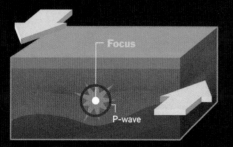

IN A "STRIKE-SLIP" fault, right, two plates grinding against each other snap into a new position, sending energy radiating outward in waves. The waves moving inside the earth are **body waves;** when they reach the ground, they are **surface waves.** There are two types of body waves, primary and secondary

Primary (P) waves travel fast, about 1 to 5 miles per second, arriving first at surface locations. The **focus** is the fracture point belowground; the **epicenter** is the corresponding point aboveground

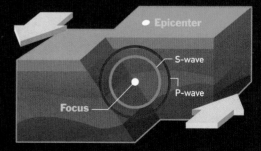

Secondary (S) waves move more slowly, causing the rolling motion of the quake. Surface waves are sometime called Long waves or L waves; they cause the damage aboveground

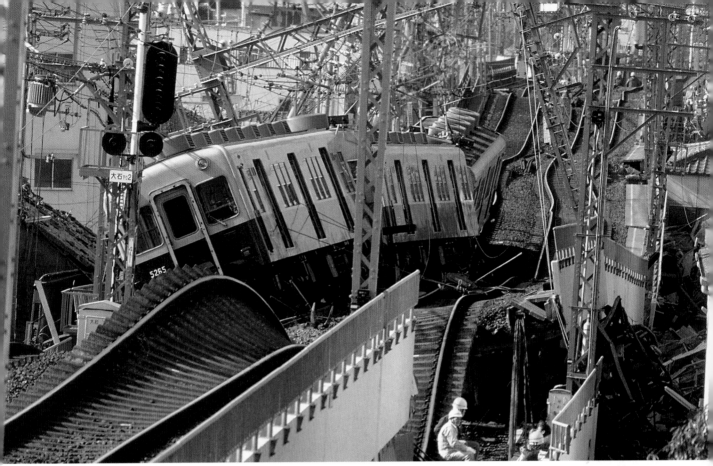

KOBE, JAPAN, 1995 The Jan. 17 earthquake, which measured 7.2, killed 6,433 people and twisted elevated railways into ribbons

science. In California, for example, seismologists have acknowledged for years the high probability of earthquakes on various sections of the San Andreas Fault system. Ironically, however, five of the six significant earthquakes that have struck California in the past 17 years (Loma Prieta in 1989, Landers in 1992, Northridge in 1994, Hector Mine in 1999 and San Simeon in 2003) did not occur on the San Andreas. In the case of the magnitude-6.7 Northridge quake, which caused $20 billion in damage, the trigger was a fault nine miles deep under the ground that had gone undetected until the shaking started.

SADLY, NORTHRIDGE REPRESENTS THE kind of deadly earthquake that most unnerves seismologists. While the majority of temblors occur along the boundaries where large tectonic plates meet, some, like Northridge, strike far from the edges of convergence zones, for reasons that we simply do not understand. A series of three such intraplate quakes radiated out from beneath the quiet town of New Madrid, in the Missouri bootheel, in the winter of 1811-12. Estimated retroactively to have peaked at magnitude 8.1, these were the most powerful seismic shocks experienced anywhere in the recorded history of North America, dwarfing even the jolt that leveled San Francisco in 1906.

Eyewitness accounts talk of the ground rippling with waves as though it were an ocean. The Mississippi River temporarily reversed course and in some places briefly raged with waterfalls and rapids. Fountains of sand erupted in gritty geysers. Shock waves, pulsing outward for hundreds of miles, wrecked boats in the Charleston, S.C., harbor, cracked masonry in

NEW MADRID

The Mississippi River temporarily reversed course and in some cases briefly raged with waterfalls and rapids in 1812

Cincinnati, Ohio, and caused church bells to peal and buildings to shake as far away as New York City and Boston.

The New Madrid quakes were felt over an area of 2 million sq. mi. (by contrast, the San Francisco quake affected an area of less than 60,000 sq. mi.), but casualties were light because the territory was sparsely populated 200 years ago. Today, the same region is home to more than 15 million Americans, and a seismic event similar to the 1811-12 quakes would likely kill hundreds of thousands of people in an arc stretching from Memphis, Tenn., to St. Louis, Mo. For this reason, scientists label the New Madrid zone as one of the most dangerous potential earthquake zones in the world. And it may be stirring: in the summer of 2005, scientists at the University of Memphis documented a five-year uptick in seismic activity in the New Madrid region. The university's Center for Earthquake Research and Information (CERI) estimates the chances of a magnitude-6 or higher quake in the area in the next 15 years to be 63%, and puts the odds of such an event over the next 50 years at 90%. "It's going to happen eventually," warns CERI geologist Eugene Schweig.

On the other side of the planet, in Kashmir, eventually is now: aid organizations and rescuers are scrambling, months after the mountains heaved, to provide homes, food, warmth and security for the millions left homeless in one of the world's most inaccessible regions. "A whole generation has been lost," lamented Pakistani army spokesman Major General Shaukat Sultan after the deadly 2005 quake. With the science of earthquake prediction still in its infancy, mankind may live in fear of terra that is not firma for many generations to come. ∎

BREAKING GROUND: GREAT EARTHQUAKES

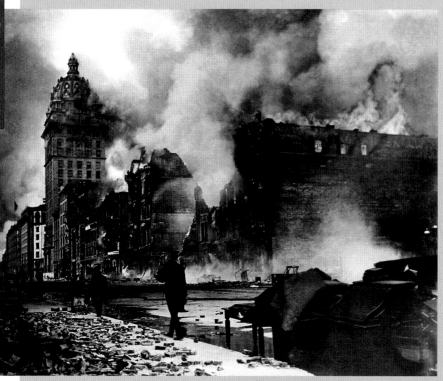

SAN FRANCISCO, 1906 Estimated to have peaked at magnitude 7.9, the Great Quake, as city residents still call it, ruptured along a 260-mile section of the San Andreas Fault, with the two plates on either side lurching past each other in 20-ft. rifts. The deadliest-ever U.S. quake wrecked 29,000 homes, but more of the city was destroyed by the fires that followed: with the water system offline for more than a week, fire fighters could do little to contain the blazes. Although more than 225,000 people were left homeless, for almost a century the death toll stood at the stunningly low figure of 478. In January 2005, city officials acknowledged what historians had long suspected: the number was fabricated by civic boosters who wanted to downplay the scale of the disaster. A more accurate death count: 3,000.

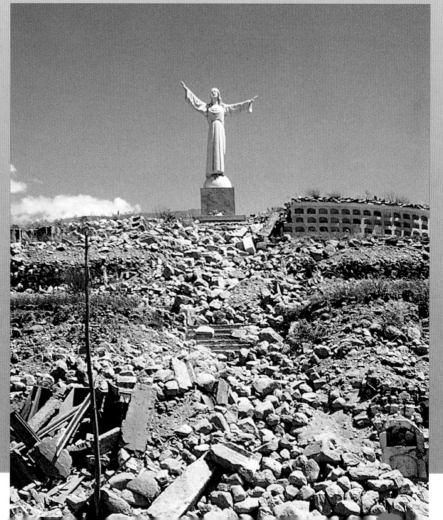

PERU, 1970 It lasted only 45 sec., but that was enough: this earthquake on the last day of May was the worst natural disaster in Peruvian history. The epicenter of the quake was in the Pacific Ocean, more than 10 miles off the Peruvian coast, but the 7.9-magnitude event destabilized the northern wall of Mount Huascarán, triggering an avalanche of 80 million cu. yds. of rock, mud and snow. A wall of debris more than 3,000 ft. wide and one mile long hurtled through Ranrahirca and Yungay at more than 100 m.p.h., completely burying the towns. In Yungay some villagers were saved by climbing the hill at right, capped with a statue of Christ. More than 70,000 people were killed in the calamity, and an additional 600,000 were left homeless.

MEXICO, 1985 The magnitude-7.8 quake that shook Mexico City on Sept. 19, below, was triggered by a seismic gap, a convergence region that had not experienced a major earthquake for many years but where bottled-up tectonic stress had reached the bursting point. Although the quake's epicenter was on the ocean floor about 150 miles from Acapulco, coastal towns like Ixtapa suffered much less damage than Mexico City, hundreds of miles inland. Reason: the shoreline is made of solid rock and thus shakes less violently, but Mexico's capital was built on an alluvial lakebed. As a result, seismic waves were amplified in the city's sediment foundation. Some tall buildings in the huge metropolis were just the right height to vibrate sympathetically with the seismic waves, amplifying their effects. More than 9,000 died.

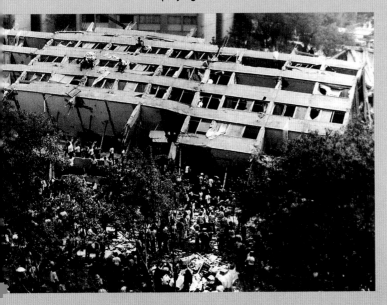

CALIFORNIA, 1994 Local mountains rose as much as a foot, nine highways buckled and warped, and 60 people died when a 30-sec. earthquake rocked Northridge, a suburb of Los Angeles. Multistory buildings like the one above simply pancaked. Some 3.1 million people were left in darkness, and an oil main and 250 gas lines ruptured. More than 1,000 aftershocks, some considerable temblors in their own right, kept the ground shaking long after the main event. Yet California is perched atop such a perilous convergence zone that this quake was far from "the Big One" that troubles the dreams of Golden Staters.

PAKISTAN, 2005 After a 7.6 quake rattled Kashmir on Oct. 8, citizens searched for survivors in the ruins of a collapsed 10-story building in Islamabad, right. By the onset of winter, more than 87,000 people were dead and some 3 million were homeless, with both totals expected to rise further. Relief efforts were hampered by the region's remoteness, tribal infighting, local corruption and a tepid response by the international community. "We thought the [2004] tsunami was bad," said U.N. aid coordinator Jan Egeland. "This is worse."

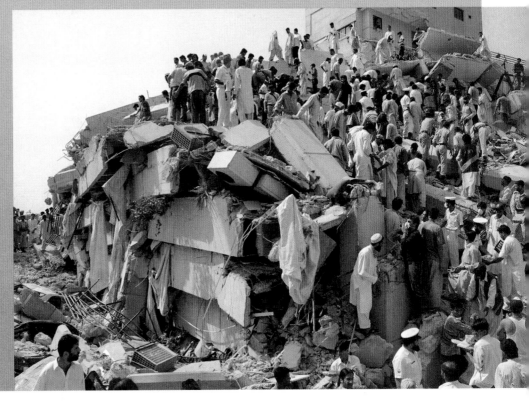

TARGET: FAULTS ALARMS

Probing the San Andreas, scientists hope to predict quakes

FOR A CENTURY, EARTHQUAKE SCIENCE HAS BEEN STUCK in a position something like trying to figure out what happened to the *Titanic* without actually diving to the wreck," says William Ellsworth of the U.S. Geological Survey (USGS), one of the scientists behind a new project that is drilling directly into the San Andreas Fault. "You can locate the hull with sonar, you can develop all sorts of theories about how it got there, but you can't confirm or disprove any of them without direct observation."

Now the San Andreas Fault Observatory at Depth (SAFOD)—a project that aims to insert probes directly into the stress points where temblors happen—hopes to give scientists an unprecedented firsthand look at the mechanics behind earthquakes. "Most quakes happen at a depth that is equivalent to the altitude of a jet airliner, several miles away from us," Ellsworth says. "But since earthquake science began, around the time of the 1906 San Francisco quake, we've been taking measurements only from the surface."

In June 2004 a team of scientists from the USGS, the National Science Foundation and Stanford University began drilling with high-tech oil-prospecting equipment into the fault that shook San Francisco a century ago . In August 2005 they reached target depth, just shy of two miles down.

"We chose this point," Ellsworth explains, "because we know this is the site of quakes that recur frequently, usually begin at a relatively shallow depth and are generally quite mild." Generally, but not always: the SAFOD drilling rig is located just outside the hamlet of Parkfield, site of a September 2004 magnitude 6.0 earthquake. It is also believed by some scientists to have been the epicenter of the 1857 Fort Tejon quake (magnitude 8.0), which is now considered the largest to hit California in the past 300 years.

After the probe reached its maximum depth, the research team lined the 8-in. cavity they had reamed out with steel and concrete and began packing it with instruments. At the tip of the probe, the SAFOD subterranean spyglass—earthquake science's version of the Hubble telescope—is aimed at a geophysical trouble spot on the San Andreas that is a miniature earthquake machine. The size of a football field, it rattles with microquakes (magnitude 2) with surprising regularity.

THE SAN ANDREAS FAULT
Scientists are drilling deep into the tectonic convergence zone at its most volatile point, near Parkfield, Calif., roughly midway between Los Angeles and San Francisco

More such microquake clusters lie within a two-mile radius. In the coming years, Ellsworth anticipates, SAFOD will record fine-grained portraits of thousands of tiny temblors, some scarcely bigger than magnitude .01. By closely examining those profiles, the SAFOD scientists hope to tell how closely one event resembles another. The ultimate goal: to determine whether earthquakes, at least in principle, can be predicted.

In the summer of 2006, SAFOD engineers will begin drilling again, this time horizontally, boring a lattice of new holes that will skip back and forth across the fault itself, which is formed by the border of the Pacific and North American plates. In 2007, the SAFOD team will also start to retrieve core samples, bringing back to the surface pieces of rock that have been heated, crushed and ground into sand by the action of the plates as they grind against each other. Additionally, the team will bring up samples of fluids and gases found within the fault.

These samples may help unravel a mystery that has frustrated earth scientists for decades. "We know with a pretty high degree of precision the size and mass of the plates that are moving against each other," explains Ellsworth, "and we know approximately how much force they are exerting. With this information, the laws of physics allow us to predict how much heat should be generated by the resulting friction."

The problem: researchers have been looking for this heat for more than 50 years, and haven't found it. "One theory is that the fluid and gas we're finding in the fault may act as a lubricant and reduce the friction, which could help explain the missing heat," Ellsworth says. But this raises as many questions as it answers: "Nobody knows where the gas we're finding—mainly hydrogen and radon—is coming from."

Even some surprisingly basic questions about the San Andreas are still unanswered. "Nobody can say with any confidence how wide the fault itself is at that depth," Ellsworth notes. "Theories range from a few fractions of an inch to more than 10 ft. wide. But this is a question that we should be able to nail down within the next year or so."

In the meantime, the SAFOD probe is demolishing as many theories as it gives rise to. "For decades, the conventional wisdom has been that the San Andreas derived part of its power from fluids kept under very high pressure," Ellsworth says. "But so far, at least in the Parkfield area, that doesn't appear to be the case.

"One of the first rules of science is that you get the best information by going where the action is," Ellsworth says. "For this reason, the study of earthquakes is about to change fundamentally. We're on the threshold of a whole new era of direct observation." Quake science is about to pass GO. ∎

SMOKE IN THE WATER

Hot geysers in the ocean floor alter our definition of life

JACQUES COUSTEAU, THE ANCIENT MARINER OF THE undersea world, did his best to inspire each of us with his sense of rapture for the deep. Yet despite his efforts, the world beneath the waves remains one of the planet's last frontiers. While scientists and the general public wax enthusiastic over the vaguest hint that there once might have been water on Mars, the exploration of our own oceans is halting at best. A glaring example: it was not until 1977 that scientists first discovered hydrothermal vents on the ocean floor, cracks in earth's crust that supported life-forms never encountered or even suspected before. Here, in ink-black waters deep below the seas, mankind also first found animals whose energy source was not based in some way on light from the sun.

Like geysers aboveground, hydrothermal vents occur when seawater seeps through fissures into the crust and is heated by hot reservoirs of magma to some 350° to 750°F, until it bursts through the oceanic crust. (Water that hot would boil on land, but at the depths the vents are located, the pressure of the surrounding ocean water raises the boiling point.) The first hydrothermal vent was discovered by a team of scientists operating the deep-sea submersible *Alvin* near the Galápagos Islands some 1.8 miles beneath the ocean's surface; since 1977, many other vents have been charted.

The hot water that pours up through the vents is rich in minerals: when it mingles with the cold seawater, the minerals separate, in a process known as precipitation. Then they crystallize, often forming a chimneylike structure that surrounds the vent. Reflecting the enormous power that creates them, chimneys can grow very quickly, up to 30 ft. in 18 months. The vents that spout water most heavily laden with minerals appear deep black and have been dubbed "black smokers"; other vents are "white smokers."

Yet if earth scientists were thrilled by the discovery of these undersea geysers, which had been predicted by tectonic theory, it was biologists who had to rewrite their textbooks. For unique life-forms, including giant tube worms and spider crabs, were soon discovered, thriving near these smoking vents on the ocean floor. Unlike any other sea or land animals, they are sustained by energy that is not derived from the sun, via the photosynthesis that was long believed to be essential to vegetable and animal life.

How do the creatures survive in this most inhospitable of environments? It turns out that they harbor within their bodies large aggregations of bacteria that sustain themselves by turning the mineral sulfides pouring from the vents into oxygen—in short, by chemosynthesis rather than by photosynthesis. These bacteria, in turn, provide nutrition for their hosts. And that's how life scientists found illumination in one of the darkest places on the planet. ∎

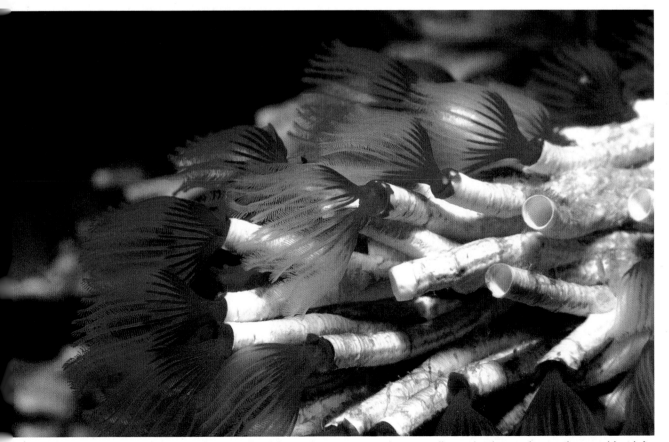

GRACE UNDER PRESSURE Above, tube worms flourish near hot vents more than two miles under the sea, in a sunless world; at left, a black smoker at the bottom of the Mid-Atlantic Ridge, a tectonic convergence zone, billows with heated, mineral-rich seawater

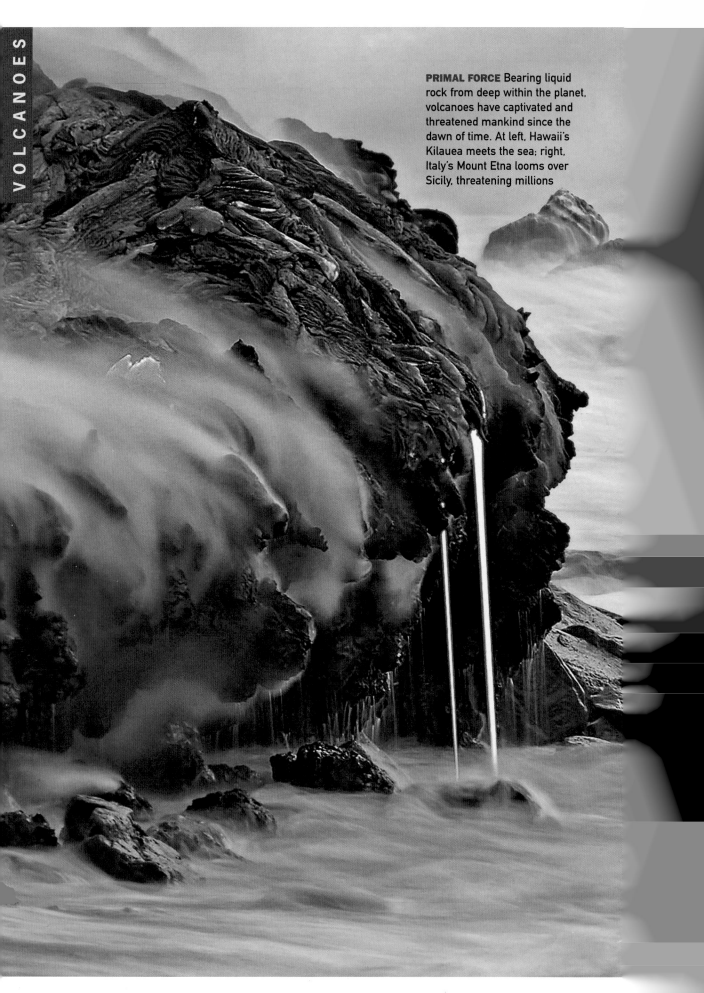

PRIMAL FORCE Bearing liquid rock from deep within the planet, volcanoes have captivated and threatened mankind since the dawn of time. At left, Hawaii's Kilauea meets the sea; right, Italy's Mount Etna looms over Sicily, threatening millions

PORTALS OF FIRE

Gateways to a molten world, volcanoes bring forth fresh land from within the planet, often at a cost. Two scientists who survived a deadly eruption recall their ordeal

T HE EXPEDITION SEEMED ROUTINE—YET as its participants should have known, little is routine in the ever simmering, unpredictable world of volcanoes. The month was January 1993, and the 13,680-ft. Galeras volcano in the Colombian Andes had experienced a few minor eruptions in

the past six months. Before that, with the exception of a significant blow in 1988, Galeras had been almost completely dormant for more than 40 years.

So when a team of 13 scientists attending a nearby United Nations conference on volcano prediction set out to descend into the volcano's cone to collect data, they believed they were not placing themselves in significant danger. The outing promised to be a bonding experience for the scientists, a bit of a busman's holiday, and the light-hearted mood was amplified when a group of tourists joined the volcanologists on the climb up to the volcano's rim.

The expedition was led by University of Arizona geologist Stanley Williams and included Florida International University earth scientist Andrew McFarlane, as well as Igor Menyailov, a Russian specialist from the Institute of Volcanology in Petropavlovsk on the Kamchatka Peninsula, home of some of the planet's most fascinating geological formations. Menyailov, who had taught himself English by listening to Elvis Presley records, had been friends with Williams since they first met in 1982 on a volcano watch in Nicaragua. "Igor was excited because he was using a new device," Williams recalls today; the instrument was designed to collect samples of gases emitted from Galera's vents.

Shortly after 1 p.m., having spent about four hours inside the volcano's cone, the scientists had collected a substantial amount of data and were relaxing before starting the trek back down the mountain. "I was talking to them about what they were doing and whether they were pleased with the data," Williams remembers. "Igor had never been to South America before, and he was excited. He stood there, smoking a cigarette before he was going to climb up to me."

Suddenly a single rock tumbled from the rim above them and landed inside the crater. It was followed by another, then another. "I remember hearing three rock falls in the space of about a minute," says McFarlane. "After a couple of them, I asked Stan, 'You hear those rock slides?' Right after that the thing blew up—BOOM!"

"I yelled to everyone to get out," Williams says. In the next few seconds, jets of searing gas blew straight up from beneath their feet, as tons of stone were blasted skyward faster than a bullet from a gun. "Suddenly there were these big rocks, the size of television sets and baseballs, flying through the air at hundreds of miles an hour," he recalls. "And they were on fire." Within a few seconds, Menyailov was incinerated, along with Colombian scientist Nestor Garcia; both of their remains vaporized into gas. A local college professor, Carlos Trujillo, was cut in half by falling debris.

"I'm looking up, trying to see something," remembers McFarlane. "And I hear three or four heavy impacts around me, big blocks coming in that I hadn't seen at first. They split open when they hit the ground. Inside they were glowing red. And I just think, 'Well, this isn't going to work. I'm just going to have to run for it.' Out of the corner of my eye, I see one of the tourists getting hit by some big piece of rock, and I remember thinking at the moment he looked like a fence post getting driven into the ground. It was horrendous.

"I said to myself, 'I don't want to die. I don't want to leave my wife and kids alone,'" Williams says. "I turned and ran as fast as I could. I didn't make it very far, only about 20 meters below the rim." At that point, Williams was hit by flying rocks that broke his left leg and nearly severed his right, where a piece of bone now protruded through the flesh. He also suffered a broken back and jaw. As Williams lay immobilized, a large stone hit him directly on top of the head, driving skull fragments deep into his brain. "I was on fire by that time," he says, "because the rocks were incandescent."

McFarlane says, "I was running and falling, getting up, running and falling. And I fell down close to Stan. I thought, 'Well, there's only one thing I can do for him that's going to be meaningful and that's to pick him up.' But I was too weak. And I thought, 'If I try to do this, we're both going to get killed.' So I had to leave him there. I just kept running. That was really awful because I thought I was probably leaving him to die."

In all, six scientists who trekked to the rim of Galeras that morning died, along with three members of the tourist party. Both McFarlane and Williams survived—in the latter's case, just barely. "I was marginally alive," recalls Williams, who was covered with burns. When rescuers finally reached McFarlane and Williams and the two other survivors several hours later, they found Williams' backpack, altimeter and sunglasses melted onto his body.

MOUNT DOOM Volcanologists pose for a snapshot before descending into Galeras in 1993. Standing, from left: Alfredo Manzo, Nestor Garcia, Fabio Garcia, Igor Menyailov; seated, Stanley Williams and José Arles Zapata Arles. Not shown: Andrew McFarlane. Below, Galeras smokes in 2005

INALDO PEREZ—AP/WIDE WORLDINSET: FABIO GARCIA

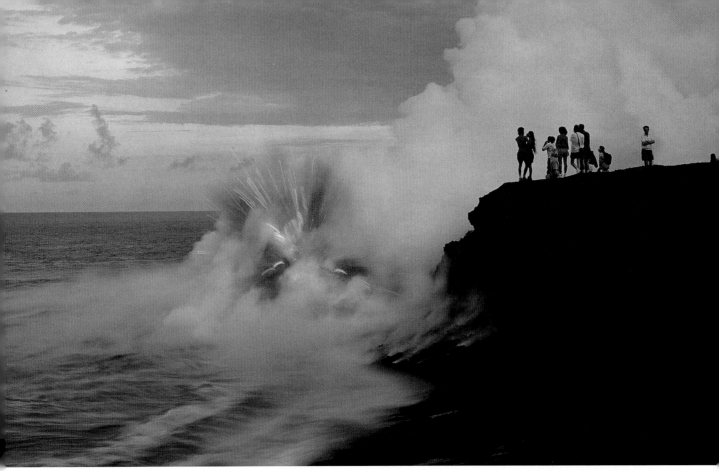

FIRE AND WATER Kilauea in Hawaii is a very active, relatively tame volcano, providing tourists with a spectacular clash of elements

In a telling irony, when the survivors reached Pasto, the town that lies at the foot of the volcano, they were told that the inferno they had experienced was a relatively minor eruption; nothing special. Galeras had barely shrugged.

THERE IS NO MORE CONVINCING—AND DEVASTATING— evidence that we inhabit a living planet than the restless, unpredictable and occasionally cataclysmic activity of volcanoes. Everywhere around the globe, including under the oceans, the planet's crust is constantly breaking open, spewing forth the raw material of new plains, plateaus and mountains, then subsiding into itself, or rumbling furtively, in portents that may augur imminent destruction or may mean nothing at all. Small wonder volcanoes are enduring symbols of nature's raw power. Mountains of fire erupt time and again in man's legends and stories: the god Vulcan of Roman mythology lent his name to the phenomenon, and volcanoes play central roles in the Norse sagas, the German *Nibelungunlied*, the operas of Richard Wagner and in such modern iterations as Mount Doom in J.R.R. Tolkien's *Lord of the Rings* trilogy. Seeking to end his epic *Star Wars* series with a bang, George Lucas set the climactic battle in *Revenge of the Sith* on the volcanic planet of Mustafar.

More than 1,500 active volcanoes dot our planet's land masses, hundreds more lie beneath its seas, and an unknown number of others are lying dormant or gestating deep within the earth, waiting to be born. On average, a volcano erupts somewhere in the world once each week. Most gently spill lava—molten rock—down their slopes; some explode with a force many times greater than all the world's nuclear weapons combined.

The need to predict when a volcano will blow its top, and with how much force it will do so, drew Williams, McFarlane,

VOLCANOES 101

Eruption cloud

Wind

Tephra

Pyroclastic flow

Lava flow

Lava plug

Landslide

Magma

MAJOR ERUPTIONS OCCUR when hot magma—essentially liquid rock—is plugged up in a volcano's channel, usually by a hardened plug of old lava, to a bursting point. Once magma is ejected from the cone, it is termed lava. Air-borne ash, cinders and rock are termed tephra. They can collect to form fast-moving fluidized bodies called pyroclastic flow

THE RING OF FIRE

Tracing the seams where giant tectonic plates collide, a crescent of volcanoes encircles the Pacific Ocean

ASIA

Kurile Islands

Japan
Fuji

Aleutian Islands

Mount Rainier
Mount St. Helens
Mount Shasta

NORTH AMERICA

Taiwan
Philippines
Pinatubo

Marianas Trench

Hawaii

Pacific Ocean

Sta. Maria

Galeras

Equator

Galápagos Islands

SOUTH AMERICA

New Guinea

Samoa

Krakatoa
Indonesia

San Pedro

AUSTRALIA

Sections of 10 different tectonic plates collide around the edges of a 25,000-mile arc that surrounds the Pacific Ocean. Along these convergence zones, more than half the world's active volcanoes above sea level are found and the majority of significant earthquakes occur

BLASTOFF: **GREAT ERUPTIONS**

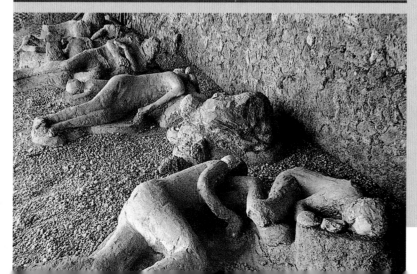

Volcanic eruptions are surprisingly common. Some active volcanoes, like the tourist-friendly cones of Hawaii, bubble and spout lava almost every day. But the greatest of eruptions have scalded themselves a place in mankind's collective memory.

POMPEII Italy's Mount Vesuvius exploded in A.D. 79, burying the cities of Pompeii and Herculaneum and fossilizing citizens in the very postures in which they were buried in ash, left. The preserved ruins of the towns offer an enduring window into life in the Roman Empire at its height—while Vesuvius remains as one of the world's most threatening active volcanoes.

and their colleagues to Galeras. Just a decade earlier, incorrect predictions of an eruption at Colombia's Nevado del Ruiz volcano led to an unnecessary evacuation of the region. In a tragic case of ignoring cries of "wolf," local officials later disregarded another warning that proved all too accurate—and more than 26,000 people died in a few ghastly hours.

As Williams and McFarlane can attest, what little volcanologists have learned over the centuries has come at a fearsome price. Beginning in A.D. 79, when the Roman scientist Pliny the Elder was killed while observing an eruption of Mount Vesuvius, volcanology has been one of the world's more dangerous fields of study. In an average year, at least one volcano scientist is killed in the field.

Yet humans have been drawn to volcanoes since ancient times. The surrounding soils are mineral rich, and dried volcanic mud and lava flows often form flat areas, conducive to settlement. Today, says Williams, about 500 million people (1 person in 13 of the planet's population) lives close enough to an active volcano to be in danger. The two volcanoes with today's deadliest potential are both active and perilously close to large population centers: Italy's Mount Vesuvius towers over Naples and its surrounding towns, home to more than 11 million people, while Africa's Nyiragongo volcano glowers over the Congolese city of Goma. But these two are hardly unique: Mexico City sits in the shadow of the Popocatépetl volcano, which has been growling for years and could someday rain ash and rock on the homes of 20 million people. But few volcanoes can be safely ignored. Among the world's known active cones, more than one-third have erupted violently in the past 400 years, a sign that indicates they remain dangerous.

HOT STUFF Molten lava reaches temperatures of 1300°F to 2000°F

Most volcanoes, like earthquakes, are caused by the action of tectonic plates grinding against one another. Thus they are especially common in the same areas where quakes are prevalent, such as the Pacific Ocean's "Ring of Fire." They are most often found where huge slabs of the earth's crust are forced downward, into the planet's superheated interior, where they melt. Because this molten rock, or magma, is lighter than the material that surrounds it, it is buoyant and rises back toward the surface. There it can sit, undetected, for millions of centuries. But when the accumulating pressure becomes too great, the liquefied rock finds a weak spot in the earth's surface, which buckles upward and eventually explodes as a volcano. Not all volcanoes trace the planet's fault lines, however; some sit atop "hot spots" where stable reservoirs of magma lie close to the earth's surface. The Hawaiian archipelago was formed by one such series of volcanoes.

Although the science of predicting eruptions is still in its infancy, great strides have been made in recent years. Many researchers are focusing on the small earthquakes that precede most eruptions. Using seismographs, acoustic sensors, and GPS satellite-navigation beacons, volcanologists have learned to recognize a signature of distinctive tremors that almost always precede a violent eruption. The signals come in two forms: A-type, which begins with a sharp crack and then trails off quickly; and B-type, which builds slowly and then trails off gradually. These signals, scientists believe, correspond, respectively, to the crumbling of solid rock under the upward pressure exerted by liquefied rock and the liquefied rock slowly filling the cracks made by the crumbling action. A repeating pattern of A-type and B-type readings, coming one after another with increasing rapidity, like the contractions of a woman going into labor, was used to anticipate the 2000 eruption of Mexico's Popocatépetl. Interpreting the signals given off by the volcano since 1993, scientists were able to peg the exact date of the Dec. 18 eruption two days in advance.

The early warning provided enough time for the Mexican army to evacuate more than 30,000 people from the most threatened areas. Just as important, scientists were able to estimate the severity of the event, accurately predicting it would be a moderate eruption. Thus no needless evacuations were ordered, precluding the false alarms that led to the tragedy at Nevado del Ruiz. The power of volcanic eruptions is far beyond man's ability to control—a lesson that Andrew McFarlane learned the hard way. His advice to amateur volcanologists who seek the thrill of traipsing into a "dormant" cone: Just say the final syllable of volcano. ∎

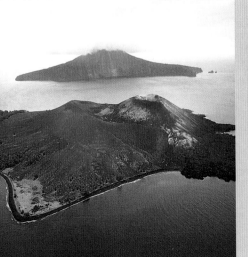

KRAKATOA In the most powerful modern eruption, this volcano in Indonesia's Sunda Strait exploded beginning on Aug. 27, 1883. The force of the blast altered the shape of the archipelago, sent deadly tsunamis across the region and spewed so much ash into the air that the sun was dimmed and temperatures around the globe were reduced for more than a year.

PINATUBO The Philippine volcano blew in 1991, right, killing more than 300 people, injuring hundreds more and displacing millions.

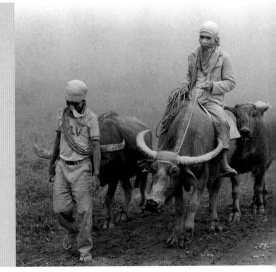

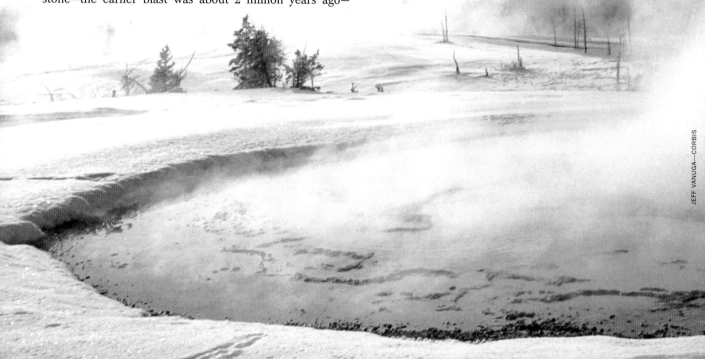

BLAST FROM THE PAST

A supervolcano may make Yellowstone rock and roll again

WE'RE STILL FINDING BURIED ASH DEPOSITS MORE than 20 feet deep in California and all over the Great Plains," Bob Christiansen says of a volcano that exploded in what is now Yellowstone National Park 640,000 years ago. "It covered most of the western United States in a blanket of hot ash," says Christiansen, a scientist emeritus at the U.S. Geological Survey, "and even did significant damage east the Mississippi," where scientists have uncovered shallower layers of rock and ash in Louisiana and Mississippi. "For comparison," Christiansen says, "when Mount St. Helens erupted in 1980, it threw one cubic kilometer of rock and ash into the air." The Yellowstone supervolcano (as such a massive eruption is called) "tossed around 2,000 cubic kilometers of debris and ejecta into the atmosphere," Christiansen explains. "So we're talking about a level of force that is several thousand times greater than any volcano that has erupted during recorded human history."

In technical terms, a supervolcano is a volcano that erupts with magnitude 8 or greater on the Volcano Explosivity Index, which means that more than 1,000 cu km of lava and ash are blown out of the cone. The Yellowstone eruption left a hole in the ground more than 35 miles wide. This structure, known as the Yellowstone caldera, is so large that it went unnoticed until the 1960s, when it was first detected in satellite photographs. "Supervolcanoes usually don't take the shape of mountains, the way ordinary volcanoes do," Christiansen explains. "They are caused by the uplift of massive pools of molten rock, rising from deep within the earth. Often they appear to take the form of the ground bulging over a large area, until it simply explodes."

And when the ground explodes, as it has twice in Yellowstone—the earlier blast was about 2 million years ago—

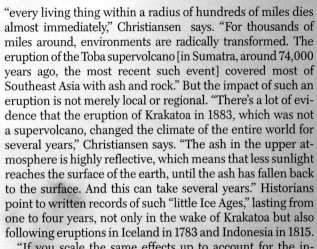

"every living thing within a radius of hundreds of miles dies almost immediately," Christiansen says. "For thousands of miles around, environments are radically transformed. The eruption of the Toba supervolcano [in Sumatra, around 74,000 years ago, the most recent such event] covered most of Southeast Asia with ash and rock." But the impact of such an eruption is not merely local or regional. "There's a lot of evidence that the eruption of Krakatoa in 1883, which was not a supervolcano, changed the climate of the entire world for several years," Christiansen says. "The ash in the upper atmosphere is highly reflective, which means that less sunlight reaches the surface of the earth, until the ash has fallen back to the surface. And this can take several years." Historians point to written records of such "little Ice Ages," lasting from one to four years, not only in the wake of Krakatoa but also following eruptions in Iceland in 1783 and Indonesia in 1815.

"If you scale the same effects up to account for the increased power of a supervolcano," Christiansen says, "you're talking about catastrophic effects on the climate around the world, lasting for decades, maybe centuries." Indeed, Stanley Ambrose, an anthropologist at the University of Illinois at Urbana-Champaign, has theorized that after the Toba supervolcano erupted, the worldwide population of *Homo sapiens* dwindled to just a few thousand and nearly became extinct. In Ambrose's view, that explains the mystery of why all human beings appear to be genetically related to a relatively small number of common ancestors.

After the eruption of a supervolcano, the underground chamber that housed its several thousand cu km of liquefied rock usually collapses, leaving a vast depression in the earth's surface, like the Yellowstone caldera. Such depressions can be found in more than a dozen places on the earth's surface, most of them above the hot spots where mantle plumes (pools of molten rock welling up from deep beneath the planet's crust) rise toward the surface.

The bad news: a team of U.S. geologists warned in 2001 that the Yellowstone caldera remains active and is likely to erupt at some point in the future, covering up to half of the U.S. in a layer of rock and ash at least 3 ft. deep, although they declined to predict when.

The good news: it doesn't appear to be anytime soon. "These are extremely rare events," says Christiansen. "And all the evidence we now have says that the event would be preceded by decades, if not centuries, of warning signs. So it's true that a supervolcano will again erupt somewhere in the world someday. But it's not something we have to worry about in the foreseeable future." Reader, feel free to exhale. ∎

THAR SHE BLOWS!
Geysers in Yellowstone Park indicate that it sits atop a geological hot spot, with magma pools not far below the ground. "Old Faithful" is in the background

INSIDE THE PLANET

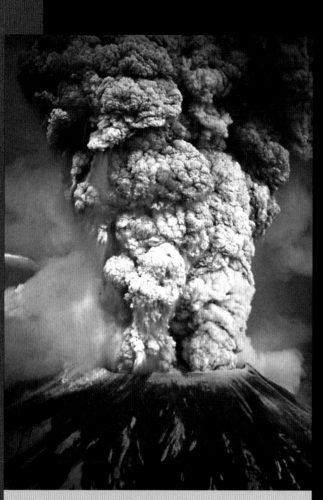

FLASHBACK: Mount St. Helens

TIME, JUNE 2, 1980 A stupendous explosion of trapped gases, generating about 500 times the force of the atomic bomb dropped on Hiroshima, blew the entire top off Mount St. Helens. In a single burst St. Helens was transformed from a postcard-symmetrical cone 9,677 ft. high to an ugly flattop 1,300 ft. lower. Clouds of hot ash made up of pulverized rock were belched twelve miles into the sky. Giant mud slides, composed of melted snow mixed with ash and propelled by waves of superheated gas erupting out of the crater, rumbled down the slopes and crashed through valleys, leaving millions of trees knocked down in rows, as though a giant had been playing pick-up sticks.

IN THE FIELD **The Thrill of the Drill**

GEOPHYSICIST MARK ZOBACK, *who works with William Ellsworth on the San Andreas Fault Observatory at Depth (SAFOD), talked to TIME about a breakthrough:*

All through the spring and summer of 2005, I was spending a lot of time at the SAFOD drill site on a ranch in the California countryside. There was one period of maybe a week when the drill head became stuck about a mile and a half underground, and it wasn't clear that we would be able to free it. The entire team was worried that the project was going to die then and there. Eventually, the oil-drilling technicians we brought in were able to get it moving again and we continued drilling. Later, during the first week of August, I was at SAFOD when we finally penetrated the San Andreas Fault itself.

The drilling site is located to the west of the San Andreas, and we had stopped seeing the mostly granite composition you generally find on that side of the fault a week earlier. We thought we had cracked through once before but that turned out to be a different, previously unknown fault.

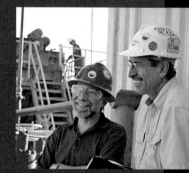

SMILES Ellsworth, left, and Zoback cheer when the SAFOD drill hits the fault

Suddenly, the drill head hit something that caused it to move much faster, which is always exciting. This turned out to be an area with a lot of liquid and gas. Then we started seeing these strange rocks—mostly shale and clay, which you expect to see on the east side of the fault. We had to wait for test results to confirm that these rocks were from the far side of the fault, but we were pretty sure that we had punched through once those samples came up. Somebody had brought a bottle of champagne to celebrate, but no alcohol is allowed at the drilling site. We had planned a party for a house nearby, but once it became clear that we were through the fault, everybody was so excited analyzing the samples, and we got so busy reviewing the data, that the idea of a party was forgotten. I remember thinking that even though we had already drilled as deep as we were going to go, this was not the end, it was a beginning. We're on the threshold of a new era of discovery.

MEASURING STICKS

EARTHQUAKES MOMENTUM-MAGNITUDE Everyone knows the Richter scale, but not everyone knows it is widely considered obsolete. Devised in 1935 by the American seismologist Charles F. Richter (1900-1985), the scale is logarithmic: the amplitude of the waves increases by powers of 10 in relation to the Richter magnitude numbers. The energy released in an earthquake can easily be approximated by an equation that includes this magnitude and the distance from the seismograph to the earthquake's epicenter. Numbers for the Richter scale range from 0 to 9, although no real upper limit exists.

Because the Richter scale is localized for California terrain, it has generally been replaced by the more universal momentum-magnitude scale, whose ratings are similar to Richter's.

DEADLIEST EARTHQUAKES, 1900-2005			
1. TANGSAN, CHINA	1976	255,000 deaths	
2. TOKYO/YOKOHAMA	1923	143,000	
3. KASHMIR, INDIA/PAKISTAN	2005	87,350	
4. MESSINA, SICILY	1908	70,000-100,000	
5. GANSU, CHINA	1932	70,000	

DEADLIEST VOLCANOES, 1900-2005		
1. MOUNT PELEE, MARTINIQUE	1902	30,000 deaths
2. NEVADO DEL RUIZ, COLOMBIA	1985	26,000
3. MOUNT PINATUBO, THE PHILIPPINES	1991	350
4. MOUNT ST. HELENS, U.S.	1980	57
5. MONTSERRAT, WEST INDIES	1997	20

VERBATIM

❝ I will try the radio. Mayday! Mayday! Ash is coming down on me heavily. It's either dark or I am dead. God, I want to live! ❞

—DAVID CROCKETT,
TV Cameraman caught in the
eruption of Mount St. Helens. He lived.

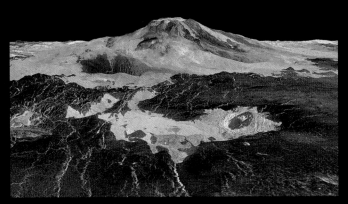

A VOLCANO ON VENUS
As NASA planetary probes explore our solar system, we're learning that familiar geological phenomena from Earth are found on other planets, even on asteroids. A camera aboard the Magellan probe of planet Venus helped create this image of Maat Mons, an active volcano that rises five miles above the surface of the planet. The false-color image was released in 1992; lighter colors toward the bottom are lava flows

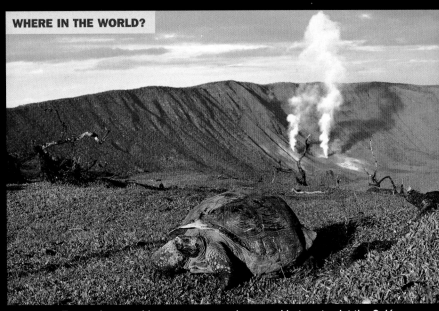

WHERE IN THE WORLD?

STEAMING Fumaroles, smoking vents near underground hot spots, dot the Galápagos Islands. This volcanic archipelago of young islands is still in the process of formation

VOLCANOES
CATEGORIES
Scientists divide eruptions into four categories.
Hawaiian Like Mauna Loa, nature's tamest volcanoes expel a relatively quiet effusion of lava, without large explosions or the expulsion of fragments.
Strombolian Like Mount Stromboli in the Lipari Islands north of Sicily, these volcanoes continuously expel viscous lava in a series of small explosions, accompanied by incandescent, luminous clouds.
Vulcanian Far more potent than the first two types, these volcanoes erupt in huge explosions after magma blocked in the vent by a hardened plug is finally released from tension by the build-up of gases.
Peléean Like Mount Pelée in Martinique, nature's most violent volcanoes erupt massively, expelling ash, lava and superheated clouds of gas high in the air.

SOURCES: TIME.COM: TIME ALMANAC; INFOPLEASE.COM; USGS; NOAA; NASA; COLUMBIA ELECTRONIC ENCYCLOPEDIA

2
THE WATER PLANET

MISSISSIPPI RIVER DELTA, 2001 This picture, taken by a satellite camera that records heat emissions, shows the river as a broad strip running diagonally across the image. The green areas are mainly mud and marshland

Perhaps because man is a creature of the land, we tend to see our globe as a collection of seven large continents separated by **OCEANS** and seas. That is a deeply flawed perspective, for the earth is a water planet, on which the continents, not the oceans, are the minority partner. There is a vantage point in space, high above the South Pacific Ocean, from which astronauts can regard the planet whole and see it in proper balance—as a brilliant **BLUE SPHERE** of water, fringed by a ring of land, Asia and Australia to the left, the Americas to the right. On this blue world, life depends on water: just as it accounts for 70% of the surface of the planet, water makes up more than half the human body. That reliance makes us subject to the delicate mechanisms of climate and geography that keep us wet—rivers and lakes, swamps and aquifers, **MONSOON** rains and ocean currents. And that reliance, in turn, makes man a subject of the weather. When it rains too much, **FLOODS** overwhelm us. When it rains too little, **DROUGHTS** parch us. When it rains too little for too long, entire civilizations can fall. Today this water planet is undergoing a wrenching change: the **CRYOSPHERE**—the polar zones where much of the planet's water is stored in the form of glaciers and **ICE CAPS**—is melting. The results, scientists say, could be catastrophic. While we fiddle, Nome yearns—for snow.

NASA/GSFC/METI/ERSDAC/JAROS, AND U.S./JAPAN ASTER SCIENCE TEAM

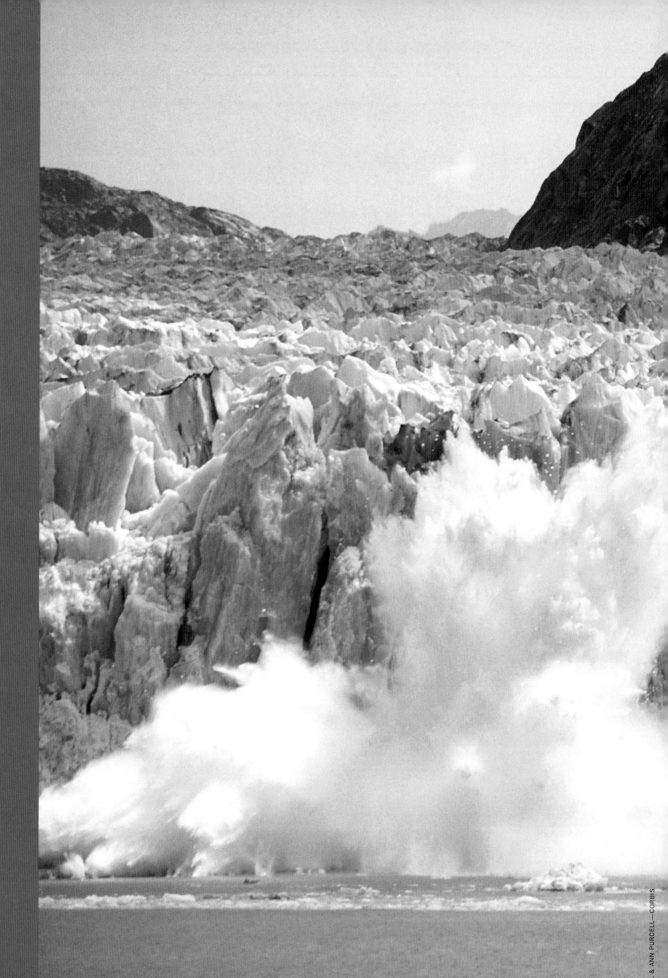

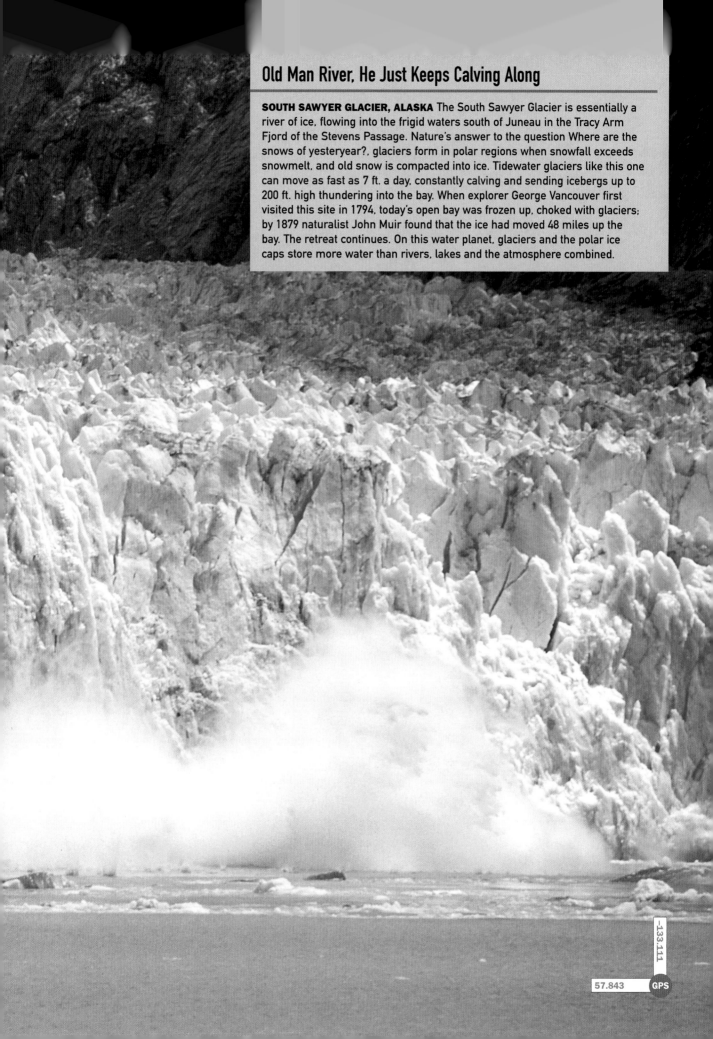

Old Man River, He Just Keeps Calving Along

SOUTH SAWYER GLACIER, ALASKA The South Sawyer Glacier is essentially a river of ice, flowing into the frigid waters south of Juneau in the Tracy Arm Fjord of the Stevens Passage. Nature's answer to the question Where are the snows of yesteryear?, glaciers form in polar regions when snowfall exceeds snowmelt, and old snow is compacted into ice. Tidewater glaciers like this one can move as fast as 7 ft. a day, constantly calving and sending icebergs up to 200 ft. high thundering into the bay. When explorer George Vancouver first visited this site in 1794, today's open bay was frozen up, choked with glaciers; by 1879 naturalist John Muir found that the ice had moved 48 miles up the bay. The retreat continues. On this water planet, glaciers and the polar ice caps store more water than rivers, lakes and the atmosphere combined.

-133.111

57.843 GPS

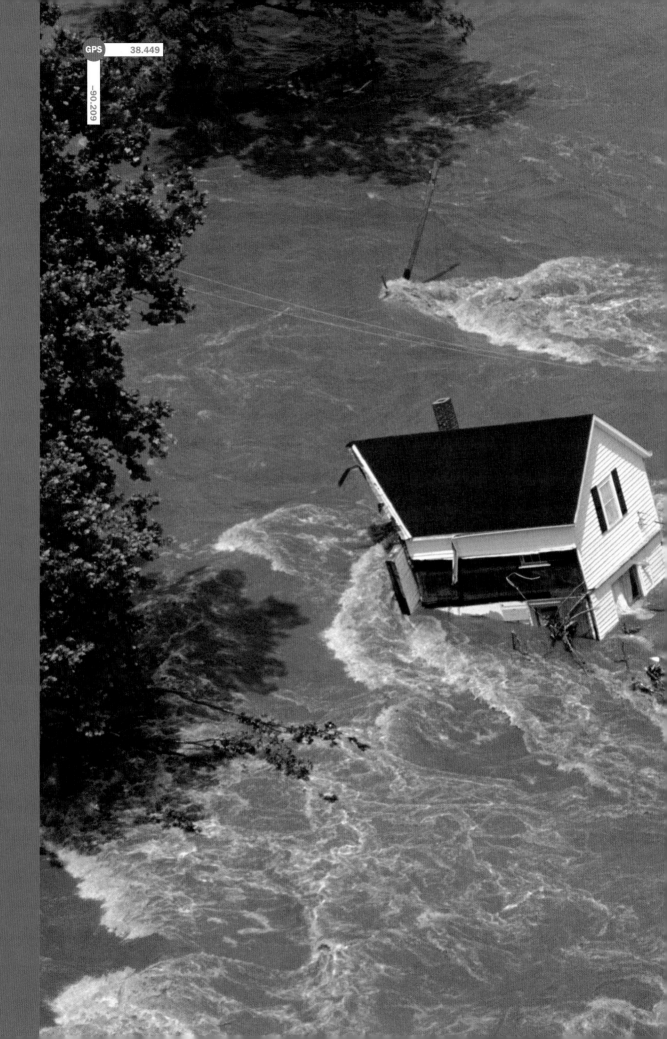

THE WATER PLANET

GPS 38.449

-90.209

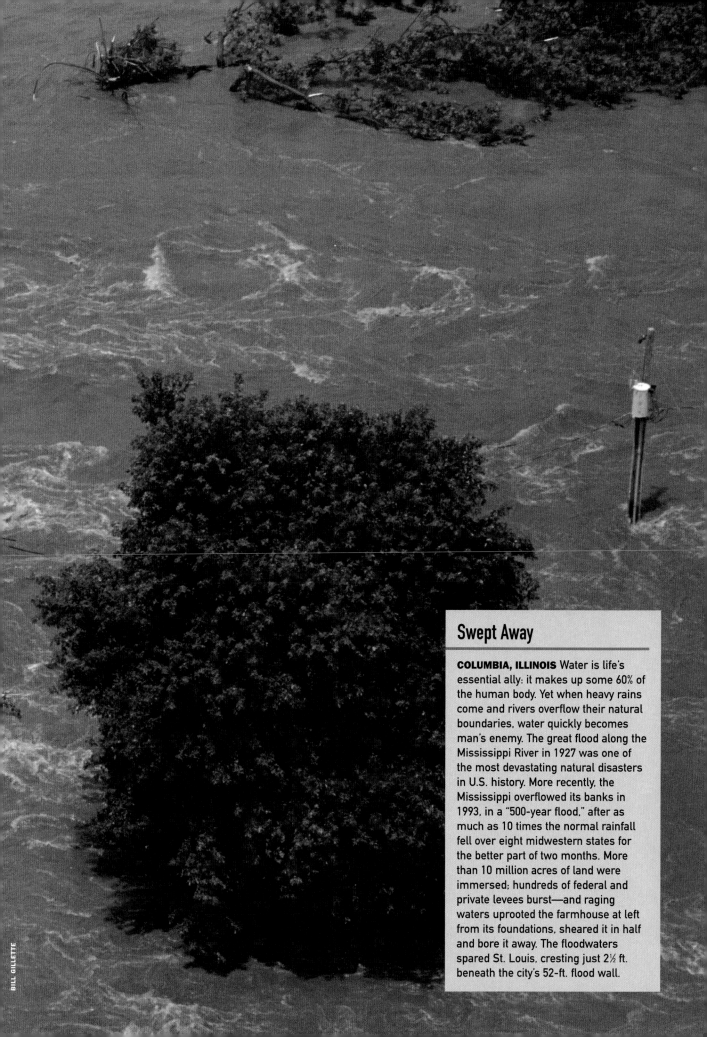

Swept Away

COLUMBIA, ILLINOIS Water is life's essential ally: it makes up some 60% of the human body. Yet when heavy rains come and rivers overflow their natural boundaries, water quickly becomes man's enemy. The great flood along the Mississippi River in 1927 was one of the most devastating natural disasters in U.S. history. More recently, the Mississippi overflowed its banks in 1993, in a "500-year flood," after as much as 10 times the normal rainfall fell over eight midwestern states for the better part of two months. More than 10 million acres of land were immersed; hundreds of federal and private levees burst—and raging waters uprooted the farmhouse at left from its foundations, sheared it in half and bore it away. The floodwaters spared St. Louis, cresting just 2½ ft. beneath the city's 52-ft. flood wall.

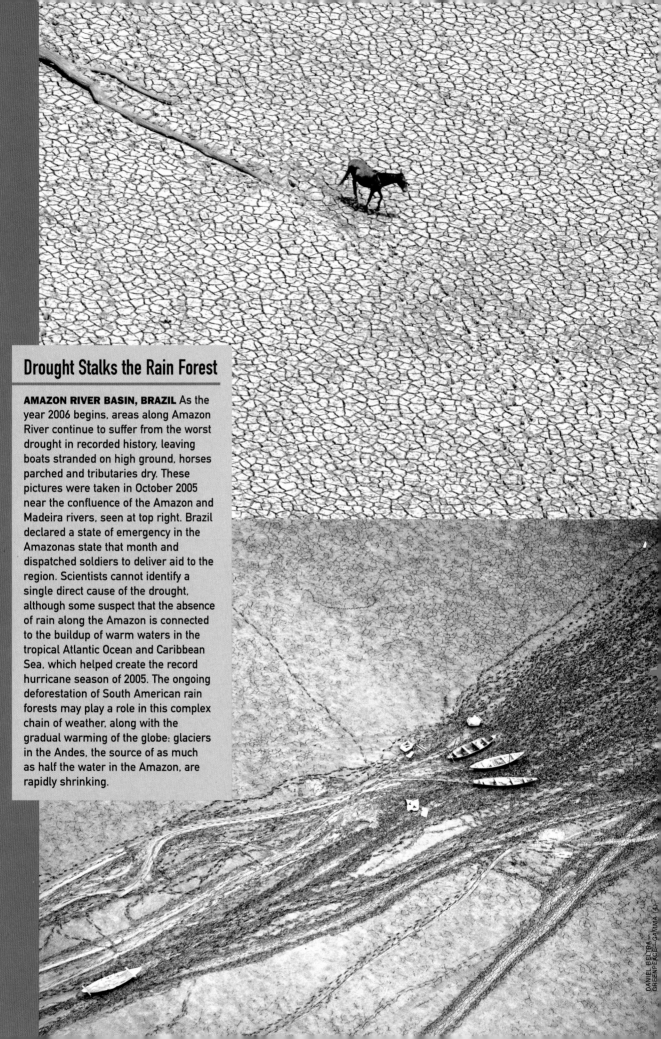

Drought Stalks the Rain Forest

AMAZON RIVER BASIN, BRAZIL As the year 2006 begins, areas along Amazon River continue to suffer from the worst drought in recorded history, leaving boats stranded on high ground, horses parched and tributaries dry. These pictures were taken in October 2005 near the confluence of the Amazon and Madeira rivers, seen at top right. Brazil declared a state of emergency in the Amazonas state that month and dispatched soldiers to deliver aid to the region. Scientists cannot identify a single direct cause of the drought, although some suspect that the absence of rain along the Amazon is connected to the buildup of warm waters in the tropical Atlantic Ocean and Caribbean Sea, which helped create the record hurricane season of 2005. The ongoing deforestation of South American rain forests may play a role in this complex chain of weather, along with the gradual warming of the globe: glaciers in the Andes, the source of as much as half the water in the Amazon, are rapidly shrinking.

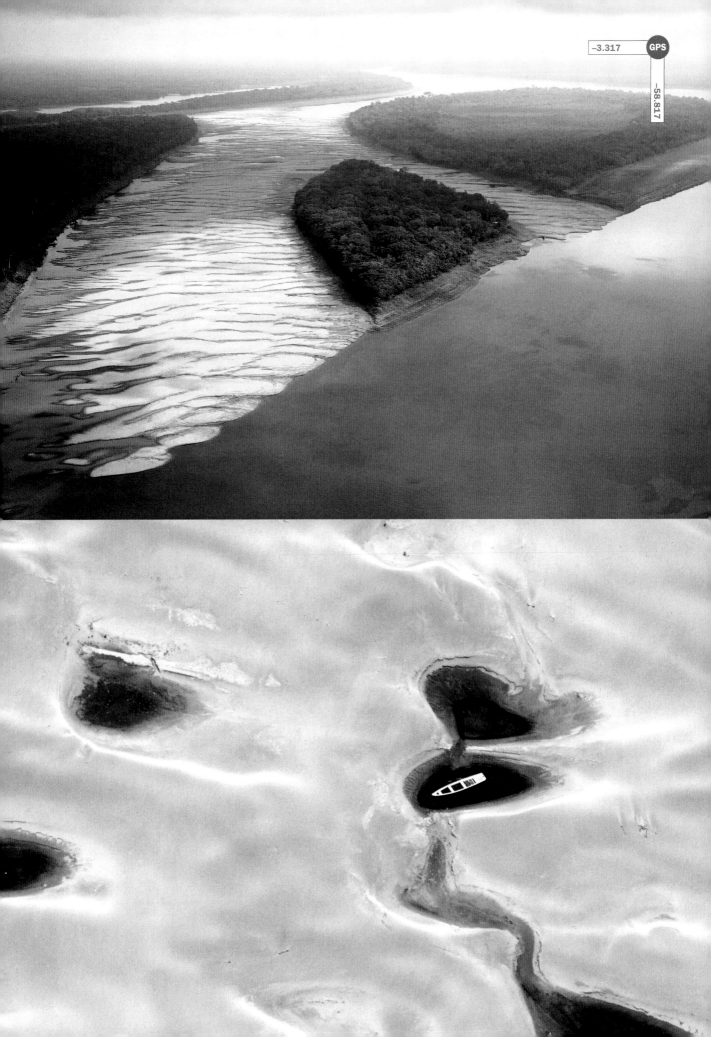

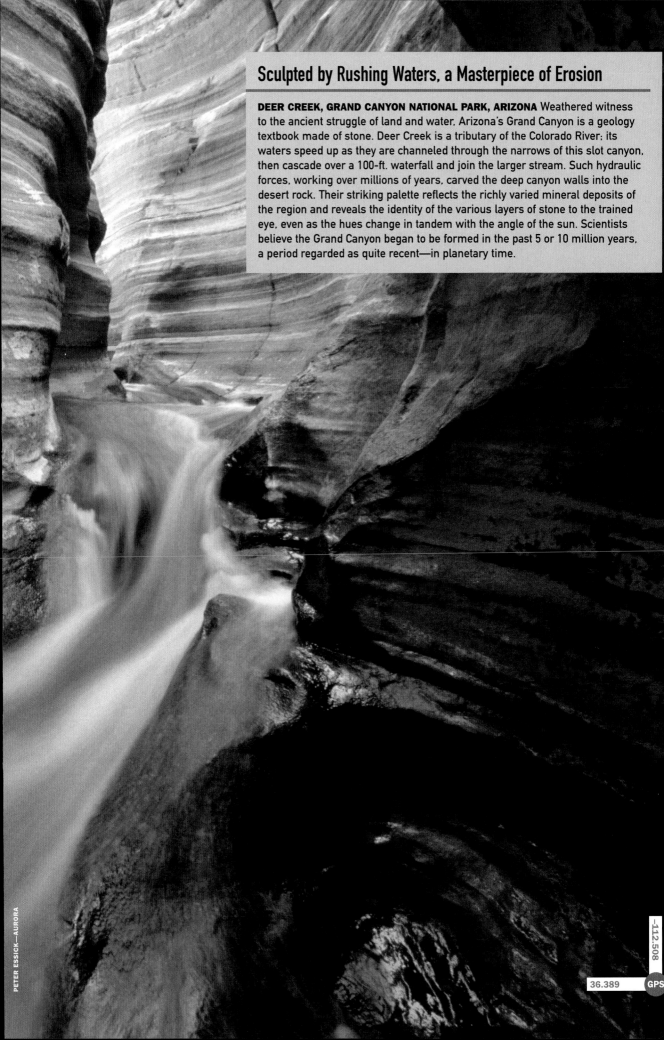

Sculpted by Rushing Waters, a Masterpiece of Erosion

DEER CREEK, GRAND CANYON NATIONAL PARK, ARIZONA Weathered witness to the ancient struggle of land and water, Arizona's Grand Canyon is a geology textbook made of stone. Deer Creek is a tributary of the Colorado River; its waters speed up as they are channeled through the narrows of this slot canyon, then cascade over a 100-ft. waterfall and join the larger stream. Such hydraulic forces, working over millions of years, carved the deep canyon walls into the desert rock. Their striking palette reflects the richly varied mineral deposits of the region and reveals the identity of the various layers of stone to the trained eye, even as the hues change in tandem with the angle of the sun. Scientists believe the Grand Canyon began to be formed in the past 5 or 10 million years, a period regarded as quite recent—in planetary time.

PETER ESSICK—AURORA

-112.508

36.389　GPS

WATERS OF WOE

Tsunamis are among nature's deadliest killers, yet they remain a mystery

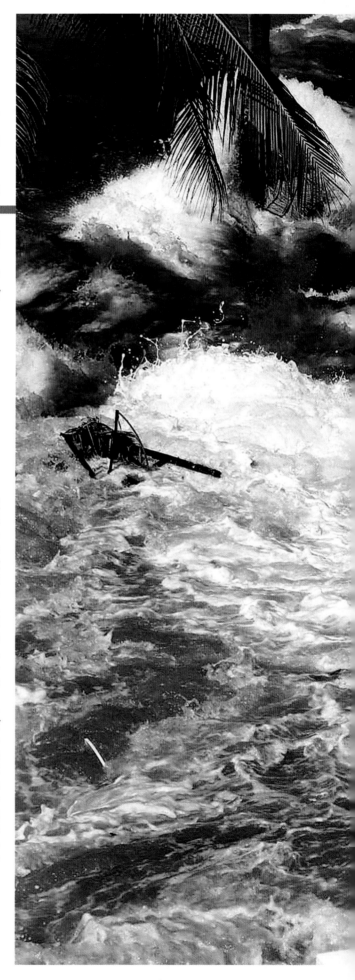

AT FIRST, THE EVENT SEEMED more bizarre than threatening. As Bustami, a fisherman from the Sumatran village of Bosun, set out from shore in his small boat on

the morning of Dec. 26, 2004, he felt the sea moving around him. "That must have been when the earthquake hit," he said later. (The precise time of the shock was 7:58 a.m.) But the disturbance subsided, and the fisherman went about his business for another half an hour or so. Then he saw the water along the beaches begin to retreat, and stranded fish leaping on the empty shore. Moments later: "I heard this strange thunderous sound from somewhere, a sound I'd never heard before. I thought it was the sound of bombs." The water rose behind Bustami as high as the coconut trees on the shoreline, and he was thrown off his boat. "It felt like doomsday," said Bustami, but he escaped: after clinging to a coconut tree, he was eventually picked up by a soldier three hours later, almost two miles away from where he had lost his boat.

Although Bustami had no way of knowing it, 18 miles beneath the surface of the ocean, where two vast pieces of earth's crust—the Indian Plate and the Burma Plate—converge, the planet had convulsed. The Indian Plate, which usually moves northeast about 2.4 in. a year, twice the rate at which our fingernails grow, had instead lurched more than 50 ft. in the course of a few seconds. That had forced the Burma Plate to snap upward along 745 miles of fault line, setting off an earthquake that eventually measured 9.0 on the Richter scale and triggered 68 aftershocks within three days.

But all that was a only a preamble. For reasons that scientists are still struggling to understand, undersea quakes—which often pass without incident, barely noticed on adjacent land—sometimes unleash killer waves known as tsunamis. Such waves can travel hundreds or even thousands of

PHUKET, THAILAND
Resort waiter Supet Gatemanee, 19, battles giant waves on Dec. 26, 2004; he survived the ordeal

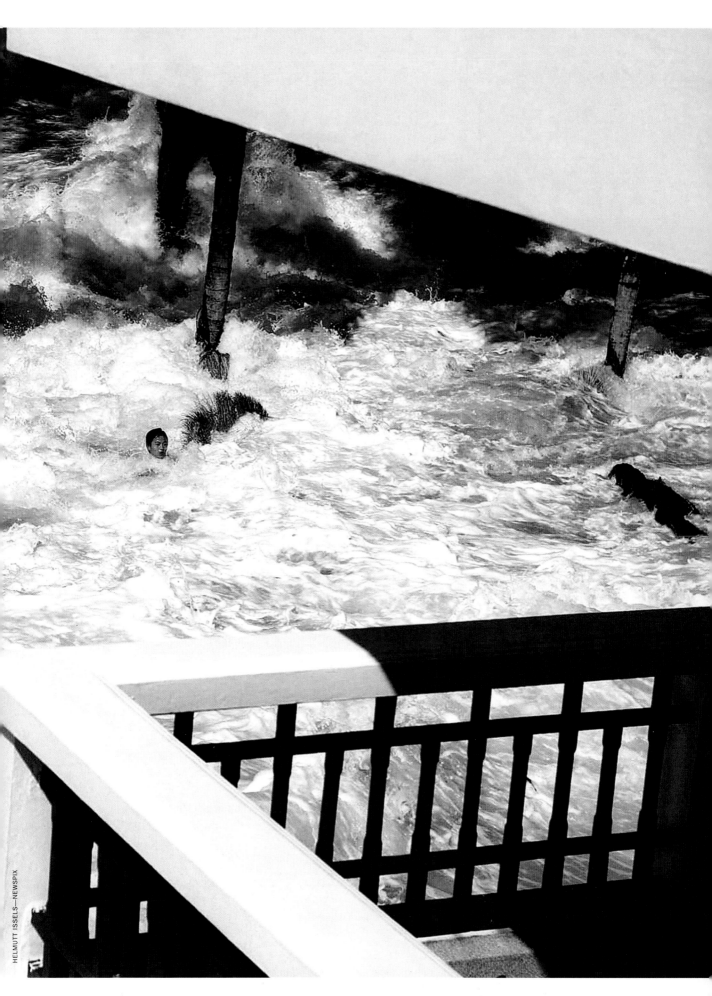

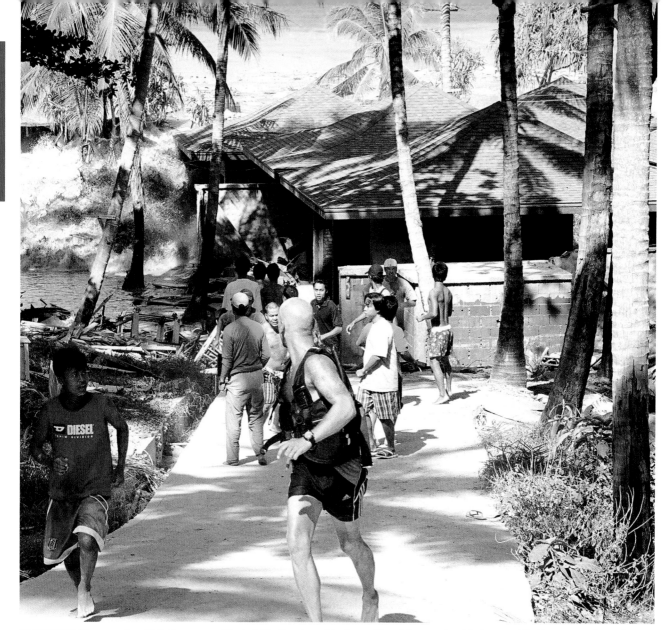

INCOMING! At a resort on Koh Raya, near Phuket, Thailand, residents and tourists are about to be engulfed by a wave from the 2004 tsunami. Photographer John Russell said this was the first and smallest of three major waves; he managed to escape

miles across the ocean at speeds of up to 500 m.p.h., almost undetectable as long as they remain submerged in the deep.

When the massive swells approach the uphill slopes that link shorelines to the ocean floor, tsunamis compress and speed up, racing up the incline and emerging from the surf as giant walls of water bearing overwhelming power, forces of mass plus energy that destroy everything in their path. And that's what happened on the morning of Dec. 26. When the killer waves unleashed by the undersea earthquake finally receded from shorelines across a vast swath of the Indian Ocean, more than 225,000 people were dead.

T SUNAMI IS A JAPANESE WORD MEANING "GREAT HARBOR wave"; perched atop tectonic convergence zones, the Japanese are all too familiar with the phenomenon. Because tsunamis resemble the rising level of water associated with incoming tides, they are often mistakenly referred to as "tidal waves," but the term is a misnomer. However imperfectly understood, tsunamis have shaped human history. Giant waves spawned by earthquakes are believed by some scholars to have submerged ancient cities in the Mediterranean, which may have given rise to the legend of Atlantis. In the shoreline areas of India affected by the 2004 tsunami, archaeologists have uncovered ruins of an ancient Hindu temple, built sometime between the 2nd century B.C. and the 1st century A.D., that shows signs of having been destroyed by a tsunami. On All Saints' Day in 1775, the great earthquake that flattened the city of Lisbon triggered a tsunami that flooded much of coastal Spain and Portugal. But earthquakes are not the only cause of killer waves: the eruption of the Krakatoa volcano in 1883 stirred up a tsunami that drowned 36,000 people and hurled 600-ton blocks of coral ashore as if they were pebbles.

The April Fools' Day tsunami of 1946 illustrates the challenges scientists face in understanding tsunamis. That day a medium-strength earthquake off the coast of Alaska's Aleutian Islands sent powerful waves racing across the Pacific. One crashed into the Aleutians at a height of 139 ft. but did little damage in the sparsely inhabited area. The Hawaiian Islands weren't so lucky. When one of the waves reached the Big Island, five hours after the quake, it reared up to a height of 45 ft. and tore through the coastal communities of Hilo and Haena, killing 159 people. One person drowned in California, and fishing boats were damaged as far away as Chile.

The deadly event led to the creation of the Seismic Sea Wave Warning System, which later became known as the Pacific Tsunami Warning Center (PTWC). For 60 years, PTWC scientists have been struggling not only to predict future tsunamis but also to understand the 1946 event. Their question: How could a moderate earthquake spawn such a powerful wave? For decades, the best theory was that the quake had triggered an undersea landslide, and that one-two punch had driven the tsunami. But in 2004, an undersea expedition mounted by the Scripps Institution of Oceanography visited the quake site and found no evidence of a landslide. So PTWC scientists are going back to Square One in their efforts to explain the 1946 wave.

As difficult as it is to predict tsunamis caused by earthquakes or volcanoes, some of the largest and most powerful killer waves have been caused by neither. On July 9, 1958, the unusual topography of the fjord-shaped inlet beside the Alaskan fishing village of Lituya Bay combined with the effects of an inland landslide to create the largest tsunami ever reported. Channeled into the narrow fjord, the height of the wave temporarily reached more than 1,720 ft. as it barreled seaward, reversing a tsunami's usual course. The wave subsided to 450 ft. when it reached the open sea, then dissipated. Because of the area's remoteness, only two people were killed.

Five years later, a landslide in the mountains north of Venice triggered another rare inland tsunami. When several hundred million cu. yds. of forest, earth and rock tumbled into an artificial lake created two years earlier by the Vajont Dam, the resulting displacement hurled a 700-ft. wave over the dam. Although the structure remained largely intact, the wave went on to inundate the villages of Longarone, Pirago, Rivalta, Villanova and Faè, killing more than 2,000 people.

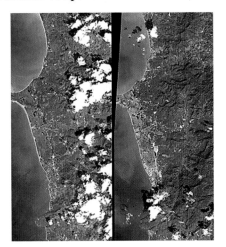

SCRUBBED CLEAN Before-and-after satellite views of Phuket, Thailand, show the tsunami's effect on local vegetation

In recent years scientists have begun to link the threat of tsunamis to global climate change. Archaeological evidence indicates that "megatsunamis," killer waves more than 1,000 ft. high, emerged from the oceans in ancient times. The best guess about what may have caused them is massive undersea landslides. The most recent megatsunamis may have been unleashed around 6100 B.C. when the Storegga Slides, a series of sudden undersea land shifts off the coast of what is now Norway, appear to have sent massive waves rushing across the North Atlantic. Because warmer air and water temperatures are associated with landslides, both undersea and on land, there is a chance that future climate changes could trigger a tsunami the likes of which our world has not experienced in recorded history.

In the meantime, the struggle to understand the tsunamis we have experienced goes on. Less than 90 days after the 2004 Indian Ocean quake and tsunami, a stronger earthquake shook the same area, its epicenter just 60 miles south of the earlier one. Kerry Sieh, a professor of geology at the California Institute of Technology, called the March 8, 2005, event, "the fraternal twin of the Dec. 26 earthquake." That led the PTWC to issue an urgent bulletin, and within hours tens of thousands of people had heeded orders to abandon their homes for higher ground.

Yet while the temblor shook the ground from Indonesia to Thailand, it was not followed by a major tsunami. One theory as to the discrepancy: an earthquake's wavelength—the frequency at which it shakes the ground—may have more affect on a subsequent tsunami than the quake's magnitude. But that is far from certain. What is certain is that we still have much to learn about the waves that can emerge without warning from the deep and erase thousands of human lives. ∎

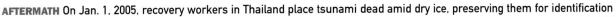

AFTERMATH On Jan. 1, 2005, recovery workers in Thailand place tsunami dead amid dry ice, preserving them for identification

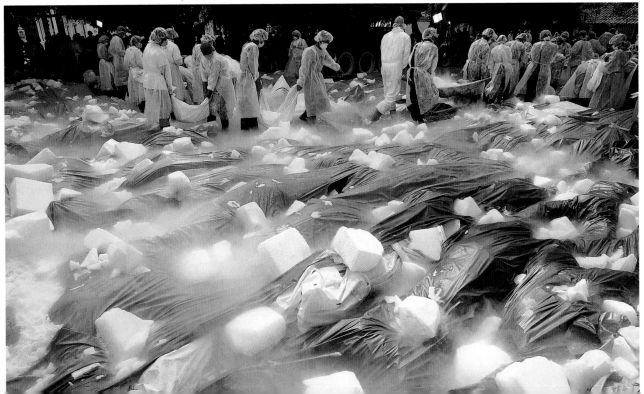

HOW THE DEADLY WAVES SPREAD

SCOPE OF THE TRAGEDY

As of December 2005, the official death toll, according to the United Nations Special Envoy for Tsunami Recovery, was 229,866. Millions more remained homeless, despite a massive global relief effort

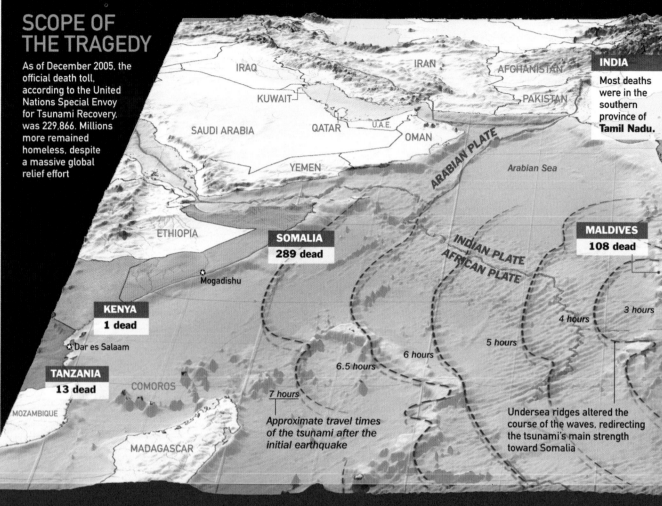

INDIA
Most deaths were in the southern province of **Tamil Nadu.**

IRAQ

IRAN

AFGHANISTAN

PAKISTAN

KUWAIT

SAUDI ARABIA

QATAR

U.A.E.

OMAN

YEMEN

ARABIAN PLATE

Arabian Sea

ETHIOPIA

SOMALIA
289 dead

INDIAN PLATE
AFRICAN PLATE

MALDIVES
108 dead

Mogadishu

KENYA
1 dead

3 hours

4 hours

Dar es Salaam

5 hours

6 hours

TANZANIA
13 dead

COMOROS

6.5 hours

MOZAMBIQUE

7 hours

MADAGASCAR

Approximate travel times of the tsunami after the initial earthquake

Undersea ridges altered the course of the waves, redirecting the tsunami's main strength toward Somalia

WHAT CAUSES A TSUNAMI?

A tsunami (a Japanese word that translates as "harbor wave") is triggered by a vertical disturbance in the ocean, such as an earthquake, landslide or volcanic eruption

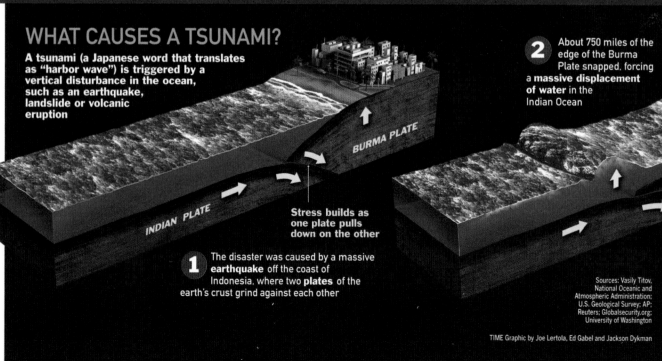

2 About 750 miles of the edge of the Burma Plate snapped, forcing a **massive displacement of water** in the Indian Ocean

BURMA PLATE

INDIAN PLATE

Stress builds as one plate pulls down on the other

1 The disaster was caused by a massive **earthquake** off the coast of Indonesia, where two **plates** of the earth's crust grind against each other

Sources: Vasily Titov, National Oceanic and Atmospheric Administration; U.S. Geological Survey; AP; Reuters; Globalsecurity.org; University of Washington

TIME Graphic by Joe Lertola, Ed Gabel and Jackson Dykman

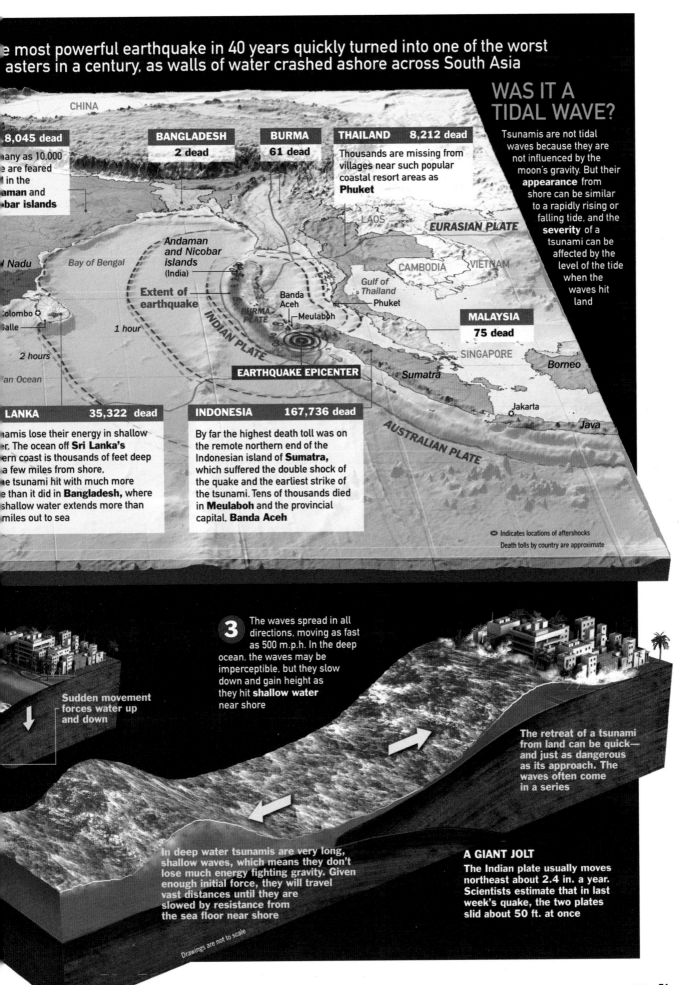

e most powerful earthquake in 40 years quickly turned into one of the worst
asters in a century, as walls of water crashed ashore across South Asia

WAS IT A TIDAL WAVE?

Tsunamis are not tidal waves because they are not influenced by the moon's gravity. But their **appearance** from shore can be similar to a rapidly rising or falling tide, and the **severity** of a tsunami can be affected by the level of the tide when the waves hit land

CHINA

8,045 dead
many as 10,000
e are feared
i in the
aman and
bar islands

BANGLADESH
2 dead

BURMA
61 dead

THAILAND 8,212 dead
Thousands are missing from villages near such popular coastal resort areas as **Phuket**

LAOS

EURASIAN PLATE

l Nadu

Bay of Bengal

Andaman and Nicobar islands (India)

CAMBODIA VIETNAM

Gulf of Thailand

Phuket

Extent of earthquake

Banda Aceh

Meulaboh

MALAYSIA
75 dead

SINGAPORE

Borneo

Colombo
alle

1 hour

INDIAN PLATE

BURMA PLATE

2 hours

an Ocean

EARTHQUAKE EPICENTER

Sumatra

Jakarta

Java

AUSTRALIAN PLATE

LANKA 35,322 dead

amis lose their energy in shallow
er. The ocean off **Sri Lanka's**
ern coast is thousands of feet deep
a few miles from shore.
e tsunami hit with much more
e than it did in **Bangladesh,** where
shallow water extends more than
miles out to sea

INDONESIA 167,736 dead

By far the highest death toll was on the remote northern end of the Indonesian island of **Sumatra,** which suffered the double shock of the quake and the earliest strike of the tsunami. Tens of thousands died in **Meulaboh** and the provincial capital, **Banda Aceh**

◯ Indicates locations of aftershocks
Death tolls by country are approximate

3 The waves spread in all directions, moving as fast as 500 m.p.h. In the deep ocean, the waves may be imperceptible, but they slow down and gain height as they hit **shallow water** near shore

Sudden movement forces water up and down

The retreat of a tsunami from land can be quick—and just as dangerous as its approach. The waves often come in a series

In deep water tsunamis are very long, shallow waves, which means they don't lose much energy fighting gravity. Given enough initial force, they will travel vast distances until they are slowed by resistance from the sea floor near shore

A GIANT JOLT

The Indian plate usually moves northeast about 2.4 in. a year. Scientists estimate that in last week's quake, the two plates slid about 50 ft. at once

Drawings are not to scale

THE NEXT WAVE: MEGATSUNAMIS?

Undersea earthquakes create big swells. Meteor impacts create mammoth swells. Any questions?

SURF'S UP This surfer's delight, a normal wave, curls up and goes tubular. In contrast, tsunami waves ripple quietly through the sea, building height and speed when they cross the ascending land near the shore.

"**D**O THE MATH," SAYS STEVEN WARD, A GEOPHYSICIST AT the University of California at Santa Cruz. "We know of 160 major impact craters on land. Because almost three-quarters of the earth's surface is covered with water, it's likely that about three times that many have landed in the oceans." What happens when big meteors splash into the ocean is a professional preoccupation of Ward's, who has done extensive research into the effects of such a collision. "They're called megatsunamis," Ward says of the gargantuan waves that would radiate outward from such a contact. "They could dwarf any wave in recorded human history—larger and more powerful than the Indian Ocean tsunami of 2004 by several orders of magnitude."

The difference between a tsunami caused by an earthquake and one caused by asteroid impacts is the amount of force behind each. "Although the energy released by a big quake is enormous," Ward says, "earthquakes can get only so big. There's a finite amount of energy trapped in the rock beneath the surface, and there are limits to how much it can build up before the rocks move and that energy is released. That's why, in the entire history of the world, there has never been a magnitude-20 earthquake. These limits carry over to the tsunamis that are sometimes created by large quakes."

But the limits don't apply to tsunamis created by asteroid impacts. "Throughout its history, earth has been hit by asteroids at least one mile in diameter once every 100 million years or so. But even a relatively small space rock can have enormous consequences," Ward says. As an example, he points to projections he has done for asteroid 1950 DA, a chunk of rock and metal slightly more than half a mile in diameter. (By comparison, the object that created Meteor Crater in Arizona was less than 200 ft. across.) "The best estimates give 1950 DA a one-third of 1% chance of hitting the earth on its next flyby. We know that the Atlantic Ocean will be facing the asteroid on that date. If it smashes into the Atlantic, it will be traveling at 38,000 m.p.h. The asteroid would vaporize on impact, but the blast would be the equivalent of 60,000 megatons." That translates into more than 4 million Hiroshima bombs being detonated all at once.

"The force would blow a hole in the ocean," Ward predicts, "which would then be filled by water rushing back into the void. The turbulence would oscillate a few times, then send shock waves radiating outward. We could expect that waves up to 400 ft. tall would reach the U.S. coastline about two hours later. These waves would engulf everything from Massachusetts to North Carolina, and would probably penetrate about two miles past the shoreline." According to Ward's projections, slightly smaller—but still devastating—megatsunamis would reach the coasts of Britain, France, Spain and Portugal about an hour later. In total, the lives of more than 120 million people would be at risk.

The good news: 1950 DA's next flyby isn't scheduled until March 16, 2880. "So we have plenty of time to prepare," Ward says. The bad news: there are many other dangerous asteroids lurking near the earth that we have not yet detected (see p. 122). "The asteroid that intrigues me most," he says, "is Apophis. It is estimated to have the same probability of earth impact as 1950 DA, but it's coming much sooner. It's only about half the later one's size, but that's still more than large enough to cause killer waves." Apophis is next scheduled to whiz by the earth in April 2029 (on the unsettling date of Friday the 13th), and again in 2036. On this second flyby, it will be so close to the planet's surface that it will pass beneath the geostationary satellites that transmit TV signals and GPS coordinates.

"On both of those dates," Ward says, "the Pacific will be the most likely zone of impact. Depending on the exact point of contact, waves as high as 50 ft. could engulf the West Coast of the United States and Canada within a few hours. Our estimates for property damage range as high as $400 billion.

"This has happened before—actually, many times before—in the history of our planet," Ward says. "It's going to happen again." Asked what can be done to prepare, Ward says "for the distant future, there is reason to hope that we'll have the technology to divert asteroids. But in the meantime, the best thing we can do is to build bigger, better telescopes," he says. "And more of them."

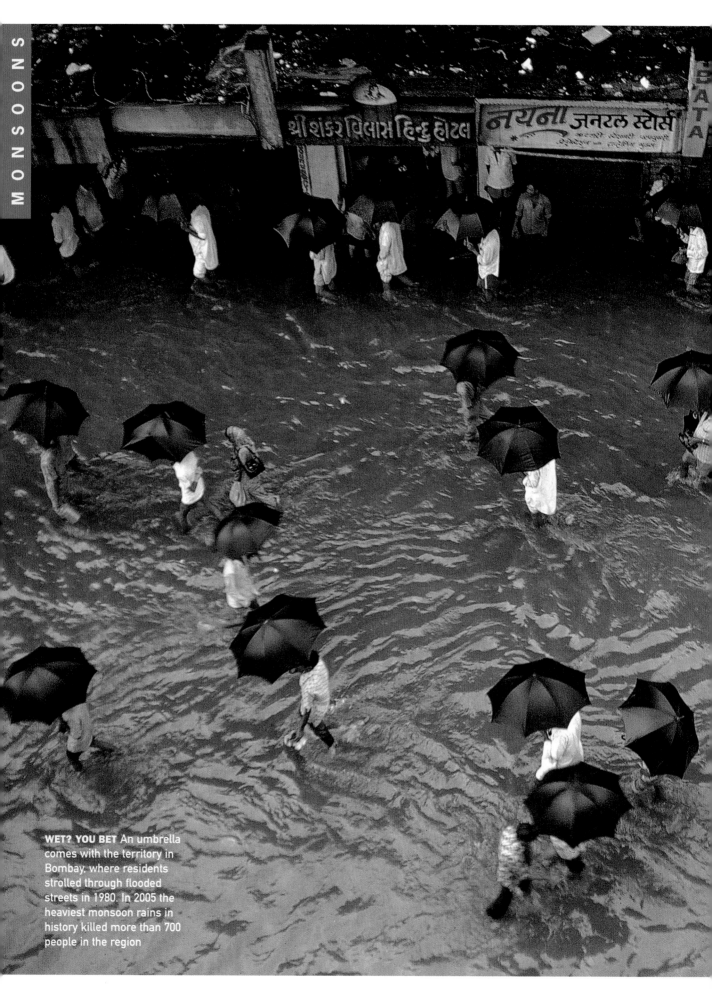

श्री शंकर विलास हिन्दु होटल

नयना जनरल स्टोर्स

BATA

WET? YOU BET An umbrella comes with the territory in Bombay, where residents strolled through flooded streets in 1980. In 2005 the heaviest monsoon rains in history killed more than 700 people in the region

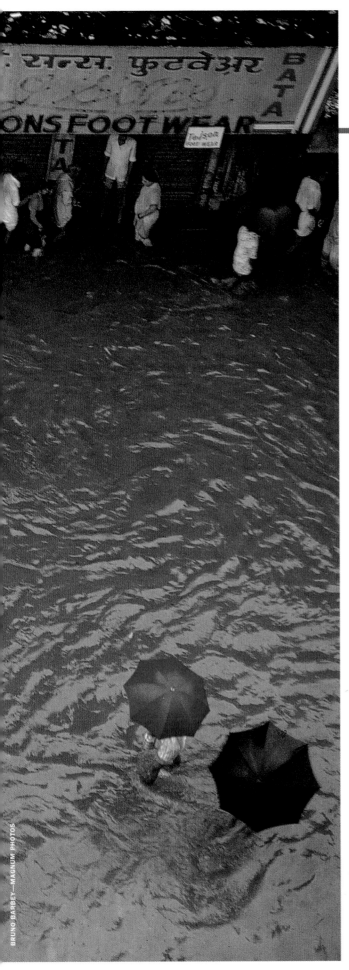

<div style="text-align: left">BRUNO BARBEY—MAGNUM PHOTOS</div>

HERE'S THAT RAINY DAY

Monsoon rains bring life—and sometimes death—to the Indian subcontinent

AS SIBERIANS KNOW COLD AND BEDOUINS KNOW HEAT, Indians know rain. The Indian subcontinent is the home of one of the globe's most predictable weather patterns, an annual, months-long immersion in wind-borne rains known as monsoon season. The term was borrowed from Arab mariners who called the weather pattern the *mawsim*, or season of winds. To scientists, the annual event is a simple matter of cause and effect, the result of India's land mass growing hotter than the surrounding Indian Ocean in the summer, causing air masses over the land to rise and creating a low-pressure area beneath them, which breeds constant winds that blow moist ocean air onto the land. Translation: it rains a lot.

Monsoon seasons are found across the globe: residents of the U.S. Southwest enjoy a summer monsoon season; Australia and southern Asia expect annual rains from a weather pattern known as the northeastern winter monsoon. Yet in India the monsoon season is far more than a matter of hot air and low-pressure zones; it is part of the rhythm of life. The winds and rain are cleansers, washing away a year's woes and bringing a sense of exhilaration, an annual confirmation that all is right with the world. Indians eagerly await the first drops of monsoon rain, a weather pattern that usually rolls in right on time, punctual as a commuter train. The rains are expected to begin falling on the Andaman and Nicobar island chains in the Bay of Bengal on May 29. They make landfall at Kerala on June 1. Eight days later they sweep into Bombay, the nation's largest city and financial hub. By July 29 they reach New Delhi, and by the beginning of August the entire nation is happily subject to the reign of the rain.

The jubilation isn't confined to farmers. As emigrant Indian Ardeep Singh, a professor at Pennsylvania's Lehigh University, noted on his blog in June 2005: "It seems to happen every year—the stock market peaks as the monsoon breaks in Bombay. I visualize happy stock traders dancing at the Bombay Stock Exchange, while barefooted children dance on the pavement outside." Meanwhile a pair of cities in the Indian state of Meghalaya, Cherrapunji and Mawsynram, vie for the honor of being the world's rainiest town.

Yet the rains can bring death as well as life. In late July 2005, more than 700 people died after torrential rains dumped an astounding 39 in. of water in 24 hours on Bombay, spawning mudslides and heavy floods across the state of Maharashtra. Part of the catastrophe was man-made: 22 people, including several children, were killed in a stampede after rumors raced through a Bombay neighborhood that a dam had collapsed from the flooding. For once, the monsoon season brought mourning, not morning, to India's year. ∎

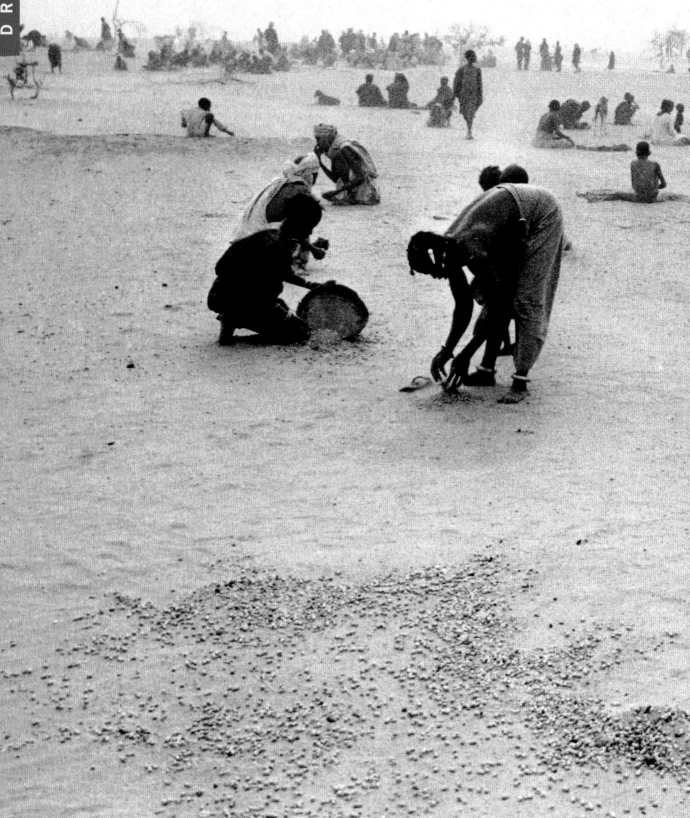

FAMINE In the drought year of 1973, nomads in the Sahel pick up bran sticks that were scattered after French army planes dropped jute bags filled with relief supplies

DUST, THE DESTROYER

One of man's greatest foes, drought kills men and empires

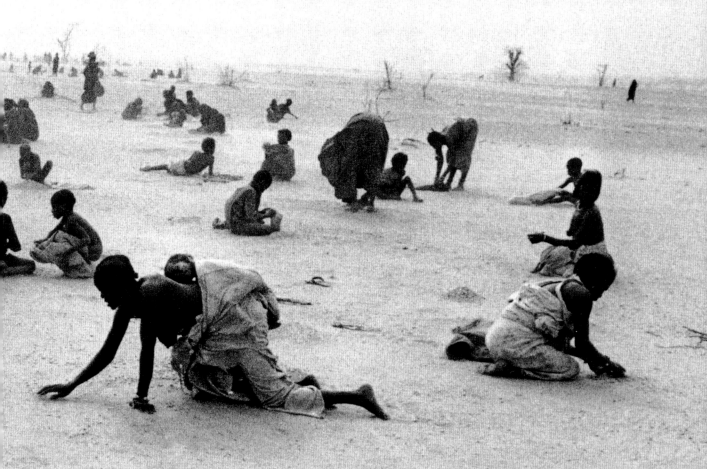

MANY OF THE EXTREMES OF NATURE ADDRESSED IN this book are sudden, violent events, calamities that strike without warning and kill in an instant. Drought is different: it's a slow-motion disaster, a killer that stalks rather than erupts, slowly strangling the life from fields and rivers and people. Drought kills more than individuals; it kills off entire civilizations. Scientists believe that a long period of climate change that included three intense droughts brought down the great Maya civilization, which flourished between 200 B.C. and A.D. 900 in Central America, then abruptly died. To the north, awestruck modern-day tourists ponder the cliff-clinging homes of the Anasazi Indian tribes of the U.S. Southwest; their culture's decline has long been traced to drought, though some scientists now suspect that other forces may have played a role. Drought helped topple the ancient Indus Valley cultures of the Harappa and the Mohenjo-daro peoples, as well as the Mali Empire of West Africa.

The U.S. experienced its most damaging drought—when the Midwest was dubbed the Dust Bowl—in the 1930s. TIME reported its effects in its July 10, 1933, issue: "In Indiana there were cracks in the earth an inch wide. Motorists in Grundy County, Illinois, saw chinch bugs in ribbons 100 ft. wide in the roads. The bugs were eating their way from field

to field. North Dakota's drought brought out a destructive swarm of grasshoppers. In southwest Kansas fiery winds blew so much shifting topsoil from the fields that snow plows had to be used to clear the highways."

The science of drought can involve complex equations and the charting of ocean currents and jet streams. But any child who's ever been thirsty understands all we really need to know about this phenomenon: it is simply the prolonged absence of water. When a long-running drought overtakes a region, it begins the process scientists call desertification; some of the most extensive deserts of the modern world stand atop the dried ruins of ancient civilizations.

One of the most devastating droughts of modern times afflicted central African nations in the Sahel region, a semiarid zone that lies between the Sahara and the equator, from the 1960s through the '80s. The disaster began in 1965; before it had run its course, drought and its partner in misery, famine, had killed as many as 1 million people and left millions more homeless. Initially, suspicions focused on poor agricultural practices for the change in climate in the Sahel, but in 2003 scientists at Columbia University linked the event to rising temperatures in the waters of the Indian Ocean. Yet even this advance in our understanding offers little hope that we can avert the droughts of the future. ∎

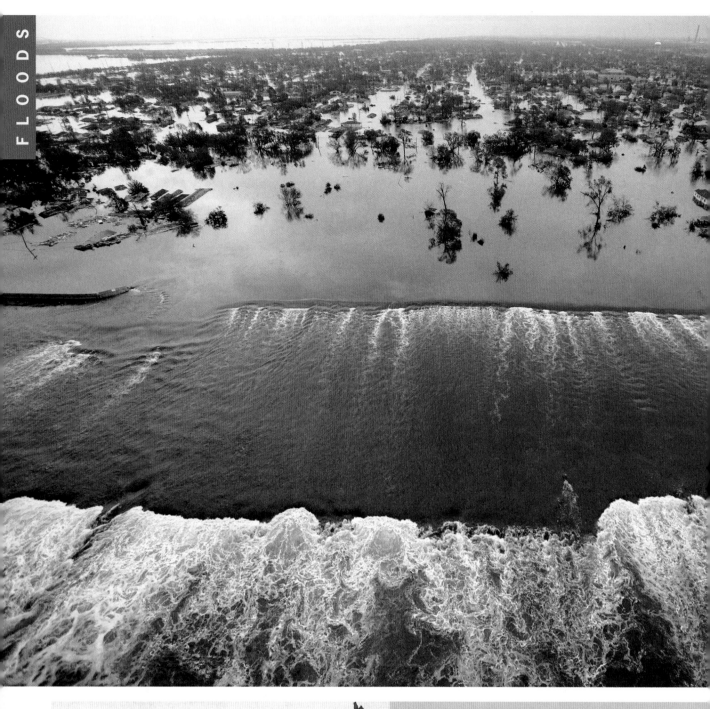

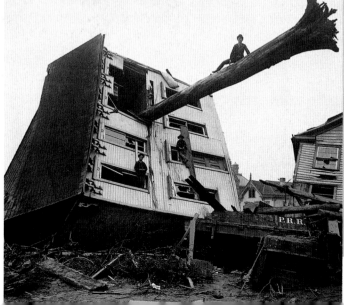

FLOODS: HIGH-WATER MARKS

JOHNSTOWN, PA., 1889 America's most memorable flood, left, claimed some 2,200 victims when a rickety dam holding back the waters of a high-ground lake gave way, sending a cascade of water to join swollen rivers as they roared down a narrow valley and swamped the city.

MISSISSIPPI RIVER, 1927 After heavy rains, right, soaked the Mississippi River Valley—including 15 in. over an 18-hr. period in New Orleans—the river rose to unprecedented heights. When hastily built levees failed, flooding inundated 27,000 sq. mi. of land. Some 700,000 people were displaced; historians trace the Great Migration of Southern blacks to Northern cities to this epochal event.

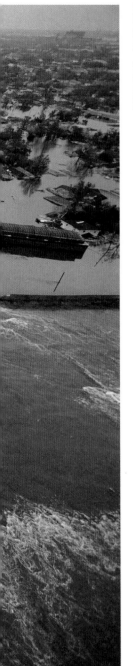

IRRESISTIBLE FORCE, MOVABLE OBJECTS

Floods transform mankind's works into flotsam

MAY 31, 1889. ANNA FENN, MOTHER OF seven children and pregnant with an eighth, clings to her baby in her rapidly flooding home in Johnstown, Pa., while the other children grab onto any handhold they can find. Moments before, their father had been swept away by a wall of water 40 ft. high and half a mile wide, roiling with bodies, horses, debris and timber, that rampaged through the narrow Conemaugh River valley, where the town was perched. As Fenn would later write, "The water rose and floated us until our heads nearly touched the ceiling … It was dark and the house was tossing every way. The air was stifling, and I could not tell just the moment the rest of the children had to give up and drown … what I suffered, with the bodies of my seven children floating around me in the gloom, can never be told." She survived and gave birth weeks later; the infant did not live.

Aug. 29, 2005. In Biloxi, Miss., Philip Bullard, 13, is trapped in the upper room of his home with a dozen other members of his family as floodwaters driven by Hurricane Katrina's storm surge rise through the floorboards. Determined to take action, Philip swims underwater to a submerged window that affords him an outlet. Returning first for his sister and stationing her safely outside, above the waters, he swims back into the house seven times, managing to save every member of the family, including his mother, grandmother, twin sister and 1-year-old sister.

As these two tales illustrate, more than a century of spectacular technological advancement makes little difference when measured against the inexorable power of vast expanses of water in motion: a flood can strip life to a primal struggle for survival. Since the archetype of the species—the biblical deluge Noah rode out in the ark—flooding has been one of humanity's central plagues.

Hurricanes and tornadoes may make more noise, and the symmetries of their familiar cloud formations may be more fearful, but flash floods are the No. 1 weather-related killer in the U.S. Major floods like the Mississippi River catastrophes of 1927 and 1993 are the result of months of above-average precipitation, yet just as deadly are flash floods: smaller, localized events that occur when heavy rains drop inches of water on a region whose topography does not offer sufficient runoff. Result: creeks, streets and low-water bridges can be inundated, and pedestrians and drivers are all too often swept away. According to the National Oceanographic and Atmospheric Administration, floods claim an average of 100 lives and cause $2 billion in damages each year in the U.S.

Yet, like wildfires, floods play an essential role in nature's balance: the work of floodwaters created the Mississippi Delta and nourished the great civilizations of ancient Egypt. After all, when the angry God of the Old Testament brought an end to the 40-day deluge that swamped Noah's world, he signed his labors with a rainbow. ∎

NEW ORLEANS, 2005 Hurricane Katrina's storm surge breached the city's low-lying levees, swamping streets and houses. Left, floodwaters pour into the city over the Industrial Canal levee

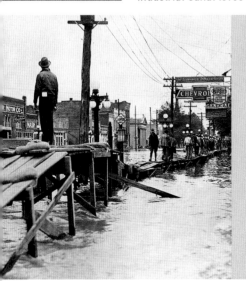

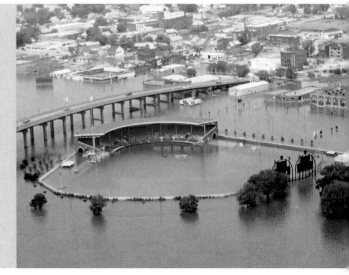

MISSISSIPPI RIVER, 1993 The most recent great flood along the big river wrought most of its damage on the Mississippi's upper section, flooding farms, fields and cities adjacent to the river in Iowa and Missouri. At right, John O'Donnell Stadium in Davenport, Iowa, is inundated. The flood's toll: 48 people dead and $12 billion in damages.

FROM ICE TO WATER

As glaciers and ice shelves melt, things aren't looking up at the bottom of the world

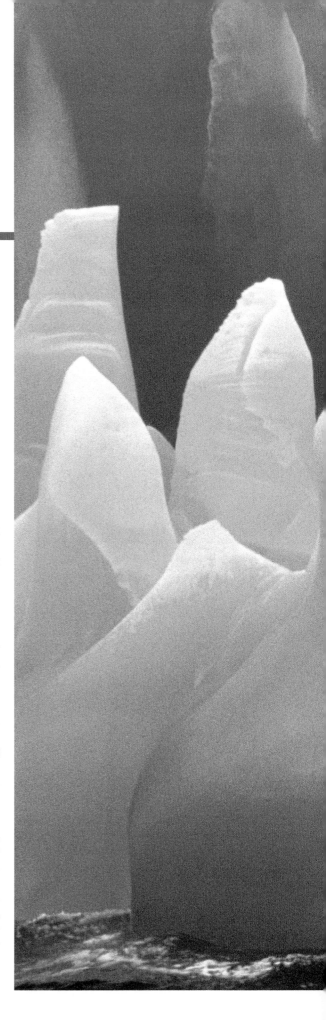

JANUARY 2006: SCIENTISTS REVEAL that they have discovered two new Antarctic lakes, buried beneath more than two miles of ice, that have been sealed off from the outside world

for more than 35 million years. The announcement confirms what an increasing number of geologists, biologists and meteorologists believe: the polar regions are one of the planet's most promising frontiers for research. Sadly, the news also comes at a time when these icy regions, which play a critical role in the vast natural mechanism of the planet, are increasingly imperiled. Scientists fear this may be the beginning of the end for the ends of the earth— at least, as mankind has always known them.

First, the good news. The two new bodies of subsurface water have been provisionally named 90°E (for its map coordinates) and Sovetskaya Lake. They cover an area of 770 sq. mi. (about the size of Rhode Island) and 620 sq. mi., respectively. Together with nearby Lake Vostok, which was discovered in 1996 and covers 5,400 sq. mi., about the size of Lake Ontario, the twin lakes are treasure troves of scientific data waiting to be tapped, natural time capsules that scientists believe will provide a window onto the world as it existed millions of years before dinosaurs walked the earth.

Scientists from Columbia University's Lamont-Doherty Earth Observatory confirmed the existence of the two new lakes by interpreting data from ice-penetrating radar, satellite images, ground surveys conducted with precision lasers, and extraordinarily sensitive instruments that can detect minute fluctuations in the earth's gravity. "Over the lakes, the pull of gravity is much weaker," explained Robin Bell, a geophysicist at Lamont-Doherty, "so we know there must be a big hole down there."

Despite surface temperatures of 26°F, all three lakes, as well as about 140 much smaller bodies of water in the area, remain liquid because they are warmed by geothermal heat from the ground below and insulated from the freezing polar air by the blanket of ice over them. In addition, the pressure exerted by the ice cover forces the water's freezing point to a lower-than-normal temperature.

Drilling toward Lake Vostok began shortly after its discovery,

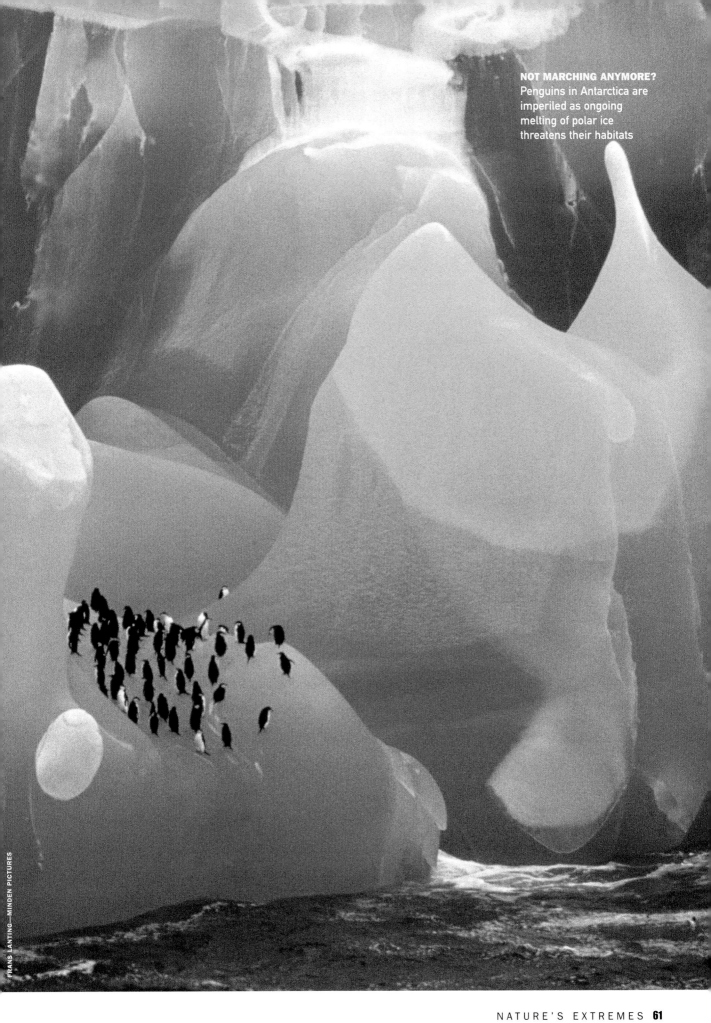

NOT MARCHING ANYMORE?
Penguins in Antarctica are
imperiled as ongoing
melting of polar ice
threatens their habitats

but was stopped in 1999 a few hundred yards from the boundary between the ice sheet and the water. For the next six years, an international consortium of scientists worked on developing sterile drilling equipment that would not contaminate the lake's ecosystem with microbes from the outside world. In the meantime, scientists found living microbes of several entirely new species in the ice cores they had extracted from the region near the lake's surface. Drilling resumed in January 2006. Scientists now expect to puncture the ice and delve into the lake sometime in 2007.

The 2006 discovery followed good news from the other end of the planet. In August 2005 scientists exploring the edge of the ice cap surrounding the North Pole discovered several previously unknown species of sea life, including a new type of ctenophore, a jellyfish-like creature whose body behaves more like a liquid than a solid, pouring out of specimen jars. Only one month earlier, scientists stumbled upon an entirely new ecosystem owing to the 2002 collapse of the Larsen B Ice Shelf in Antarctica. A remote video camera exploring the area, which had been left undisturbed for at least 10,000 years, documented new species of clams and mats of bacteria thriving in this sunless environment, living on methane seeping out of the ocean floor.

ONLY DECADES AGO, THE POLES WERE THOUGHT TO be lifeless regions, frozen zones almost entirely devoid of biological activity and largely lacking in even basic chemical reactions. They seemed to have little to teach human beings. But thanks to the recent discoveries, the poles are coming into focus as one of the planet's richest and most instructive frontiers, an untapped source of discoveries for biologists, geologists, even space scientists. Because the poles are the earthly environment that most closely matches extreme environments elsewhere in our solar system, they also may have much to teach us about how life might—or might not—exist on Mars, the moons of Jupiter and Saturn and in other harsh locales.

The steady trickle of new polar discoveries affects scientists of all stripes. In November 2005, German scientists announced that they had detected and recorded acoustic signals from a "singing" iceberg. In much the same way that desert sand dunes emit an audible hum as wind passes over them, some icebergs vibrate when water is pushed through subsurface crevasses and tunnels under high pressure. The resulting vibration creates a thrum with such a low frequency that it cannot be detected by human hearing, although the frequency can be speeded up to resemble a cluster of bees.

Alas, icebergs are not vying with whales for maritime vocal honors. But insights gleaned from studying the sounds given off by pressurized water rushing through an iceberg have serious implications for volcanologists. The fluid dynamics of water inside a mountain of ice are similar to those of molten rock inside a volcano and may help refine models that can assist in predicting eruptions.

In December 2005 geologists announced that something else was on the move in the Arctic Circle: earth's magnetic pole. The position of the North Pole (the magnetic pole, rather than the geographic point where all lines of longitude converge) is shifting. Readings taken over the past decade have shown that the topmost point of the earth's magnetic field, which is generated by the liquid iron spinning around the planet's core, has begun to migrate from Northern Canada toward Siberia. The pace has been so steady that researchers believe the Northern Lights, which are generated when charged particles emitted by the sun interact with the planet's magnetic field, may no longer be visible in Alaska within 50 years but may become visible from Siberia and parts of Europe.

Discoveries in the life sciences may have trumped other fields in recent revelations from the ice caps. Richard Hoover, a researcher at NASA's Marshall Space Flight Center, announced in February 2005 that he had not only discovered an entirely new form of bacterial life buried in the Arctic permafrost for at least 32,000 years—but that the microbe (given the name *Carnobacterium pleistocenium*) had been successfully revived. In fact, it began swimming as soon as it was thawed out. More intriguing, this bacterium, like many others, subsists on sugars and proteins but (unlike almost any others) can do so in the total absence of oxygen. That discovery has profound implications for the possibility that

ICE CAPS: BREAKING UP IS EASY TO DO

One hundred years ago, the poles exerted a strong pull on men's imaginations as the last unexplored areas of the globe. Thanks to pictures like the one at right, which shows the Larsen Ice Shelf in the Antarctic breaking up into icebergs due to high summer temperatures, the poles may be the subject of intense scientific scrutiny in this century as well.

Ice shelves are essentially glaciers extending over the open sea. In a 2002 paper in the *Journal of Glaciology* based in part on this and similar images, NASA researchers and university scientists concluded that warmer surface temperatures over just a few months in the Antarctic can splinter an ice shelf and prime it for a major collapse. The process is expected to accelerate if Antarctic temperatures continue to increase. The image was taken on Feb. 21, 2000; a similar breakup in 2002 exposed previously hidden waters to scientists, who found new species of sea life in them.

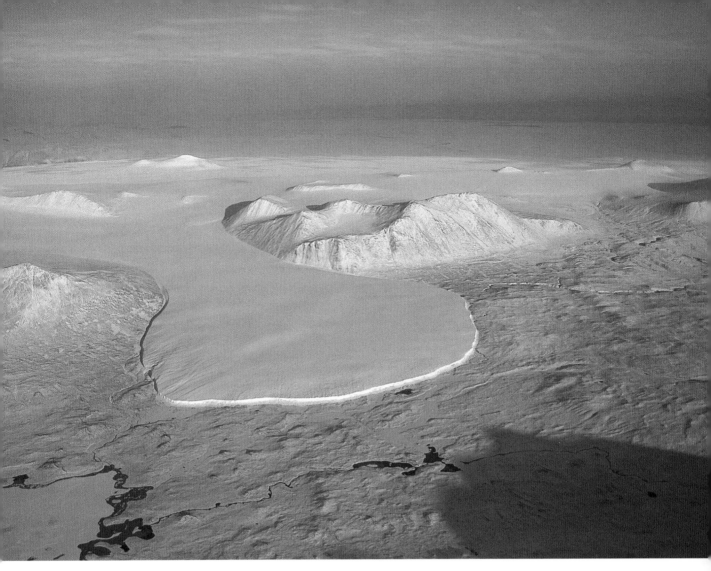

RECEDING A glacier spills from the polar ice cap into Antarctica's Taylor Dry Valley; many glaciers here are smaller each year

life, at least in the form of bacteria, may exist suspended in ice on Mars or other worlds in our solar system and beyond.

NOW FOR THE BAD NEWS: THE POLES ARE IMPERILED. Since the late 1990s, vast icebergs, many of them the size of U.S. states, have been breaking off from the South Pole and wandering into the Southern Ocean. In 2000, a 180-mile-long chunk of ice dubbed B15 (which contained enough fresh water to supply the entire world for the better part of a year) broke free of Antarctica's Ross Ice Shelf. A hazard to shipping, it roamed the waters around the South Pole for five years, during which time it was the largest moving object on the planet. A related process of glacial melting near the North Pole prompted the World Wildlife Fund to announce in January 2005 that several species of Arctic animals, including polar bears and seals, could become extinct in a matter of decades.

Why are the ice caps breaking up? Global warming is the chief suspect, although the mechanisms driving the process remain unclear. Scientists warn that the world's glaciers, which cover about 10% of the planet's surface, could theoretically cause sea levels to rise more than 200 ft. worldwide in the unlikely event that they were to melt entirely.

MELTDOWN

If the polar glaciers thaw out, the water they release could raise ocean levels by more than 200 ft. around the world

More realistically, even a partial liquidation of the planet's glacial ice cover could have catastrophic consequences. And this frightening possibility may be on the horizon. As recently as 50 years ago, most glaciers near the poles were growing slowly but steadily. But in recent years, this pattern has been reversed, and many glaciers (both at the North and South Poles) are retreating and melting. An April 2005 study by Cambridge University's British Antarctic Survey documented that the Sjogren Glacier near the South Pole has retreated more than eight miles since 1993. An August 2005 study by the National Science Foundation's Arctic System Science Committee concluded that within a century, the oceans around the North Pole may be ice free during the summer for the first time in a million years. The same study warned that as permafrost, the perpetually icy soil near the poles, begins to melt, the process may release vast amounts of methane and other greenhouse gases, possibly accelerating global climate change.

For better or for worse, the polar ice caps may hold they keys to humanity's future—whether that consists of looking to the stars to confirm the belief that we are not the only forms of life in the universe, or looking anxiously over our shoulders and wondering how much time our own form of life has left. ■

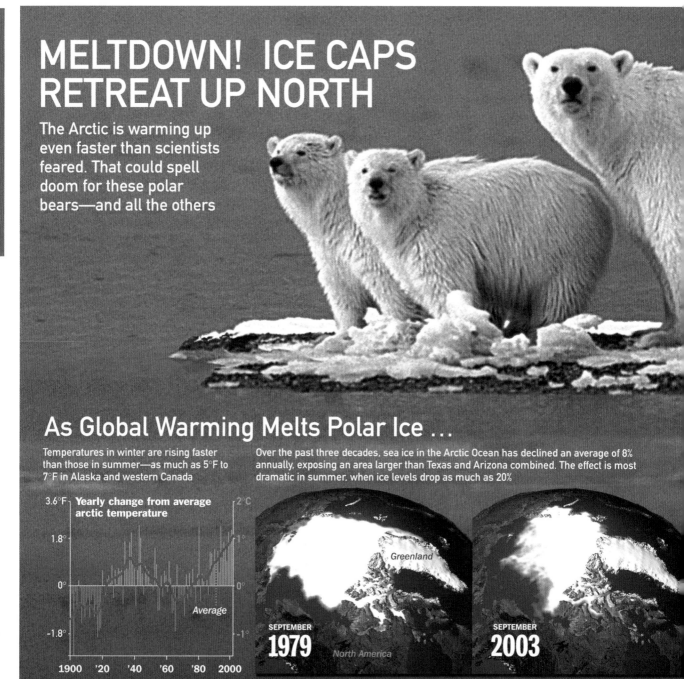

MELTDOWN! ICE CAPS RETREAT UP NORTH

The Arctic is warming up even faster than scientists feared. That could spell doom for these polar bears—and all the others

As Global Warming Melts Polar Ice ...

Temperatures in winter are rising faster than those in summer—as much as 5°F to 7°F in Alaska and western Canada

Over the past three decades, sea ice in the Arctic Ocean has declined an average of 8% annually, exposing an area larger than Texas and Arizona combined. The effect is most dramatic in summer, when ice levels drop as much as 20%

Yearly change from average arctic temperature

3.6°F — 2°C
1.8° — 1°
0° — 0°
Average
-1.8° — -1°

1900 '20 '40 '60 '80 2000

SEPTEMBER **1979**
Greenland
North America

SEPTEMBER **2003**

POLAR BEARS: STEVEN KAZLOWSKI

THE IMPACT WILL BE FELT IN MANY WAYS

COASTAL AREAS
As protective sea ice disappears and permafrost underlying the land's surface softens, coastal erosion will speed up dramatically. Floods will inundate marshes and estuaries, damaging both human and animal habitats

ARCTIC POPULATIONS
Indigenous people from Alaska to Canada to Siberia rely on fish, polar bears, seals and caribou for food, clothing and trade. As warming imperils these animals, it also threatens a way of life that has been unchanged for centuries

VEGETATION
Rising temperatures will let forests expand north into areas that now support only scrubby flora. Trees absorb more heat than bushes, speeding up local warming. Loss of tundra will also rob many animals of breeding and feeding grounds

WILDLIFE
Seals rest and give birth on sea ice; polar bears use it to stalk seals. Loss of ice will threaten both. On land, disruption of nesting areas could reduce populations of some migratory birds as much as 50% by the year 2100

SUN-SENTINEL—AP; CLARK JAMES MISHLER—ALASKA STOCK; AREND/PINKERTON—ALASKA STOCK; ALASKA SEALIFE CENTER—AP

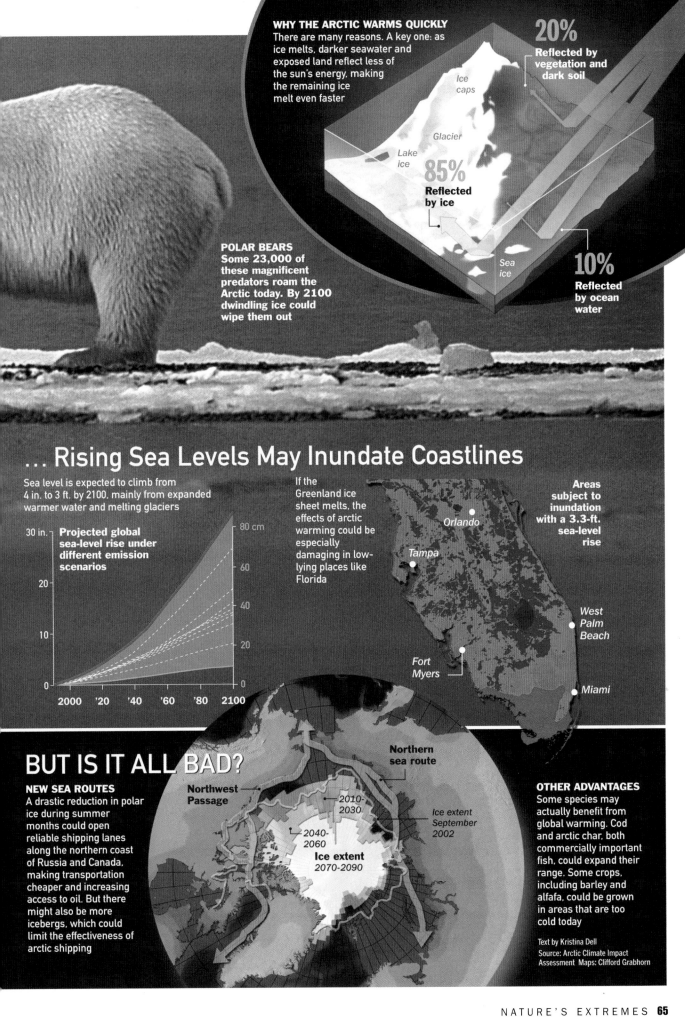

20%
Reflected by vegetation and dark soil

Ice caps

Glacier

Lake ice

85%
Reflected by ice

Sea ice

10%
Reflected by ocean water

POLAR BEARS
Some 23,000 of these magnificent predators roam the Arctic today. By 2100 dwindling ice could wipe them out

... Rising Sea Levels May Inundate Coastlines

Sea level is expected to climb from 4 in. to 3 ft. by 2100, mainly from expanded warmer water and melting glaciers

Projected global sea-level rise under different emission scenarios

30 in.

80 cm

20

60

10

40

20

0

2000 '20 '40 '60 '80 2100

If the Greenland ice sheet melts, the effects of arctic warming could be especially damaging in low-lying places like Florida

Areas subject to inundation with a 3.3-ft. sea-level rise

Orlando

Tampa

West Palm Beach

Fort Myers

Miami

BUT IS IT ALL BAD?

NEW SEA ROUTES
A drastic reduction in polar ice during summer months could open reliable shipping lanes along the northern coast of Russia and Canada, making transportation cheaper and increasing access to oil. But there might also be more icebergs, which could limit the effectiveness of arctic shipping

Northern sea route

Northwest Passage

2010-2030

Ice extent September 2002

2040-2060

Ice extent 2070-2090

OTHER ADVANTAGES
Some species may actually benefit from global warming. Cod and arctic char, both commercially important fish, could expand their range. Some crops, including barley and alfafa, could be grown in areas that are too cold today

Text by Kristina Dell
Source: Arctic Climate Impact Assessment Maps: Clifford Grabhorn

CARDIO CORAL This unusually shaped coral reef is located off Hardy Reef, a section of Australia's Great Barrier Reef. Such reefs consist of an accumulation of skeletal material produced by corals, protozoa, mollusks and tube-building annelid worms. Coral reefs form only in tropical waters on either side of the equator.

IN THE FIELD Mowing the Pacific's Lawn

RESEARCH GEOPHYSICIST STEVE WARD *talked to TIME about tracking the effects of ancient megatsunamis:*

In the summer of 2004, I spent 35 days on the research vessel *Kilo Moana,* which is operated by the University of Hawaii. The National Science Foundation had given us a grant to study the undersea landscape around the Ritter Island volcano, off the coast of Papua New Guinea. It collapsed in 1888, and what had been a 2,000-ft.-high mountain, covering several square miles of ocean, was reduced to a little spit of rock, no more than 200 ft. high and about a quarter of a mile long, in the space of a few minutes.

The question we were there to answer is, What happened to all that material? This is important because the undersea landslide caused by the volcano's collapse triggered a huge tsunami, as high as 60 ft., that hit coastlines hundreds of miles away. It may have killed many thousands of people; we'll never know for sure.

Underwater landslides are fascinating events. They can cause

WARD: Aboard the *Kilo Moana,* he trails tsunamis

megatsunamis in much the same way that asteroid impacts do, and are believed to have caused, in prehistoric times, some of the largest waves in the history of the world. For this expedition, we used highly sensitive sonar equipment. You basically trail a very long cable about two miles behind the ship and slowly move back and forth over a grid, like you're mowing the lawn. This probably sounds tedious, but the sonar gave us intriguing images of the ocean floor. We were able to track debris from the Ritter collapse up the sides of underwater canyons, where it gouged huge grooves into the canyon walls. Based on the height of these grooves, and the angle of the wall, we calculated that millions of tons of debris had moved through at speeds of up about 150 ft. a second. We also found debris as far as 50 miles away from the site of the Ritter collapse, which gives you some idea of the forces involved.

MONSOON MISCHIEF When annual rains flood shorelines along the River Ganges in Varanasi, India, local boys use the temple's tower as a diving board. Sadly, the 2005 monsoon season was one of the deadliest in India's history, as floods in Bombay killed more than 700 people.

MEASURING STICKS

DROUGHTS
PALMER INDEX
Developed by meteorologist Wayne Palmer in the 1960s, this index applies a formula to temperature and rainfall information to determine dryness. The National

Oceanographic and Atmospheric Administration refers to it as the "semiofficial" drought index. Standardized to local U.S. climate conditions, it notates normal conditions as 0, with drought severity

noted in minus numbers: −2 is a moderate drought, −4 is extreme. The index is also used to measure rainfall in plus figures: +2 is moderate rainfall, +4 is far above average.

The Crop Moisture Index,

also developed by Palmer, is used not only to measure dryness but also to forecast the possibility of short-term relief. The formula used in this index places more emphasis on recent data than does the Palmer Index.

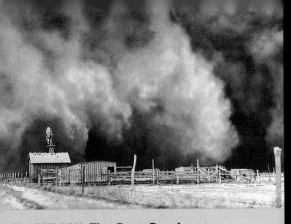

FLASHBACK: The Dust Bowl

TIME, APRIL 1, 1935 Kansans breakfasted by lamp light and read in their morning papers that one of the worst dust storms in the history of their state was sweeping darkly overhead. Damp sheets hung over the windows, but table cloths were grimy. Urchins wrote their names on the dusty china. Food had a gritty taste. Dirt drifted around doorways like snow. People who ventured outside coughed and choked as the fields of Kansas, Colorado, Wyoming, Nebraska and Oklahoma rose and took flight through the windy air. [Above, a dust cloud in Boise City, Okla., 1935]

VERBATIM

❝ The kids know that someday they are going to return to a farm. They just don't know it is not going to be this one. **❞**

—CRYSTAL GOEDERIS, whose farm in Illinois, in the family for 160 years, was lost in the 1993 Mississippi flood

DEADLIEST TSUNAMIS

1.	INDIAN OCEAN	12/26/2004	229,866 deaths
2.	MEDITERRANEAN	1645 B.C.?	100,000 (est.)
3.	PORTUGAL/MOROCCO	11/1/1775	60,000
4.	SOUTH CHINA SEA	5/22/1782	41,000
5.	KRAKATOA, INDONESIA	8/26/1883	36,417

DEADLIEST FLOODS

1.	HWANG-HO RIVER, CHINA	1931	3.7 million death
2.	HWANG-HO RIVER, CHINA	1887	2 million
3.	KAIFENG, CHINA	1642	300,000
4.	YANGTZE RIVER, CHINA	1975	80 to 200,000
5.	HOLLAND	1228	100,000

U.S. DROUGHTS & HEAT WAVES, 20th CENTUR'

1.	DUST BOWL	1930-40	Worst of century
2.	EAST-CENTRAL U.S.	1980	10,000 deaths
3.	EAST-CENTRAL U.S.	1988	5 to 10,000
4.	LOS ANGELES	1955	946
5.	NEW YORK CITY	1972	891

WHERE IN THE WORLD?

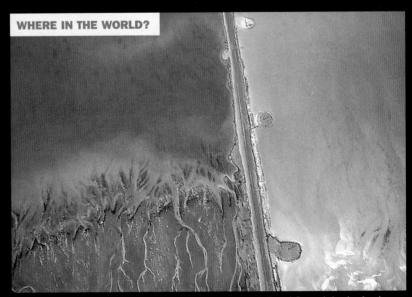

NEAR DEATH Salt evaporates, left, near the brackish Dead Sea, right, in Jordan

TSUNAMIS
There is no uniform system for measuring the relative strength of tsunamis, since the large waves can be caused by a variety of different events, including earthquakes, volcanic eruptions and undersea landslides. One of the deadliest tsunamis in history was caused by the eruption of Krakatoa in 1883. The waves reached 135 ft. in height, killing an estimated 36,417 people.

FLOODS
Like tsunamis, floodwaters are not measured by a scientific scale. Instead, scientists record the size of a flood by a method as old as history: measuring how high the floodwaters mount over normal water levels.
Oceanographers employ the science of hydrography to measure tides, currents and waves; mariners use a specialized branch of that science, marine hydrography, to chart courses.

3
THE LAND PLANET

PAYSON, ARIZ., 2004 This false-color infrared image, taken from a satellite, shows the Willow wildfire, center, burning on July 3. Scorched areas show up as magenta; active fires are red-orange; vegetation is green; smoke is blue

The recipe for creating land is staggering. Man's natural habitat is cooked up in the heated core beneath the planet's crust and expelled as lava through fiery volcanoes. Then it is further shaped, riven by tectonic fault lines, scoured by glaciers and **WINDS**. After the land simmers for 20 or 40 centuries in local climatic conditions, the result is what scientists call a **BIOME**, an environment conducive to the growth of specific plants and animals: a desert or a rain forest or a vast **TUNDRA**. The end? No. There is no stopping the changes nature works upon the land, but they take place on a timetable that is far too expansive for our eyes to see. Our view is a short segment of a lengthy story, a single frame in a movie that is eons long. Our closest encounter with these mighty forces is through weather: **WILDFIRES** torch forests, mudslides thunder down mountainsides, **SANDSTORMS** sweep across the desert. Yet in the past two centuries, a new force—man himself—has entered the equation, and for the first time a power other than nature is shaping nature. Look to the **RAIN FORESTS**, where in 2006 scientists identified the warming of the globe caused by the emission of carbon dioxide fumes as the catalyst in the extinction of entire species. The victims: tropical frogs that bring bright splashes of red and orange to the hushed green spaces of the forest canopy.

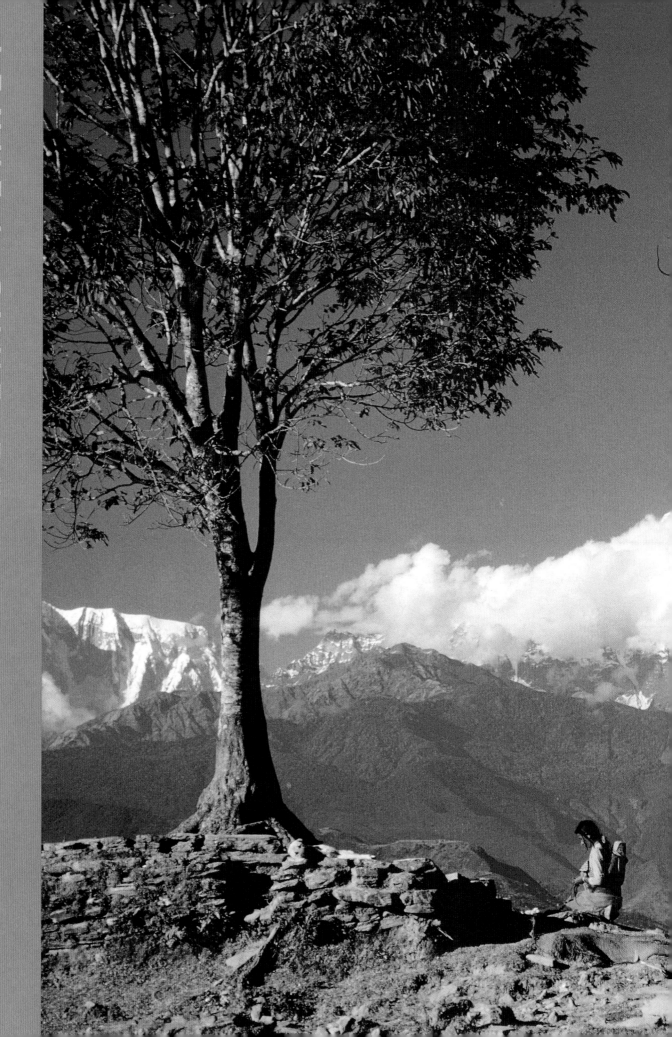

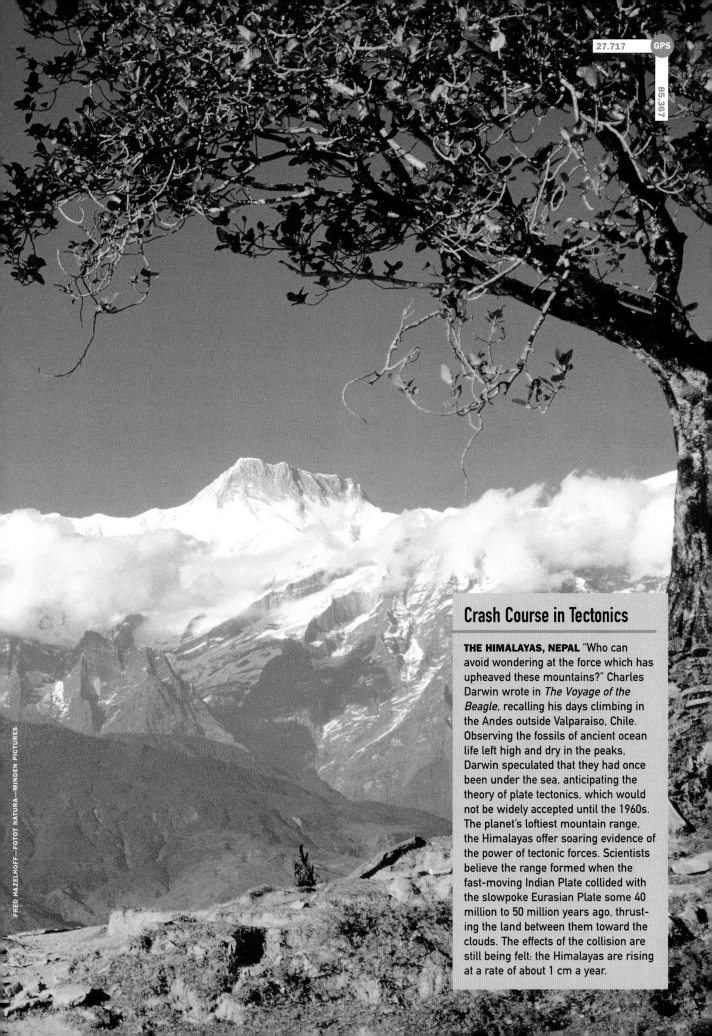

FRED HAZELHOFF—FOTOT NATURA—MINDEN PICTURES

Crash Course in Tectonics

THE HIMALAYAS, NEPAL "Who can avoid wondering at the force which has upheaved these mountains?" Charles Darwin wrote in *The Voyage of the Beagle*, recalling his days climbing in the Andes outside Valparaiso, Chile. Observing the fossils of ancient ocean life left high and dry in the peaks, Darwin speculated that they had once been under the sea, anticipating the theory of plate tectonics, which would not be widely accepted until the 1960s. The planet's loftiest mountain range, the Himalayas offer soaring evidence of the power of tectonic forces. Scientists believe the range formed when the fast-moving Indian Plate collided with the slowpoke Eurasian Plate some 40 million to 50 million years ago, thrusting the land between them toward the clouds. The effects of the collision are still being felt: the Himalayas are rising at a rate of about 1 cm a year.

Home, Home on the Range

ARCTIC NATIONAL WILDLIFE REFUGE, ALASKA Two large groups of caribou, the Porcupine herd (named for a local river) and the Central Arctic herd, live in this federally protected wildlife preserve. Here, some of the estimated 123,000 caribou of the larger Porcupine herd are moving north and east toward their annual calving grounds on the coast of the Beaufort Sea, part of the Arctic Ocean. Scientists divide the areas of the planet that support life, the biomes, into five major categories: aquatic, deserts, forests, grasslands and tundra. Home of the caribou, tundra is characterized by a very cold climate, a short growing season, simple vegetation and the presence of only a few types of animals, most of which migrate each year. The 19 million cold acres of this wildlife refuge are the subject of hot political debate: in December 2005 the U.S. Senate rejected a bill supported by the Bush Administration that would permit oil drilling in the area. The fate of these animals is part of that dispute.

70.325 GPS

148.711

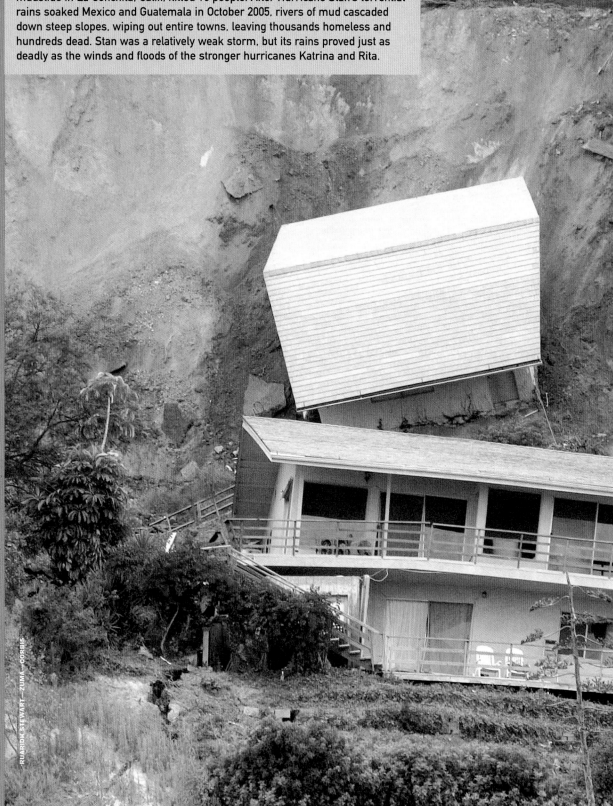

It Begins with Raindrops. Soon, There Goes the Neighborhood

LAGUNA BEACH, CALIF. This house, built on hilly terrain, was one of several million-dollar homes that lost their footings and were carried downhill when a landslide rocked Bluebird Canyon, an exclusive enclave along the Pacific Coast, on June 1, 2005. Scientists traced the event to heavy rains that fell in the region earlier in the year. "It was like something out of a movie," resident Ryan Haskell told reporters, recalling how his home was lost. "Our only recourse was to run down the canyon as the houses were sliding around us." Fortunately, no one perished in this catastrophe, although landslides can be deadly; earlier in 2005 a mudslide in La Conchita, Calif., killed 10 people. After Hurricane Stan's torrential rains soaked Mexico and Guatemala in October 2005, rivers of mud cascaded down steep slopes, wiping out entire towns, leaving thousands homeless and hundreds dead. Stan was a relatively weak storm, but its rains proved just as deadly as the winds and floods of the stronger hurricanes Katrina and Rita.

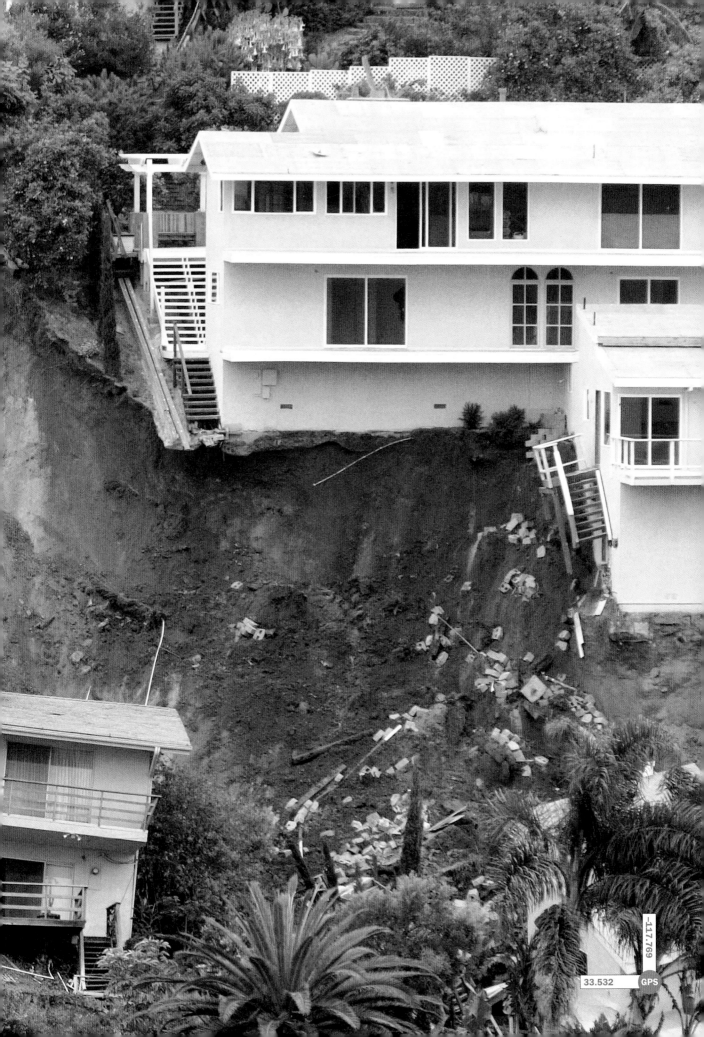

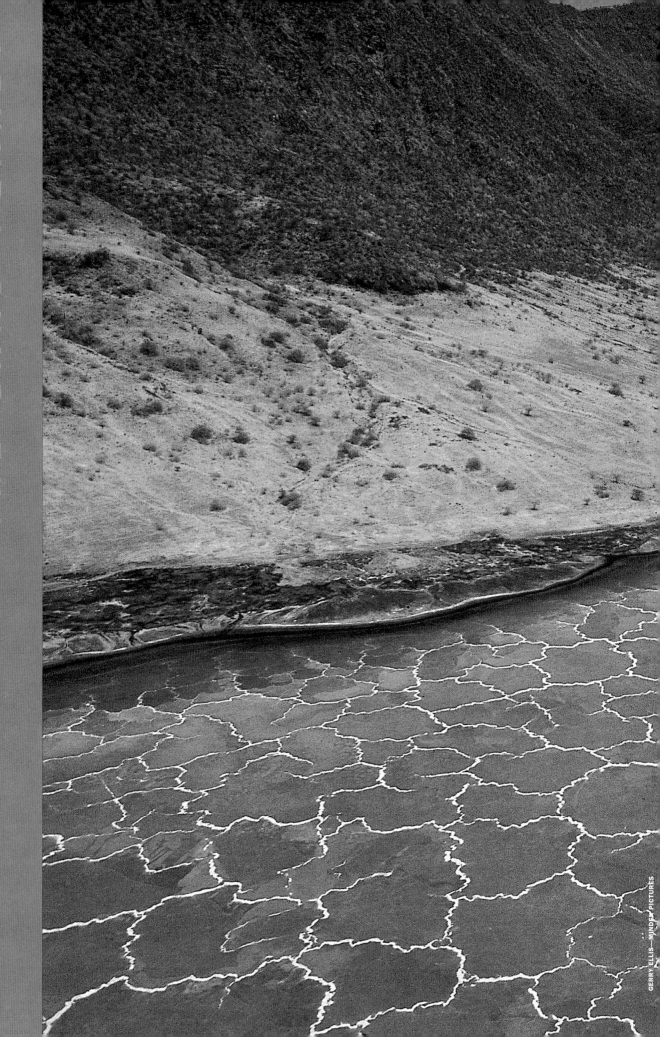

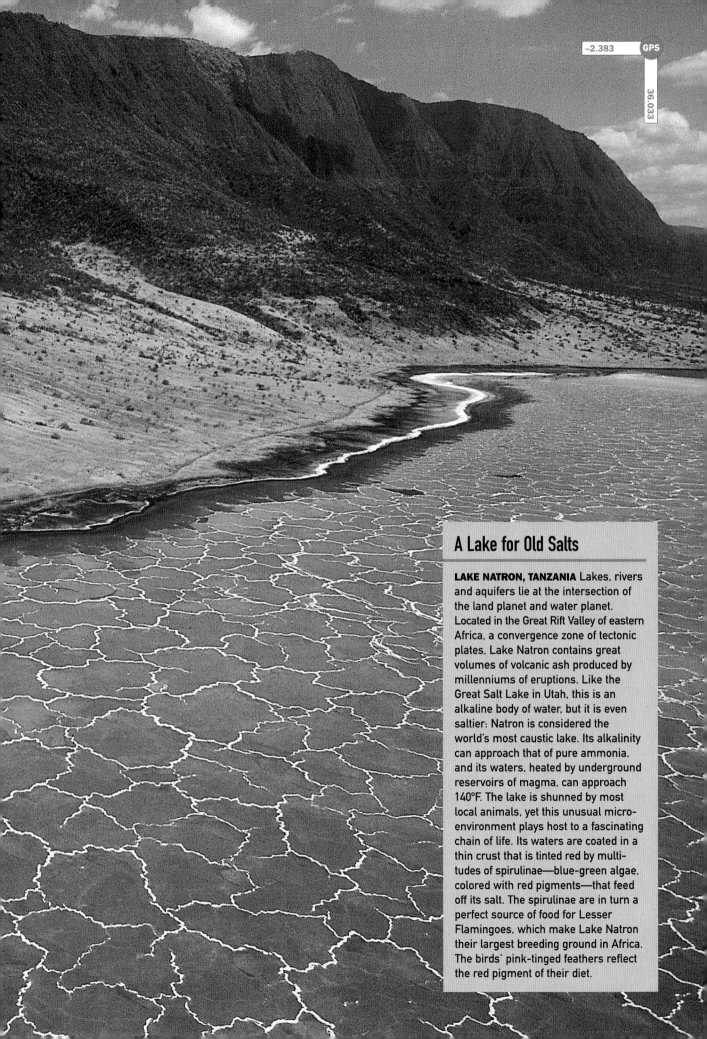

A Lake for Old Salts

LAKE NATRON, TANZANIA Lakes, rivers and aquifers lie at the intersection of the land planet and water planet. Located in the Great Rift Valley of eastern Africa, a convergence zone of tectonic plates, Lake Natron contains great volumes of volcanic ash produced by millenniums of eruptions. Like the Great Salt Lake in Utah, this is an alkaline body of water, but it is even saltier: Natron is considered the world's most caustic lake. Its alkalinity can approach that of pure ammonia, and its waters, heated by underground reservoirs of magma, can approach 140°F. The lake is shunned by most local animals, yet this unusual micro-environment plays host to a fascinating chain of life. Its waters are coated in a thin crust that is tinted red by multitudes of spirulinae—blue-green algae, colored with red pigments—that feed off its salt. The spirulinae are in turn a perfect source of food for Lesser Flamingoes, which make Lake Natron their largest breeding ground in Africa. The birds' pink-tinged feathers reflect the red pigment of their diet.

TORRENTS OF SLIME

When rain turns soil to mud, gravity becomes the enemy

AS TROPICAL STORMS GO, JOSÉ was nothing to write home about. Yet he turned out to be a killer, just the same. The low-pressure system departed the coast of Africa on Aug. 8, 2005, and its clouds bulked up a bit on the warm waters of the Caribbean Sea. By the time the weather system drew close to Mexico's Yucatán Peninsula on Aug. 22, it had attained sufficient strength to be designated a tropical storm and christened José by the National Hurricane Center in Miami. José never grew to hurricane strength, however: when it made landfall in Mexico, it lacked the strong winds that are the howling signature of a hurricane. But José dumped as much as 10 in. of rain on some towns in the region in a 24-hr. period—and that was enough to trigger big mudslides in

the area's hilly terrain. By the time José broke up and entered the record books as just another routine, short-lived storm, the big cascades of mud unleashed by its rains had left six people dead and thousands homeless.

If deadly José was a relatively minor event, consider a real mass murderer, Hurricane Stan. Like José, Stan was described as a rather weak storm. But Stan's clouds, in tandem with a larger rainstorm system of which it was a part, dumped some 20 in. of rain across portions of Mexico and Central America early in October 2005. The deluge set off monster mudslides all around the region. The worst tragedies afflicted Panabaj, a poor village perched precariously on the slopes near Lake Atitlán in Guatemala's Sololá department, and Piedra Grande, a small town in the municipality of San Pedro Sacatepéquez. Both hamlets were essentially buried in mud, not so much wiped off the face of the earth as absorbed into it. The towns are now considered graveyards; in Piedra Grande some 1,400 people were buried alive. In El Salvador, the rains of Hurricane Stan were compounded by the entirely unrelated eruption of the Santa Ana volcano, located near the

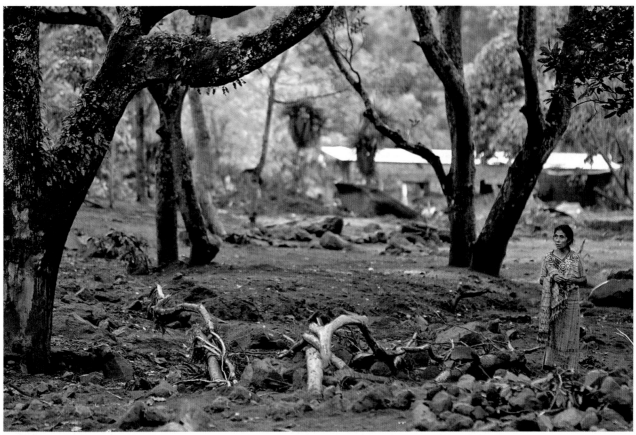

PANABAJ, GUATEMALA, 2005 A woman surveys the devastation that resulted when much of the town was inundated by sludge

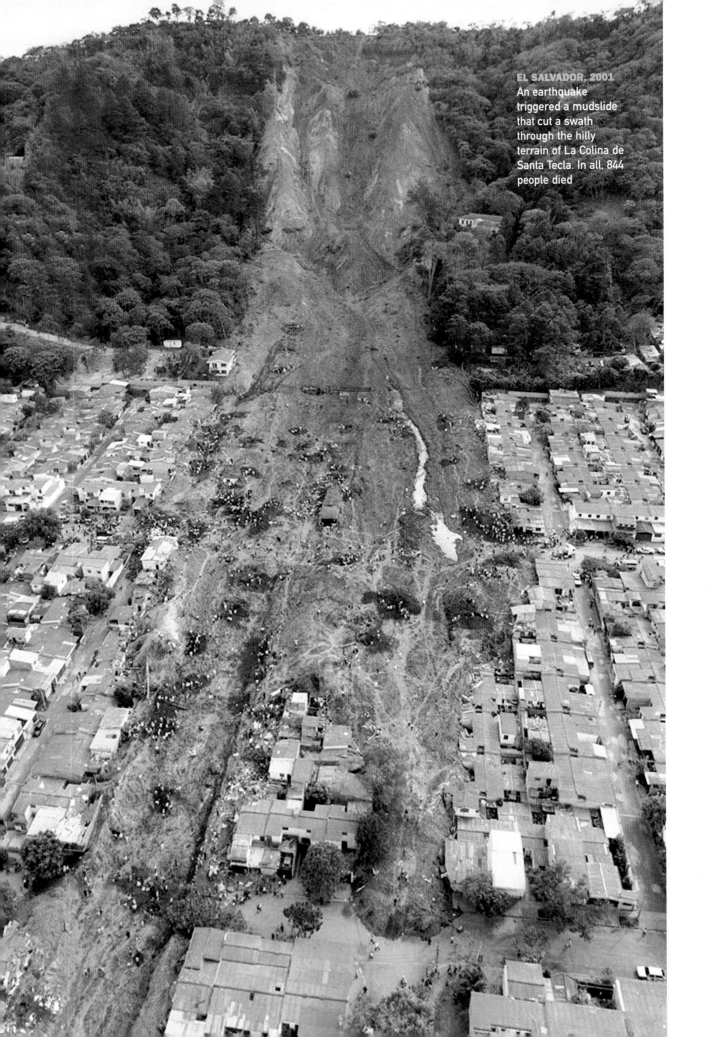

EL SALVADOR, 2001
An earthquake triggered a mudslide that cut a swath through the hilly terrain of La Colina de Santa Tecla. In all, 844 people died

capital city, San Salvador, which exacerbated the threat of landslides. Across the region, people were forced to abandon their homes: some 37,000 were on the run in El Salvador, more than 100,000 in Mexico, some 54,000 in Guatemala. One month after the rains subsided, the death toll in the region stood at 1,625.

EVEN HURRICANE STAN'S DEATH COUNT PALES WHEN compared with the calamity that struck the nation of Colombia in 1985. In one of the great natural disasters of the 20th century, the long-dormant volcano Nevado del Ruiz suddenly came alive on Nov. 13. Within hours, that rebirth left upwards of 23,000 people buried in a steaming, mile-wide avalanche of mud and ash that swept down the slopes of the 17,716-ft. mountain. The town of Armero (pop. about 22,500) essentially disappeared, along with the majority of its inhabitants.

Nevado del Ruiz did not produce the spectacular lava displays we associate with eruptions. Instead, the tragedy began when superheated magma within its cone began to melt the thick blanket of snow and ice that capped the uppermost 2,000 ft. of the peak. Filthy water started to flow down the sides of the mountain. The trickle swiftly turned into a torrent of viscous mud, stone, ash and debris, cresting between 15 and 50 ft. The liquid avalanche, known as a lahar, was soon hurtling down the steep slopes at speeds of up to 30 m.p.h., following the riverbeds that channel water from the peak.

In Armero, as survivor Rosa Maria Henao, then 39, told TIME later, the mudslide "rolled into town with a moaning sound, like some sort of monster. Houses below us started cracking under the advance of the river of mud." Fortunately, her home was on relatively high ground; Henao grabbed her two children and sought refuge on its roof. As they watched, more than 80% of the roughly 4,200 buildings in Armero simply vanished into the torrents of slime.

Survivors testified that the first wave of mud to hit the town was ice cold, like the mountain snows that spawned it. Only later, as it rolled onward, did the cascade turn smoking hot, as lava from the volcano caught up with the mudslide it had unleashed. What was left behind in Armero, in Henao's words, was "one big beach of mud." A viscous gray layer, between 7 ft. and 15 ft. thick, covered most of the town. Thousands of bodies were buried deep in the sludge, their location sometimes marked by pools of blood on the surface. Many of the living were naked or only partly clothed; their garments had been torn from them by the swift-moving lahar. All were encrusted with ash-colored goo that quickly

ARMERO, COLOMBIA, 1985
Much of the town was buried by the mudslide. Below, rescuers could not free Omaira Sanchez, trapped when the town was hit

TIE THAT BINDS
Omaira Sanchez, 13, was washed up against her aunt, who grabbed hold of her. The aunt died but kept her grip, even as rigor mortis set in

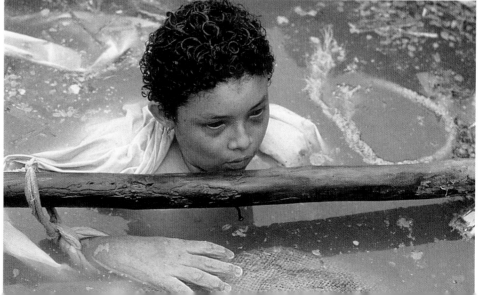

LANGEVIN JACQUES—CORBIS SYGMA

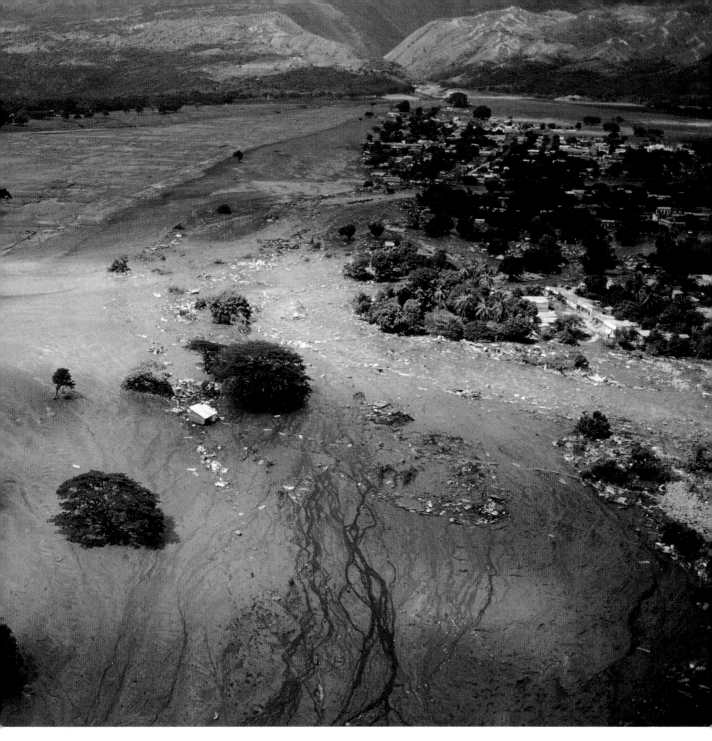

hardened under the next morning's sun into a gritty carapace.

Most horrifying of all was the plight of those who were trapped, still living, in the mud. Many were buried up to their necks; some had their mouths stopped with filth, so they could not cry for help. Sometimes the buried survivors were still locked in gruesome embrace with the dead. One was Omaira Sanchez, 13, who remained up to her neck in ooze two days following the disaster. When the mudslide struck, Omaira was washed up against her aunt, who grabbed hold of her. The aunt died but kept her grip, even after rigor mortis had set in. Finally, after rescuers had worked fruitlessly for 60 hours, Omaira died of a heart attack. One doctor estimated that there were at least 1,000 living victims trapped in the morass; few escaped with their lives.

The science of landslides is not esoteric; they are essentially a marriage of gravity and mud. But today scientists are beginning to implicate landslides in a different kind of dis-

aster, as they explore the possibility that undersea landslides can either cause tsunamis or heighten the effects of one caused by an undersea earthquake. After a magnitude 7 earthquake on July 7, 1998, giant waves swamped beaches on the north coast of Papua New Guinea, killing more than 2,200 people on the island. But as scientists from the National Oceanic and Atmospheric Administration (NOAA) reviewed the event, they were puzzled that the killer wave was not only larger than predicted by models for an earthquake that size but also arrived some 10 minutes later than expected. Explorations of the undersea earthquake site by manned submersibles found evidence that the big wave may have been triggered by the undersea slump of a slope of seafloor perched on vertiginous ground. The research suggests that the term landslides may be a misnomer; these events may be stealth killers, working their deadly processes miles from the sight of land. ∎

WHITE DEATH

Snow symbolizes purity and renewal—most of the time

WHY DO AVALANCHES SEEM MORE APPALLING, more inexplicable and uncalled-for than other natural disasters? One reason is that they occur in mountainous regions, areas that take us close to the heavens, where the air is thin and all seems pure. Another is that their occurrence is so unpredictable as to seem whimsical. But surely the main reason is because an avalanche is a killer dressed in white, and we are raised to believe that bad guys wear black.

Herman Melville was one the few to see danger in white. In Chapter 42 of *Moby Dick*, "The Whiteness of the Whales" he wrote, "… for all these accumulated associations, with whatever is sweet, and honourable, and sublime, there yet lurks an elusive something in the innermost idea of this hue, which strikes more of panic to the soul than that redness which affrights in blood." Although Melville cites polar bears, sharks and Samuel Taylor Coleridge's famous albatross as dangerous animals cloaked in white, and he also lists the Milky Way and New Hampshire's White Mountains as further examples of the terror lurking in this hue of seeming purity, his lengthy list never gets around to avalanches.

If only Melville had been a skier rather than a sailor. Skiers know that avalanches—swift, powerful, silent and deadly—are their greatest enemy. Torrents of sliding snow claim some 150 lives across the planet each year, and that number is rising, not falling, as skiing, snowmobiling and other frosty sports attract ever more enthusiasts.

As with their ugly cousins, mudslides and landslides, avalanches are scientifically simple: the recipe calls for snow, slopes, mass and gravity. The problem: there's often a lot of mass involved. A typical U.S. avalanche might release 250,000 to 350,000 cu. yds. of snow, enough to fill, well, a lot of dump trucks. Scientists divide the event into three stages, beginning with the topmost section, the starting zone. The trouble begins here, when unstable snow splits off from the main snowpack and starts to slide. The second section is the avalanche track, the path the snow follows until it reaches a stop in the third stage, the runout zone.

Skiers, hikers and snowmobilers: listen for a hollow "whumping" sound as you pass over the snow. That's the telltale sign of an unstable snowpack that may be ready to start slipping. Give it the slip instead, by clearing out. ■

LOOK OUT! Snow cascades into Zurs, Switzerland, in February 1999, when some of the century's heaviest snowfalls fueled avalanches. A slide in Austria that month killed 38 skiers

LENHOF—REY—GAMMA

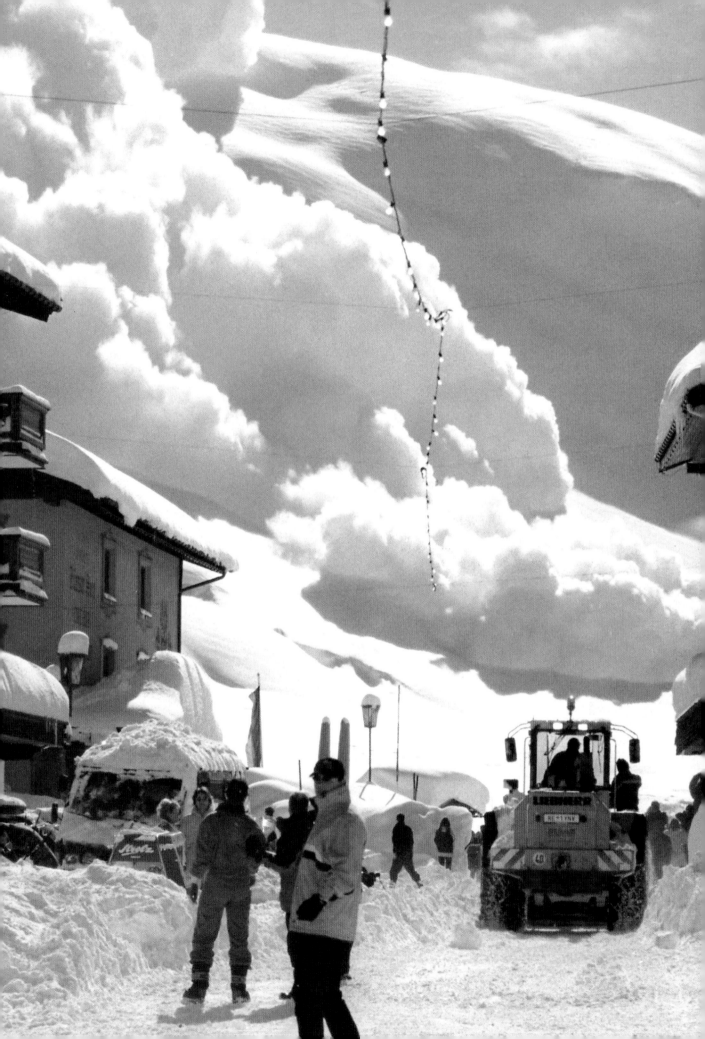

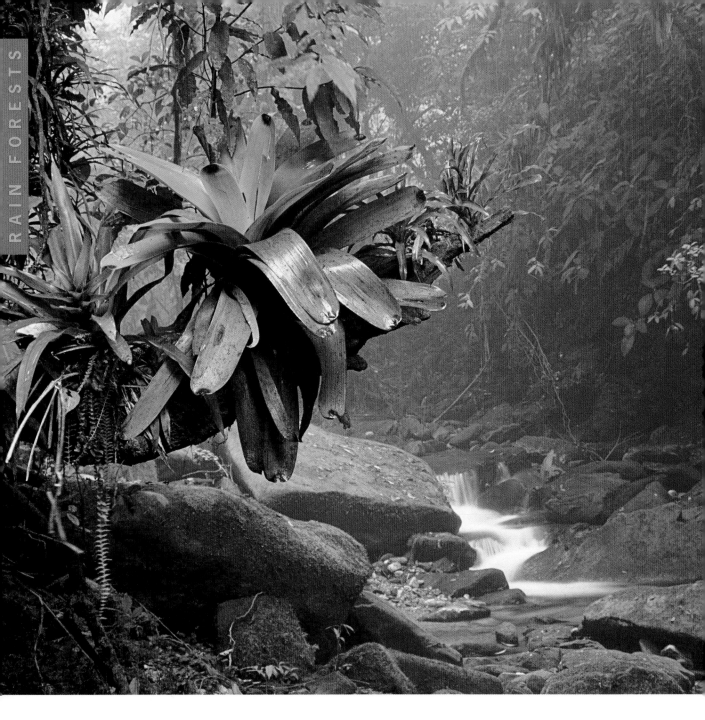

PARADISE LOST

Rain forests, the planet's lungs, are hothouses for new life

BACK IN THE EARLY 1990S, I WAS cataloging plant species in the Colombian rain forest," recalls Cristian Samper, the renowned biologist who is the director of the Smithsonian Institution's National Museum of Natural History, "I had been there for several days, when a colleague and I came upon a stunning flower that was like nothing we had ever seen before. It was bright orange and had long, beautiful petals. We took it back to the taxonomists, who realized that this was an entirely new species of flower in the family Gesneriaceae. They eventually called it *Sinningia elatior*."

Such moments of discovery have enchanted and inspired the native Colombian since he was a teenager. Samper be-

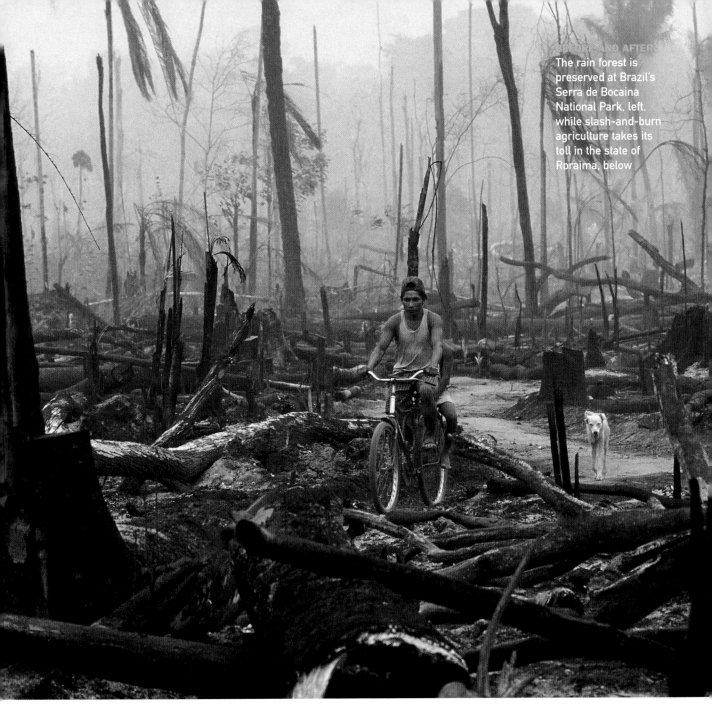

LEFT: TUI DE ROY—MINDEN PICTURES; RIGHT: JOAO LUIZ BULCAO—CORBIS

The rain forest is preserved at Brazil's Serra de Bocaina National Park, left, while slash-and-burn agriculture takes its toll in the state of Roraima, below

gan collecting rare plants and insects as a boy and embarked on his first scientific trek into the Amazon rain forest at age 15. He believes there is far more at stake in identifying new species of flora and fauna than the thrill of discovery.

"Plants and animals are always engaged in what we call a 'co-evolutionary arms race,'" Samper says. "Unlike animals, plants can't run away from the things that eat them. So they have to devise chemical defenses against animals, diseases and other plants." This treasure trove of natural chemical innovation explains why one-quarter of all prescription drugs are derived from plants. "The competition among plants and between plants and animals," Samper continues, "is the most intense where the greatest number of them live." More than 50% of all animal species on the planet—and more than 66% of all varieties of plant life—inhabit only 2% percent of its surface: the lush, densely overgrown rain forests.

Scientists say there is every reason to suspect that there are hundreds, perhaps thousands, of miracle drugs hidden be-

neath the canopies of the world's rain forests. They remain undiscovered only because the rain forests themselves are largely unexplored. "We just don't know about most of the living things inside of rain forests," Samper says. "Some estimates are that we have cataloged as few as 10% of the plants and mosses and have overlooked more than one-third of all the animals." We do know that fewer than 1% of all the plants so far identified have been tested for medicinal properties. Of these, according to the Nature Conservancy, more than 2,000 have been demonstrated to have potential in fighting cancer, while many more show promise as therapies against other diseases.

Sadly, the hidden bounties of these exotic woodlands may remain secret forever, because the rain forests are disappearing. Paleontologists estimate that the ancient world contained more than 6 million sq. mi. of rain forest. Much less than half of those forests remain—and about a quarter of the original amount has been cleared in the past 200 years. To-

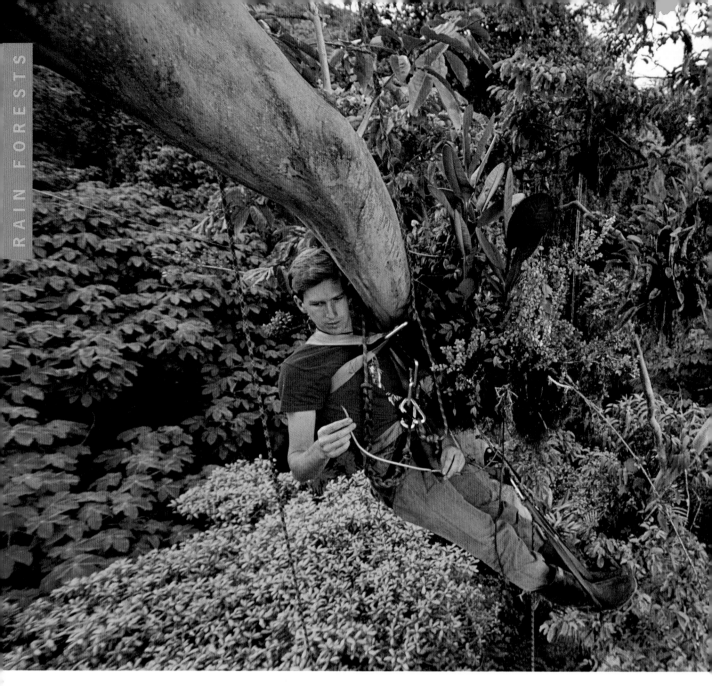

day, a slice of rain forest the size of a football field is harvested, burned or cleared every second of every day: that's more than 56,000 sq. mi. each year. Large forests in India, Sri Lanka, Bangladesh and Haiti have been lost entirely, while those in West Africa and South America are shrinking rapidly.

As the forests are slashed and burned, the life within them also goes up in smoke. The consensus among biologists is that more than 50 different species of plants and animals are becoming extinct within the world's forests every 24 hours. That far exceeds the rate at which new species are developing, and amounts to the greatest die-off since the dinosaurs became extinct. In human perception, this registers—if at all—as a slow-motion, silent apocalypse. But in geologic timescales, it is happening in the blink of an eye. And for those trained to listen, the wail of distress is unmistakable.

It's quite possible that human life depends on species we have not yet discovered in ways we do not yet understand. "We are taught to think of food as a chain," Samper explains, "with microbes at the bottom, plants and animals in the middle and human beings at the top. But it's really much more like a web, where every strand supports and relies upon

every other strand. If you put stress on any segment, it will be felt all across the web. Take away even one strand, and the whole web gets weaker. If you take away more than a few, the entire web may collapse."

That web has already collapsed for millions of human beings. Historians estimate that before the year 1500, there were approximately 6 million indigenous tribespeople living in the Brazilian Amazon. By the first decade of the 20th century, fewer than 250,000 remained. Even today, previously unknown cultures are being discovered deep within the jungle, as miners and timber companies cut new roads into unexplored territory. Many of the people vanish within a few decades of their first contact with the outside world.

Many of the nations with the largest rain forests are underdeveloped; their resources remain untapped. And rain forests are particularly rich, tempting assets. The timber there is heavily weighted toward valuable teak, sandalwood, mahogany, rosewood and balsa. Once these trees have been felled and cleared, the soil exposed is enormously fertile, making it ideal for agriculture. That translates into a devastating one-two punch in which valuable timber is clear-cut

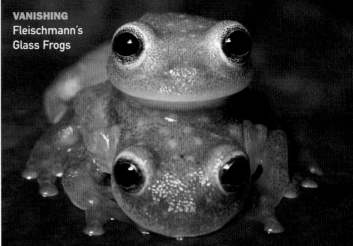

THE FIRST VICTIMS OF GLOBAL WARMING?

HARDY AND PLENTIFUL as they seem, frogs are actually frail beings, with a semipermeable skin that leaves them vulnerable to even the slightest hiccup in their environment. So when entire species of brightly colored harlequin frogs started dying off in the cloud forests of Central and South America about 25 years ago, scientists suspected that something in the amphibians' ecosystems—they weren't sure what—had gone awry.

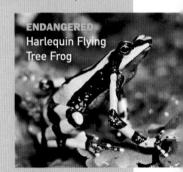

ENDANGERED
Harlequin Flying
Tree Frog

In January 2006 an international team of scientists compared changes in annual forest temperatures with the number of frog species spotted. The results, reported in the science journal *Nature*, documented for the first time a direct correlation between global warming and the extinction of about two-thirds of the 110 known species of harlequin frogs. Data collected in Costa Rica showed that species die-offs follow warm years 80% of the time. It's not heat alone that kills harlequins: a fungus that attacks their skin thrives in cool weather. Paradoxically, global warming leads to cloudier, cooler days in the frogs' forest home.

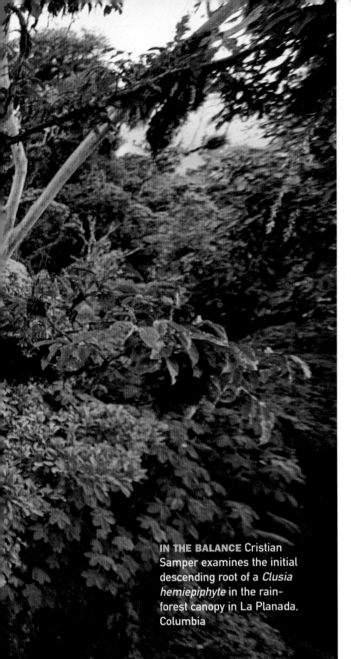

IN THE BALANCE Cristian Samper examines the initial descending root of a *Clusia hemiepiphyte* in the rain-forest canopy in La Planada, Columbia

to make way for farming or grazing. But the benefit seldom lasts: after the rain forest's protective ecosystem has been erased, the soil often degrades quickly or is eroded away. Within a few years the farmers and ranchers move on to the next swatch of recently cleared rain-forest acreage, leaving a wasteland behind them.

RAIN FORESTS ARE NOT ONLY HOTHOUSES OF BIOLOGI-cal diversity; they are also the lungs of the planet, in ways we are only beginning to measure. Because their vegetation vacuums up carbon dioxide and expels oxygen, rain forests help mitigate the effects of greenhouse gases and slow down global warming. Since they collect and concentrate humidity, the forests also help regulate temperature—not just locally, but globally.

Nothing infuriates the residents of these critical regions more than the notion that richer nations are entitled to a say in how their forests are managed. But the rest of the world does have a significant stake in the future of the forests. As a result of widespread burning to clear the land for agriculture, some scientists now calculate that major rain forests, like the

Amazon, have become net contributors of carbon dioxide and other greenhouse gasses to the atmosphere. In 2004 satellite photographs located more than 165,000 "hot spots" —fires with flames as high as 100 ft. and temperatures exceeding 2,500°F—in the Amazon Basin alone. "The consequences of deforestation are almost incalculable," Samper says. "Locally, they include flooding and loss of topsoil. But deforestation also contributes to climate change, which means that people in Africa may be affected by the loss of rain forest in the Amazon basin.

"Two years after the expedition in which we discovered the new species of Gesneriaceae," Samper recalls. "I went back to the same place in Colombia. We found that the forest where we had been working was gone. It had been burned and cleared. No other specimens of *Sinningia elatior* have ever been found. As far as we know, it is now extinct." Asked whether that plant might have held promise as a new medicine or had perhaps helped another species of plant or animal survive, he shrugs and answers, "We'll probably never know." Someday, however, we may learn the price of such self-inflicted ignorance—and sooner than we might like. ■

IN THE LINE OF FIRE

They take a terrible toll, yet wildfires are a necessary scourge

THE DATE WAS JAN. 1, 2006, BUT many residents of Oklahoma had no time to celebrate the new year: they were busy fighting to save their homes, farms and cattle, imperiled by some of the largest wildfires ever to afflict the state. Aided and abetted by a trio of contributing factors—abnormally high winter temperatures, consistently low rainfalls and steady high winds—wildfires raced across the state's dry, grassy plains beginning in November 2005. By Jan. 3, when most of the flames were finally extinguished, four people were dead, more than 250 homes and buildings had burned to the ground, and some 331,000 acres of grasslands had been consumed. At the same time, fires were also rampaging through neighboring Texas. Governor Rick Perry, de-

scribing the parched plains of the Lone Star State as "a tinderbox," declared the entire state a disaster area.

Ten days after the first wave of fires was quelled, a fresh batch swept across Oklahoma, destroying at least 24 homes and forcing hundreds of people to evacuate. At the ranch of Gayla Stacy, 53, about 60 miles south of Oklahoma City, flames burned down the barn, destroyed farm equipment and consumed 160 acres of land where her 150 head of cattle grazed. Also lost: more than 100 rolls of hay set aside for winter feed. "We've worked 35 years to get what we've got, and we're glad our house didn't burn, but it still hurts," Stacy told CBS News. "It's knocked a big hole in our livelihood." Meanwhile, Oklahoma Governor Brad Henry canceled a planned helicopter tour of the devastated area so the state chopper could be enlisted in the battle against the flames.

A tragedy? Yes. Yet wildfires cannot simply be branded as one of nature's plagues. Like the Roman god Janus, for whom the month of January is named, wildfires wear two faces. However bitter the toll they take on forests, plains and farms in the short run, their flames are essential to the planet's bal-

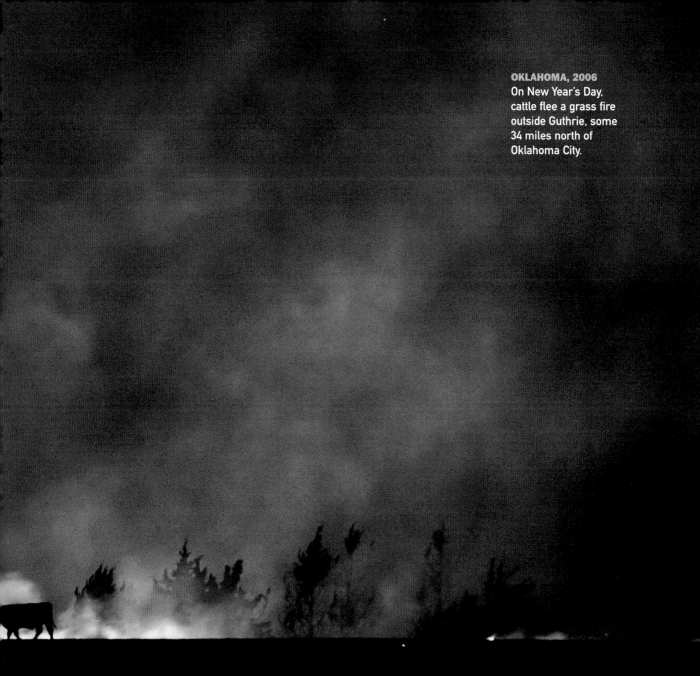

ance over the long haul, playing a critical role in the cycle of natural renewal, removing old growth to make way for new.

The fires in Oklahoma and Texas were a by-product of weather conditions, but even dry grass needs a spark to combust: the most common culprits include lightning, human carelessness and, sadly, arson. According to the Maine forest service, arsonists cause 1 out of every 4 wildfires in the state. Americans were stunned in 2002 when Terry Lynn Barton, a U.S. Forest Service employee, pleaded guilty to having started the largest wildfire in Colorado history, the Hayman blaze that consumed 138,000 acres southwest of Denver, destroying 133 homes and causing an estimated $13 million in damages. Barton, then 39, faced both state and federal trials; she was sentenced to 12 years in prison. In 2004 a U.S. Appeals Court upheld the Federal Government's request that she pay $14.7 million to cover the expenses incurred as hundreds of firefighters fought the flames. Barton, residing in a federal prison in Texas as of January 2006, may have her sentence reduced: her lawyers successfully argued that month that a state district judge's sentence was excessive, noting

that smoke from the fire she started had threatened his home and forced him to evacuate it for a night.

FOR MUCH OF THE 20TH CENTURY, WILDFIRES WERE seen as man's enemy. The lesson was drilled into generations of children by the plight of the animated forest animals that fled raging flames in Walt Disney's *Bambi.* Meanwhile, kids learned that "only you can prevent forest fires," courtesy of beloved U.S. Forest Service spokesbear, Smokey. Beginning in the 1960s, however, scientists began to realize that wildfires are essential to the long-term health of forests and praries.

That knowledge doesn't make it any easier for those whose homes and lives are challenged by fire. And those numbers are increasing, as more people build homes in known wildfire areas. Consider one of the most recent major wildfire outbreaks, the conflagrations that devastated Southern California in October 2003.

The stories are harrowing. In the small Southern California community of Valley Center, 35 miles north of San Diego,

CHARRED TIMES IN YELLOWSTONE PARK

YELLOWSTONE NATIONAL PARK holds a special place in the hearts of Americans; it is our foremost living symbol of the wide-open spaces of the West. So when wildfires broke out in the 2 million-acre Wyoming park in 1988, many Americans were outraged that the National Park Service, heeding scientists, made no initial attempts to fight the blazes but instead let nature pursue its fiery course. Firefighters were eventually brought in to control the conflagration, but when the last flames died out, more than 900,000 acres of the park had been consumed.

A follow-up report by the U.S. Department of the Interior was a muddled exercise in contradiction, arguing on the one hand that natural burning is essential but on the other that "the social and economic effects [of natural fires] may be unacceptable." Translation: Wyoming's economy needs Yellowstone tourist dollars. An increasing number of scientists are calling for national forests to be burned regularly, under tightly managed conditions.

a 20-year-old woman was horribly burned when she paused to rescue a cat. In Lake View Hills Estates, 25 miles to the south, a couple and their grown son perished as they raced in their car for the safety of a nearby reservoir. The body of one of their neighbors was found inside his charred RV, along with the remains of his four Irish wolfhounds. In Wynola, 40 miles northeast of San Diego, a firefighter trying to save a house died when a freak turn of wind blew the fire in his direction; the colleague who tried to save him sustained burns over 20% of his body. Some people were luckier. Another couple in Lake View Hills Estates rode out the fire by diving into their swimming pool as the windows of their house exploded around them.

And then, suddenly, after more than a week of rage and destruction, it was all but over. Fog and cold rolled in from the ocean to dampen the flames, leaving behind smoking rubble where houses used to be. One of the worst natural disasters in California history, the infernos enveloped more

SAN JOAQUIN VALLEY, 2003 Mike Jennings of the Woodbridge fire department fights one of California's greatest disasters

than 750,000 acres, killed 20 people and destroyed nearly 3,000 houses. Yet these were disasters foretold, the tragic but predictable result of the push of people and dwellings into forests and brush lands designed by nature to burn.

WILDFIRES, DUKE UNIVERSITY FIRE ECOLOGIST Norm Christensen explained to TIME, have been erupting in the canyons and foothills of California's coastal mountains for thousands of years. The recipe to produce them is as simple as it is effective. Take a tract of pine and fir trees or shrubby chaparral. Watch the trees grow for several decades. Then wait for the winter rains to stop so the tinder can dry. At that point, a spark is all it takes to start a conflagration. In this case, only days after that first spark was struck, 14,000 firefighters found themselves arrayed along a chaotic front, often watching helplessly as flames engulfed houses and leaped across freeways.

Fires that occur in the zone where suburban sprawl abuts rugged wild lands are known as intermix fires, and they are a firefighter's nightmare. Vastly complicating the ability to protect property and lives are nonnatural hazards like narrow, twisting roads that dead-end in blind canyons or houses with cedar-shake roofs and logs stacked beside the kitchen door. It's too late to zone against developments that are in place, but the danger can still be mitigated. Adopting and enforcing more stringent building and landscaping codes, say fire experts, is critical. California's Ventura County, for example, now requires 100-ft. buffer zones between homes and surrounding wild lands.

The goal: preserve nature's balance. According to Richard Minnich, a fire ecologist at the University of California at Riverside, it is the long history of wildfire suppression in the U.S. that has allowed fuel loads in so many areas to build to unprecedented levels. When we try to thwart nature's rhythms, it seems, we only end up playing with fire. ■

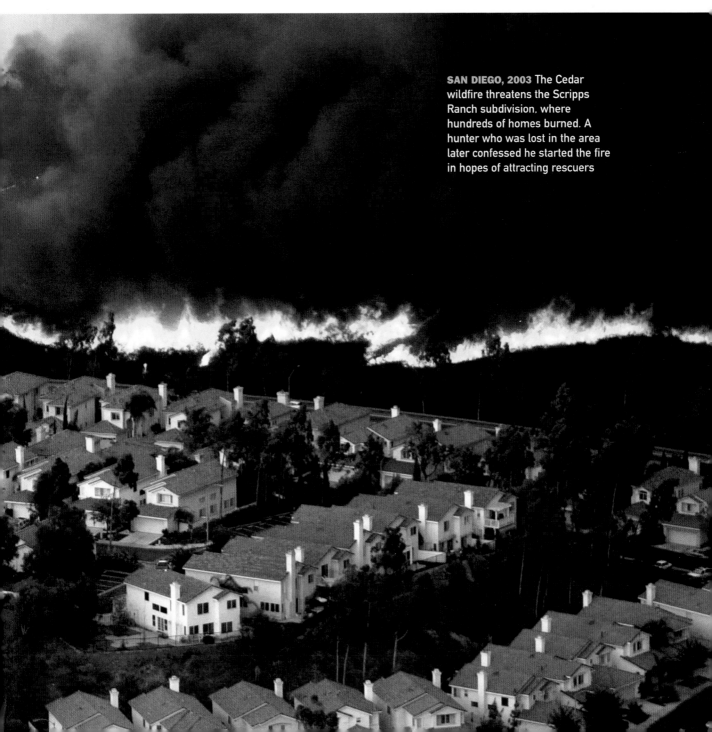

SAN DIEGO, 2003 The Cedar wildfire threatens the Scripps Ranch subdivision, where hundreds of homes burned. A hunter who was lost in the area later confessed he started the fire in hopes of attracting rescuers

THE SCIENCE OF WILDFIRES

Wildfires exist in a world of their own, with their own dynamics and their own weather. Before you can fight a fire, you need to understand the forces that drive it. The lesson of these big blazes is that fire is a natural occurrence that we must learn to tolerate and even sometimes encourage

HOW THEY START

Wildfires result from a confluence of fuel, dryness and some kind of trigger. Each factor contributes to the severity of the blaze

■ **Fuel** means flammable solids—grass, pine needles, undergrowth, smaller trees—that, with oxygen, feed the fire

■ **Dryness** can be caused by short-term weather patterns with low humidity or by a lengthy drought that parches the landscape

■ **Triggers** can be as natural as a lightning strike, as innocent as a campfire or as sinister as an arsonist

HOW THEY SPREAD

Weather is the primary force that drives or contains wildfires. But once they start burning, they create their own weather

(1) **Smoke and heat** from fires can rise thousands of feet in the air

(2) Then **cooler air** rushes in to fill the void

(3) This convection system creates **gale-force hot winds** that dry out and preheat fuel ahead of the fire and can propel burning embers as much as half a mile (0.8 km)

HOW TO FIGHT THEM

A fire dies when it is deprived of fuel, heat or oxygen. The main strategy for fighting wildfires is containment: surround the fire and starve it

■ **Helicopters and tanker airplanes** can drop water or chemical retardants to slow the spread of flames

■ **Firefighters can set up fire lines,** areas cleared of any fuel that would allow the fire to spread

■ **Controlled fires** are sometimes set to deny fuel to an approaching blaze

(1) **Column of rising hot air creates a void below**

(2) **Fresh air rushes in, bringing more oxygen to fuel the flames**

WIND

(3) **Blowing embers allow the fire to jump natural barriers such as rivers and valleys**

WIND

FUEL

It's a dangerous recipe: decades of fighting every forest fire have left many areas dangerously full of fuel—sticks, fallen timber, pine needles and brush. Long-term droughts can sap the natural moisture from the ground

TORNADO WINDS

In rare cases, erratic winds within a wildfire create powerful mini-tornadoes that can shoot spirals of flame into the air and twist trees apart at their trunks

SOIL INSULATION

Soil is an excellent insulator that can protect tree roots from a fire's heat, permitting regrowth to begin quickly. But a charred landscape is also vulnerable to erosion

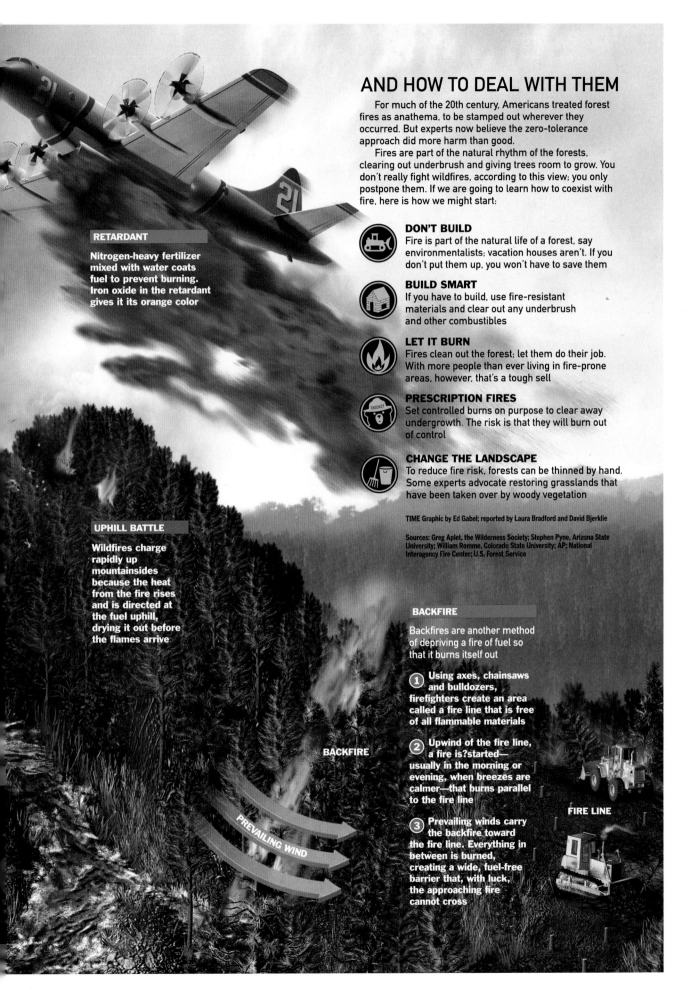

AND HOW TO DEAL WITH THEM

For much of the 20th century, Americans treated forest fires as anathema, to be stamped out wherever they occurred. But experts now believe the zero-tolerance approach did more harm than good.

Fires are part of the natural rhythm of the forests, clearing out underbrush and giving trees room to grow. You don't really fight wildfires, according to this view; you only postpone them. If we are going to learn how to coexist with fire, here is how we might start:

DON'T BUILD
Fire is part of the natural life of a forest, say environmentalists; vacation houses aren't. If you don't put them up, you won't have to save them

BUILD SMART
If you have to build, use fire-resistant materials and clear out any underbrush and other combustibles

LET IT BURN
Fires clean out the forest; let them do their job. With more people than ever living in fire-prone areas, however, that's a tough sell

PRESCRIPTION FIRES
Set controlled burns on purpose to clear away undergrowth. The risk is that they will burn out of control

CHANGE THE LANDSCAPE
To reduce fire risk, forests can be thinned by hand. Some experts advocate restoring grasslands that have been taken over by woody vegetation

TIME Graphic by Ed Gabel; reported by Laura Bradford and David Bjerklie

Sources: Greg Aplet, the Wilderness Society; Stephen Pyne, Arizona State University; William Romme, Colorado State University; AP; National Interagency Fire Center; U.S. Forest Service

RETARDANT

Nitrogen-heavy fertilizer mixed with water coats fuel to prevent burning. Iron oxide in the retardant gives it its orange color

UPHILL BATTLE

Wildfires charge rapidly up mountainsides because the heat from the fire rises and is directed at the fuel uphill, drying it out before the flames arrive

BACKFIRE

BACKFIRE

Backfires are another method of depriving a fire of fuel so that it burns itself out

1. Using axes, chainsaws and bulldozers, firefighters create an area called a fire line that is free of all flammable materials

2. Upwind of the fire line, a fire is?started— usually in the morning or evening, when breezes are calmer—that burns parallel to the fire line

3. Prevailing winds carry the backfire toward the fire line. Everything in between is burned, creating a wide, fuel-free barrier that, with luck, the approaching fire cannot cross

PREVAILING WIND

FIRE LINE

GENIES OF GRIT

The desert, my friend, is blowin' in the wind

MARCH 24, 2003: MORE THAN 167,000 U.S. AND British troops are waking up to the fourth day of Gulf War II. Invading Saddam Hussein's Iraq from the staging area in Kuwait, long convoys of armored vehicles, including tanks, artillery and personnel carriers, are racing across the desert, hellbent for Baghdad. The knife edge of the invading forces, the U.S. Army's 3rd Infantry Division, is only 50 miles outside the capital city. But now the entire mammoth operation comes to a grinding, clanking halt, throwing the Pentagon's carefully worked-out timetable off track. The long-awaited invasion has been put on hold—not by Iraq's Republican Guard or Scud missiles—but by a haboob.

A what? Haboobs are the massive dust storms that blow

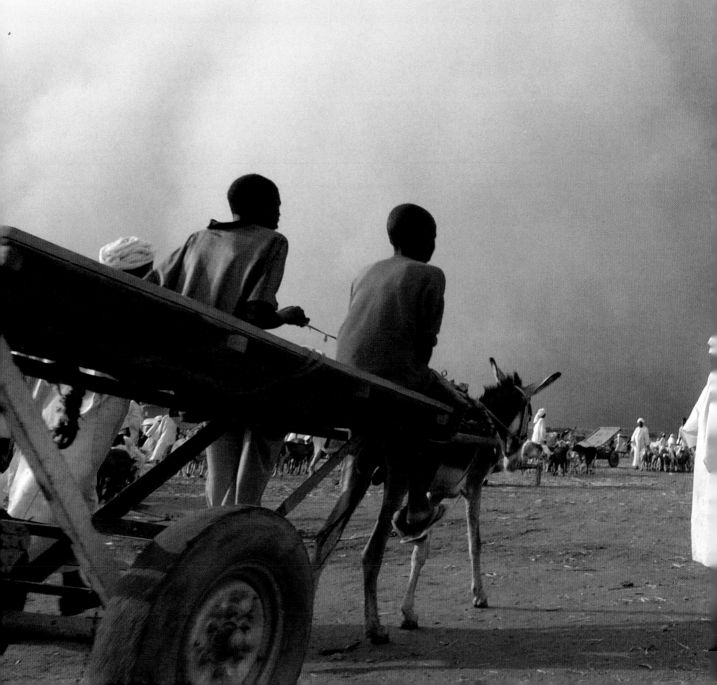

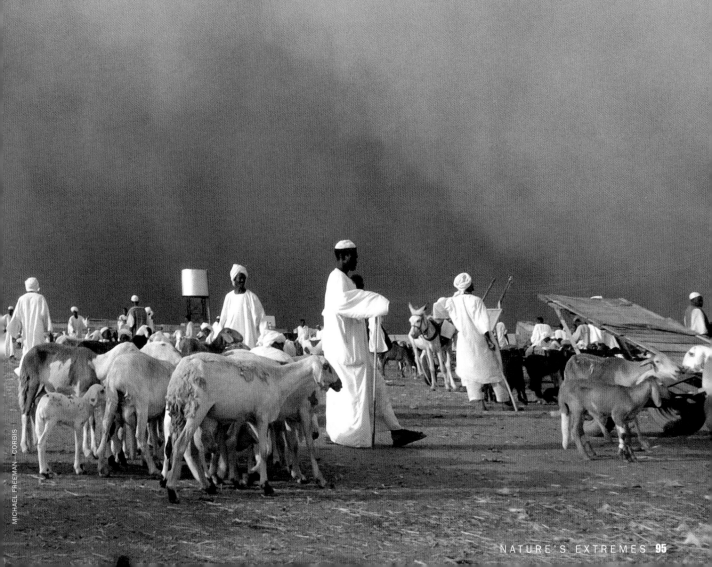

for miles (and days) across deserts and dry regions, where sand and wind are plentiful but soil is scarce. Haboobs are commonplace in the Sahara, stirred up by the region's strong sirocco winds, and they're also familiar to Americans who dwell in the desert Southwest. Haboobs can be generated by outflow winds, the horizontal, spreading downdrafts that precede thunderstorms, or they can occur when hot desert air rises and nearby cooler winds rush into a region. Towering over the desert at heights that can reach 5,000 ft., a haboob like the one that struck in Iraq in 2003 can cut off visibility completely, even as it fills every aperture it can find— a soldier's gun, say, and his boots and his pack and his eyes—with fine, irritating grit.

SUDAN, 2004
A haboob swirls into a cattle market in Omdurman, near Khartoum. The term is Arabic for, roughly, "wind phenomenon"

More than just a nuisance, sandstorms and duststorms can kill livestock, disrupt communications systems and halt travel. Even worse, they can blow away topsoil essential to agriculture, as they did in the U.S. during the bitter years of the Dust Bowl in the 1930s. Yet sandstorms also play their part in the vast global chain of natural interdependence: some scientist believe such storms are part of the process by which essential minerals are borne by jet streams high across the Atlantic from Africa to the rain forests along the Amazon River. In recent years data returned by NASA probes revealed that huge sandstorms are a common feature of the climate on Mars: they help put the red in the Red Planet. ■

DATA DOWNLOAD

FLASHBACK: Torching the Rain Forest

TIME SEPT. 25, 2000: Human penetration of the Amazon, rather than lightning or other natural phenomena, sparks most of the huge fires, and that penetration is increasing, along with deforestation and slash-and-burn agriculture. Fire, deforestation and roads are linked in an unholy trinity. Most blazes start near roads as settlers burn accessible forest to clear land for farms. [Above, the rain forest burns in 1998 in Roraima, Brazil, 1998.]

HOW DRY I AM Don't pack your umbrella if you're heading for the Atacama desert in Chile: this high-altitude plateau in the Andes is the single most arid place on the planet, with an average rainfall of .03 in. The landscape, which resembles the moon's surface, consists of salt basins, sand and lava flows.

IN THE FIELD Diversity's Many Faces

BOTANIST CRISTIAN SAMPER, *who is director of the Smithsonian's National Museum of Natural History, talked with TIME about an unusual aspect of his trade:*

One of the biggest challenges of doing research in the rainforest is managing relations with the local inhabitants. Naturalists often find that the most interesting areas to do research, from a biological standpoint, are also the most difficult and dangerous places to work, because of politics. When I was doing research in Colombia, in the 1990s, we were often concerned about problems with guerrilla groups or narcotics traffickers. Because I had testified before the Colombian legislature about narcotics eradication, it was always in the back of my mind that I might be in danger.

At the time, I was working with the Humboldt Institute, and the conventional wisdom was that you should sneak in, collect your data as quickly as possible, and leave before anybody noticed you had ever been

SAMPER On a field trip in the Galapagos Islands

there. When things worked out that way, it was fine, although it could restrict the amount and the quality of information you gathered. But if local groups happened to find you, it could lead to serious trouble.

So we developed a new protocol that was exactly the opposite of what everybody else was doing. Instead of sneaking in and out, we would send a team of scouts ahead of each expedition. Their job was to spend a few days among the locals, visiting the town square or the local bar. They would talk to everybody, have drinks with them, and distribute flyers explaining what we were doing there. We eventually found that this led to a much better relationship with the people in whose territory we were working. The larger lesson here is that the ethnosphere is linked to the biosphere. The places with the greatest biological diversity, like rainforests, also tend to be the places with the highest levels of ethnic, cultural, and economic diversity. And we can't ignore one while trying to preserve the other.

MEASURING STICKS

AVALANCHES

AVALANCHE DANGER SCALE Snow lovers around the world use five categories to denote the level of danger of an avalanche in a given area. U.S. and European color systems vary slightly.

GREEN: Low
- Stable snowpack
- Backcountry travel safe
- Avalanches unlikely

YELLOW: Moderate
- Unstable snowpack in some locations
- Human-triggered

avalanches possible
- Natural avalanches unlikely

ORANGE: Considerable (U.S.)
- Unstable areas likely
- Strong possibility of natural avalanches
- Human-triggered

avalanches probable

RED: High (U.S.)
- Unstable areas probable
- Avalanches of both kinds highly likely

BLACK: Extreme (U.S.)
- Very unstable snow
- Avalanches certain

DEADLIEST U.S. WILDFIRES, 1900-2005		
1. **CLOQUET FIRE, MINN./WIS.**	1918	400 to 500 deaths
2. **MONTANA/IDAHO**	1910	86
3. **OAKLAND HILLS FIRE, CALIF.**	1991	25
4. **CEDAR FIRE, CALIF.**	2003	24
5. **MAINE**	1947	16

DEADLIEST AVALANCHES, 1900-2005		
1. **TYROL**	1916	10,000 deaths
2. **RANRAHIRCA, PERU**	1962	3,000+
3. **BINGOL, TURKEY**	1991	255
4. **BLONS, AUSTRIA**	1954	200
5. **LAHAUL VALLEY, INDIA**	1979	200

FROM TOO FEW TO TOO MANY
Elephants in Africa, like these big specimens at a watering hole in Botswana, were endangered not so long ago; a 1989 TIME cover story traced the illegal trade in ivory that spurred harmful poaching. But a worldwide outcry led to a pact that quelled the slaughter. In a sign of how quickly such actions can make a difference, many African nations face a different problem today: too many tusks. Botswana's herd, a scanty 33,000 in 1990, now numbers more than 100,000.

VERBATIM

❝ My face went numb, my throat hurt, my chest hurt, my legs went numb. I could hardly move my fingers. ❞

—DUKE ADAMS,
Southern California resident, on suffering from smoke inhalation during the deadly Cedar Fire of 2003

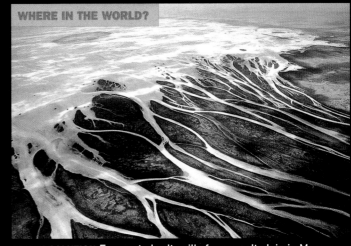

WHERE IN THE WORLD?

SALINE SOLUTION Evaporated salt spills from a salt plain in Morocco

WILDFIRES
FIRE POTENTIAL INDEX
To measure the chance of a wildfire in a given area, scientists at the U.S. Geological Survey (USGS) and U.S. Forest Service (USFS) developed the Fire Potential Index (FPI). The list charts relative fire potential for forests, ranges and grasslands. The FPI combines satellite data from the National Oceanographic and Atmospheric Administration (NOAA) with global positioning system technology to create fire-potential maps. Other data factored into the FPI include the total amount of burnable plant material, or fuel load, present in the area, plus the water content of any dead vegetation. Local weather conditions—including temperature, humidity and cloud cover—are also factored in. Daily updates are available at the National Fire Weather website, *fire.boi.noaa.gov*

SOURCES: TIME: TIME.COM; INFOPLEASE.COM, USGS, NOAA, NWS

4
ABOVE THE PLANET

ATLANTIC OCEAN, 1999 This false-color radar image, taken from a satellite, shows surface wind speeds on the sea; the orange tracks are faster, blue slower. Tropical Storm Harvey is the orange, swirling object off the Gulf of Mexico

In the delicate natural web that supports life on earth, one of the most essential ingredients is almost invisible: the **ATMOSPHERE**. The planet is swaddled in a cocoon of air, the realm of clouds and **LIGHTNING**, meteors and auroras, tiny dust devils and deadly **TORNADOES**. As technology improves, our view of this elusive world becomes richer, more complex, more surprising. In the 20th century alone, we first saw **HURRICANES** whole, first realized that enormous jet streams channel winds high across the globe, first suspected that objects originating far beyond the earth may someday put an end to it. Beyond the thinnest, highest layer of the planet's airy envelope, the exosphere, lies outer space. For thousands of years we turned our eyes to the heavens in wonder, but only in the past three decades have we learned just how menacing space can be. A collision with an **ASTEROID**, we now believe, led to the extinction of the dinosaurs. And the probability of a similarly devastating collision with a **NEAR-EARTH OBJECT**, it seems, is far higher than we would like. Even the warmth of the sun bears danger: its giant **FLARES** can disrupt communications, shut down power grids, alter the weather. Perhaps the ancients sensed this: they believed that comets and meteors ruled the world above the planet. It is not by accident that we call the study of weather meteorology.

When Sorrow Comes in Spirals

NEWCASTLE, OK. There is no more feared sight in the American Midwest than the unmistakable funnel-shaped clouds of a tornado. At right, Tammy Holmgren huddles beneath a highway underpass with her two daughters, Megan, 6, right, and Katlyn, 2 (partially obscured), as a twister approaches along the H.E. Bailey Turnpike on May 3, 1999. The Holmgrens escaped, but 44 other Oklahomans lost their lives when one of the largest storm systems ever recorded moved throught the area, spawning 61 separate tornadoes. The majority of twisters in America strike along a tornado belt that runs north from Oklahoma through Kansas and Missouri, but the destructive storms can touch down across a wide swath of the country at almost any time of year: residents of Arkansas, Tennessee, Kentucky, Ohio, Indiana and Illinois are all too familiar with the deadly formations.

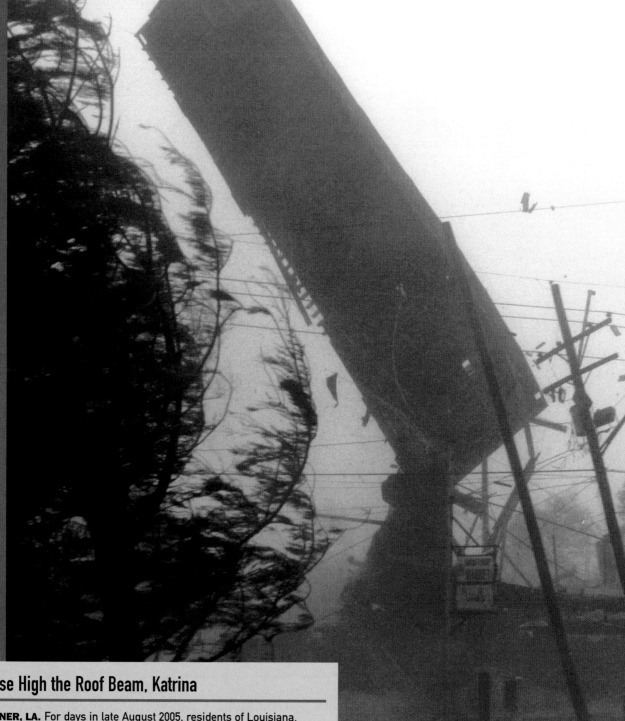

Raise High the Roof Beam, Katrina

KENNER, LA. For days in late August 2005, residents of Louisiana, Mississippi and Alabama looked to the south as Hurricane Katrina threatened their homes. First taking shape as a tropical storm near the Bahamas on Aug. 24, Katrina moved slowly west across the Florida Keys, then turned north and made a beeline for the Gulf Coast. By Aug. 28, as Katrina approached the U.S. mainland, the National Hurricane Center (NHC) in Miami rated the storm at Category 5, the highest possible listing. When it finally made landfall, about 6 in the morning on Monday, Aug. 29, in eastern Louisiana, the storm's winds were raging at some 127 m.p.h., down a bit from its strength in the Gulf, and the NHC rated it as a Category 4 storm. In December 2005, the NHC again revised its estimate of the storm's ferocity; meteorologists now believe it was a Category 3 storm at landfall. But at whatever scale scientists classify the storm, there is no doubt that its effects on the Gulf Coast were off the charts. Katrina devastated the historic Mississippi coastline, flooded and shut down New Orleans—and announced its presence by ripping the roof right off the Backyard Barbecue restaurant in Kenner, La., west of New Orleans.

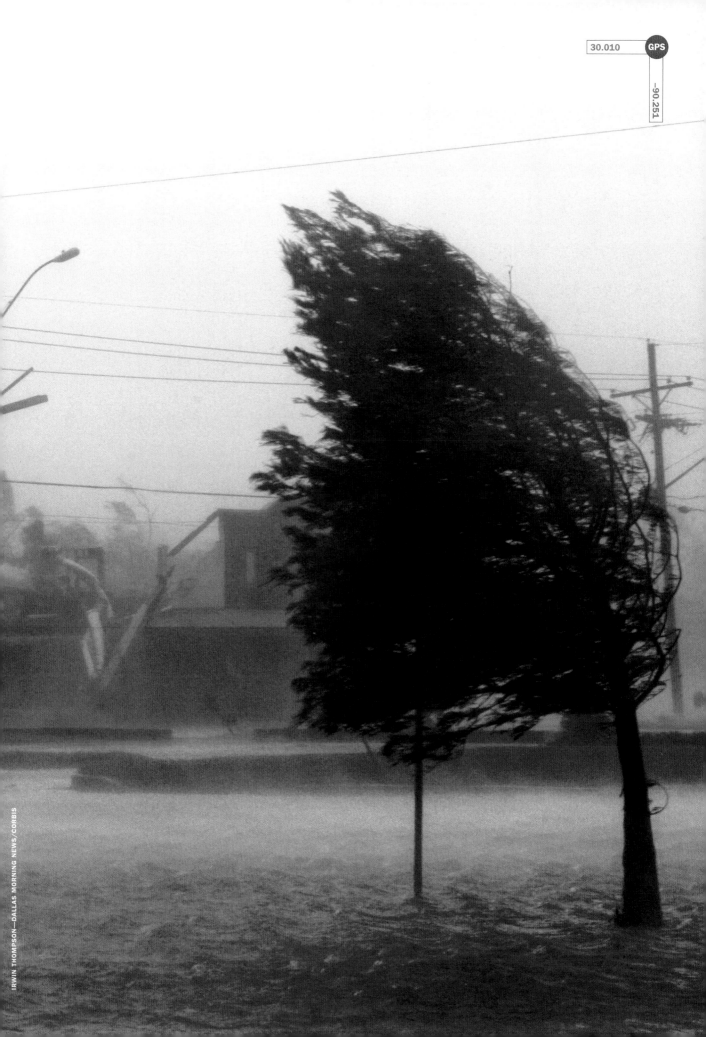

How to Make an Impression

WOLFE CREEK CRATER, OUTBACK, WESTERN AUSTRALIA In a word: BAM! When a meteorite smacked into the Australian desert an estimated 300,000 years ago, it left a crater that measures 2,887 ft. across and is almost circular; the floor of the bowl is some 197 ft. below the rim. Thanks to the remoteness of the location and the lack of rainfall in the region, the impact zone has undergone little erosion. Scientists think the meteor weighed 50,000 tons; they estimate that extraterrestrial bodies of this size strike the earth perhaps once every 25,000 to 15,000 years; collisions with larger objects that can cause major catastrophes occur perhaps once every 15 million years. Only in recent decades have scientists begun to examine how the planet's occasional encounters with such bodies affect life on earth: when first proposed, the theory that this sort of collision may have helped end the era of the dinosaurs was ridiculed by some, yet today it is widely accepted.

Mother Nature's Light Show

PANAMA CITY, PANAMA For long centuries of human history, lightning was one of the least understood and most feared of weather phenomena. In a world where most homes, churches and other buildings were made of wood, a single lightning strike—like this huge bolt that rocked Panama's capital city on Dec. 11, 2004—could set entire cities ablaze. It was not until the Enlightenment, as scientists began to explore the nature of electricity, that mankind took the first halting steps toward thwarting the power of these enormous discharges of electrical energy. Benjamin Franklin's theory that the force contained in lightning could be channeled harmlessly into the ground via a metal rod was first tested successfully by French scientists on May 10, 1752. When the experiment proved his notion to be valid, Franklin rocketed to worldwide fame and was hailed as one of mankind's greatest scientific benefactors.

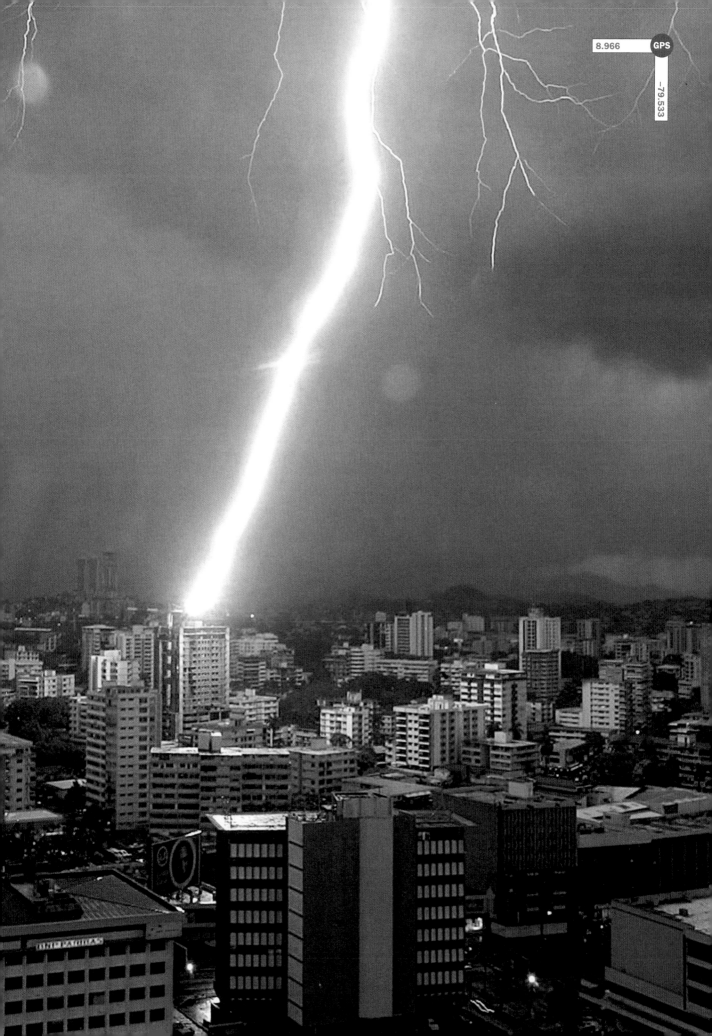

8.966 GPS

-79.533

STORMS ON STEROIDS

Vast spirals of wind and water, hurricanes are the planet's deadliest weather system

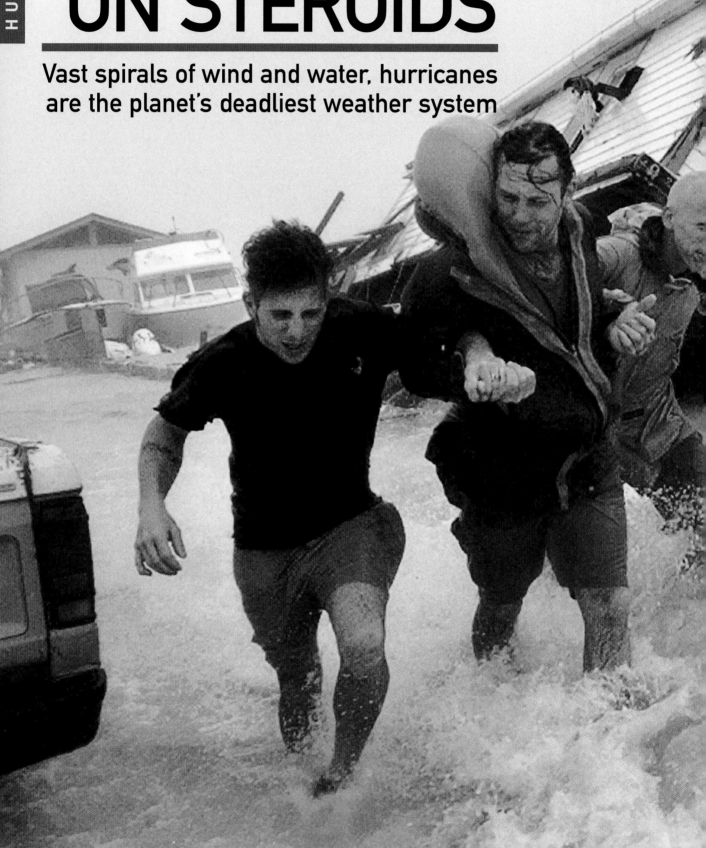

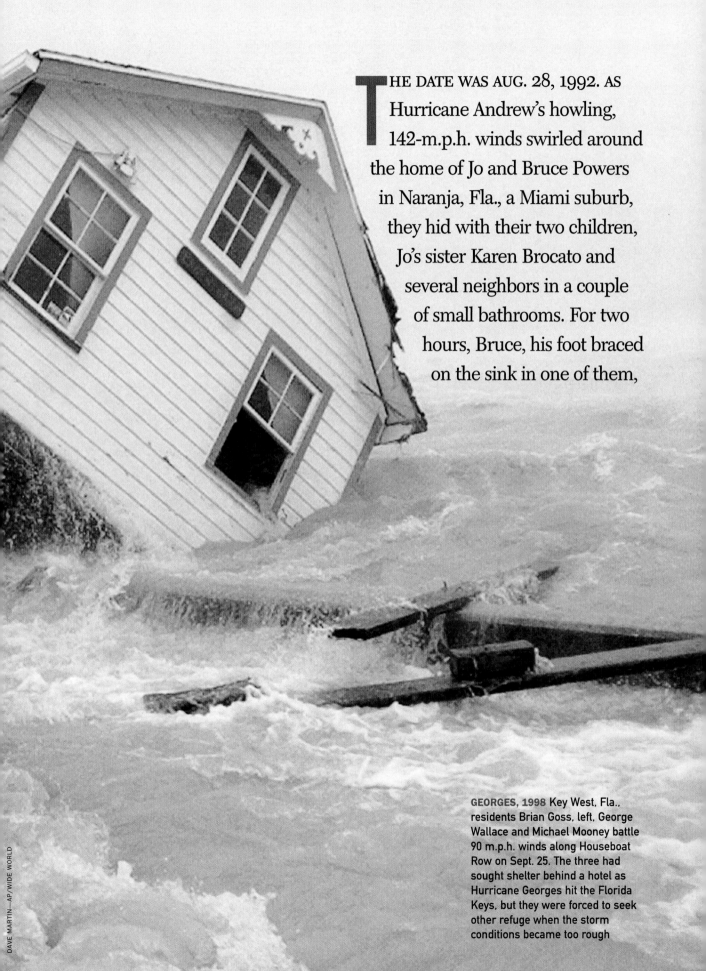

THE DATE WAS AUG. 28, 1992. AS Hurricane Andrew's howling, 142-m.p.h. winds swirled around the home of Jo and Bruce Powers in Naranja, Fla., a Miami suburb, they hid with their two children, Jo's sister Karen Brocato and several neighbors in a couple of small bathrooms. For two hours, Bruce, his foot braced on the sink in one of them,

GEORGES, 1998 Key West, Fla., residents Brian Goss, left, George Wallace and Michael Mooney battle 90 m.p.h. winds along Houseboat Row on Sept. 25. The three had sought shelter behind a hotel as Hurricane Georges hit the Florida Keys, but they were forced to seek other refuge when the storm conditions became too rough

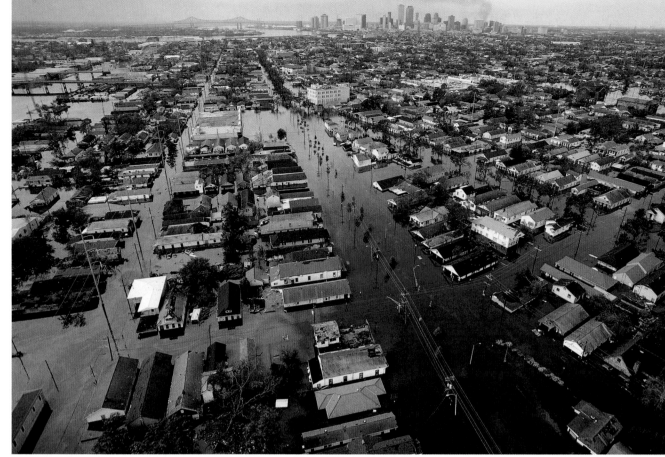

KATRINA, 2005 When the storm breached New Orleans' levees, the city flooded, above, leading to a flurry of rescues, below

wedged his 200-lb. frame against the door to keep the hurricane from ripping it open. The terrified group heard glass shatter and stick in the walls. Water poured in around the medicine chest, and the tub rattled itself away from the wall. Roof tiles flew under the door. "I've never been so scared in my life," Brocato told TIME a few days later. "I hope I die if I'm ever that afraid again. We all dirtied our pants."

A HURRICANE WILL DO THAT TO YOU. OF ALL NATURE'S deadly extremes, these big storms seem the most personal. Landslides, floods, earthquakes and volcanoes may kill, yet they never seem more than the vast, impersonal rumblings of a living planet. But the big spiral storms seem to seek people out and test their mettle in personal combat, Andrew vs. Bruce Powers. Perhaps it all goes back to the 1950 decision by the U.S. Weather Bureau to begin publicly referring to the big storms by the alphabetical nicknames used informally by staff meteorologists. Suddenly hurricanes were no longer unknowable forces of nature but clearly identifiable villains: Camille and Frances, Ivan and Charley. Even reporters trained to avoid attributing human emotions to natural events commonly refer to "Andrew's fury," "Camille's malevolence" or "Katrina's wrath," and readers nod their heads.

Hurricanes, like people, wear shrouds of legend. In 1494 Christopher Columbus became the first European to sight a hurricane on his second voyage to the Americas. Eight years later, on his fourth voyage, Columbus warned the Governor of Santo Domingo that a hurricane was approaching, but when his advice was ignored, a Spanish treasure fleet lost 20 ships and 500 men. Some 450 years later, another mariner, U.S. Navy Admiral William (Bull) Halsey, ran smack into a typhoon—the Pacific Ocean version of hurricanes—and lost three destroyers and 790 men. Neil Young writes songs

ANDREW, 1992 Winds from the fourth most intense storm to make landfall in the U.S. in modern history tossed trucks like chaff

about hurricanes; heavyweight boxers take nicknames from them; defiant New Orleanians christened a drink after them.

Thanks to advancing technology, scientists have learned much about hurricanes in the past 150 years. Today we know that one takes shape when large low-pressure systems draw in air and begin to spin in a counterclockwise direction, creating a spiral pattern around a central calm eye. The storm's power is fed as its winds draw up warm ocean water, which helps generate gradually intensifying thunderstorms. When it makes landfall, a hurricane hammers land dwellers with two mighty fists: its howling winds, which have been recorded as gusting over 200 m.p.h., and the mighty storm surge it drives before it, which can elevate ocean levels by more than 20 ft., sending floodwaters cascading over beaches, breakwaters and levees. The storm surge generated by Hurricane Katrina was so powerful that it picked up a 13,000-ton oil-rig platform from drydock on the Mobile River in Alabama and carried it upstream, against the river's natural current, then hurled it against a highway bridge, where it came to rest.

Yet all our knowledge of how hurricanes form hasn't helped us fight them; man's current tools are powerless against such vast weather phenomena. So scientists work to improve our ability to predict their movement, in hopes of providing early, accurate warnings to imperiled coastal residents. In 1943 a brave pioneer, Major Joseph Duckworth, opened a new era in storm research when he flew his trainer airplane into a hurricane and returned with valuable readings of the speed and movement of its winds.

Today weather satellites above the globe communicate real-time images of the familiar spiral cloud formations of hurricanes, but there is no substitute for the up-close-and-personal encounters provided by storm-tracking aircraft like the Lockheed WP-3D Orions operated by the National

Oceanic and Atmospheric Administration (NOAA). TIME science correspondent J. Madeleine Nash hitched a ride on one such flight in September 2004, as Hurricane Ivan was advancing on the U.S. Gulf Coast. The following paragraphs are her report of this intersection where high-tech meteorology meets old-fashioned aviation adventure, redolent of barnstorming days.

"THE BIG TURBOPROP LUMBERS DOWN A RUNWAY AT MacDill Air Force Base, rises awkwardly into the air and heads northwest from Tampa Bay over the Gulf of Mexico," Nash wrote. "For a couple of hours, it glides through an aerial fairyland, maneuvering around sun-struck clouds that resemble castles. 'This isn't so bad,' I say to my seatmate, Miami-based NOAA scientist Joe Cione, who looks at me and laughs. It's about then that I realize the pilot has executed a sweeping U-turn and pointed the plane's nose in Hurricane Ivan's direction.

"Soon sheets of rain whip against the plane's windows, dissolving the reassuring sight of the wings. On the radar screen in front of my seat, the red of the eyewall—the circle of turbulent storms that surrounds a hurricane's eye—grows thicker and more menacing. 'The red fingers of death,' pilot Mike Silah jokes grimly, and as if on cue, the plane starts to pitch, roll and yaw, a small boat at the mercy of giant, invisible waves. I tighten the straps of my shoulder harness as the plane shakes. My seat drops out from under me, and for a moment, I experience the sickening feeling of free fall.

"Later we will learn that 25 people died during Ivan's terrifying assault on the U.S., and many more might have died had people not taken the warnings issued by forecasters so seriously. For this, says Max Mayfield, director of the National Hurricane Center (NHC), part of the credit goes to aerial reconnaissance and surveillance missions similar to

HURRICANE HUNTERS

Over the past 25 years, hurricane forecasting has improved significantly, thanks in large part to advances in the technologies used to track the storms

One of eight monitoring stations

HOW HURRICANES FORM . . .

Low-pressure area

1 A cluster of thunderstorms gather to form a **low-pressure area,** which draws in air and generates **spin** in a counterclockwise direction

2 **Warm ocean water** fuels the transfer of heat and moisture to generate thunderstorms that **rise upward.** If there are no strong winds to break the storm up, it intensifies

3 When wind speeds reach **74 m.p.h. (120 km/h)** or higher and a distinct eye has formed in the center, the storm is called a **hurricane.** When the hurricane moves over cool water or land, it loses energy and weakens

Light winds

Warm ocean water

. . . AND HOW THEY ARE TRACKED

The **WP-3D Orion** aircraft flies at 1,500 to 10,000 ft. (400 to 3,000 m) through the hurricane, using a **figure-4 flight path** that allows observation of all **four quadrants** of the storm

The WP-3D has **radar systems** on its nose and under its belly that measure rainfall density to determine the level of turbulence. Doppler radar on the tail records wind speeds

Two types of probes are released: the **dropwindsonde** measures air conditions, and the AXBT plunges into the ocean to record water temperatures

Cool descending air

Warm, moist ascending air

Eye

Heaviest rain and highest wind speeds

Storm surge

Significant hurricane-force winds extend as far as 40 to 100 miles (64 to 161 km) from the eye

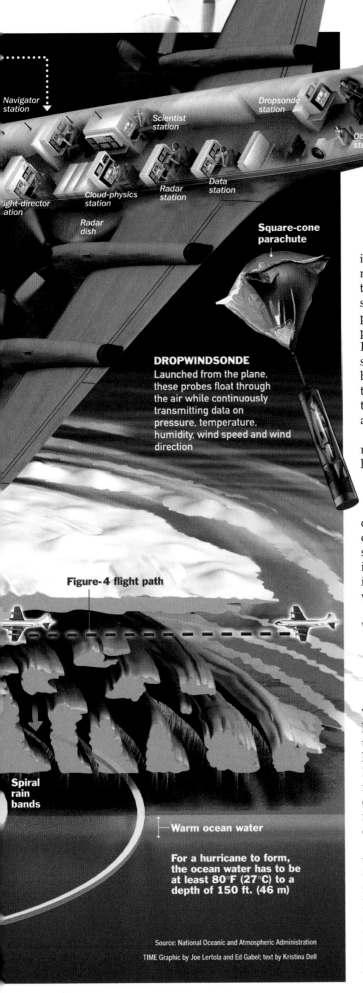

Navigator
station

Scientist
station

Dropsonde
station

Scientist
station

Observer
station

Doppler
radar

Flight-director
station

Cloud-physics
station

Radar
station

Data
station

Radar
dish

**Square-cone
parachute**

DROPWINDSONDE
Launched from the plane,
these probes float through
the air while continuously
transmitting data on
pressure, temperature,
humidity, wind speed and wind
direction

Figure-4 flight path

**Spiral
rain
bands**

Warm ocean water

For a hurricane to form,
the ocean water has to be
at least 80°F (27°C) to a
depth of 150 ft. (46 m)

Source: National Oceanic and Atmospheric Administration
TIME Graphic by Joe Lertola and Ed Gabel; text by Kristina Dell

the one I'm on. The reams of data collected by each flight—'enough to choke a horse on,' is how Mayfield puts it—have increased the credibility of hurricane landfall projections, and that, in turn, has prompted more people to evacuate to higher ground.

"The plane I'm riding in is itself a flying data-collecting instrument, with an air-sampling rod protruding from its nose and three radar units fastened to its nose, belly and tail. In addition, it has a pipe in the fuselage for launching sensor-loaded canisters known as dropwindsondes, sleek probes that take continuous readings of wind speeds, temperature, pressure and humidity as they parachute down. By combining the data obtained by multiple dropwindsondes, computer models can reconstruct the environment both inside and outside a hurricane, identifying conditions that feed or sap its strength or steer it in a particular direction. As a result, five-day hurricane-track forecasts are as accurate today as three-day forecasts were 15 years ago.

"Predicting just how strong a hurricane will grow remains more art than science, which is why my seatmate, Joe Cione, has been seeding the Gulf with devices called AXBTS (airborne expendable bathythermographs), which measure the temperature of the water column. The chief weakness of hurricane-intensity forecasts, Cione believes, is the lack of information about the state of the ocean as a storm churns through. Warm water, after all, provides the fuel that supplies a hurricane with energy, and in Ivan's case, Cione is surprised to find that the water in this region of the Gulf is not as warm as he thought, suggesting that Ivan might weaken before hitting land—which, as it turns out, it did."

YET WHEN IT COMES TO HURRICANES, WEAKNESS IS A relative term. As Cione predicted, Ivan did dial back its power. It was classified a Category 5 storm as it approached the U.S. mainland, but its wind speeds fell from 160 m.p.h. to 130 m.p.h. before it made landfall near Gulf Shores, Ala., on Sept. 16. That was bad enough. Those who rode out the storm told harrowing tales of cringing in the dark and hearing winds that screamed like jet engines. They emerged from their hiding places to a nightmare landscape: along Mobile Bay, a 16-ft. storm surge, topped by giant waves, overran almost a mile of Alabama coastline. In the Florida Panhandle, tornadoes spun off from Ivan's leading edge bent streetlights and ripped the roofs off buildings. All told, Ivan left 92 people dead in the U.S., Grenada, Jamaica and Venezuela.

As Madeleine Nash noted at the time, thanks to advance warnings, "hundreds of thousands of people fled New Orleans as Ivan approached, removing themselves from the threat of a storm surge in Lake Pontchartrain that could have flooded a city that lies largely below sea level." A year after her flight, as another hurricane approached Louisiana, the warnings went out again. That time around, the levees guarding the historic Crescent City were breached, and one of the great American cities was swamped into submission by Katrina's power—or, if you prefer, by Katrina's wrath. ■

HURRICANES: A CENTURY OF DEVASTATION

GALVESTON, 1900 Striking at the beginning of the 20th century, the greatest natural disaster in U.S. history swamped the island city off the Texas coast on Sept. 8, killing at least 8,000 people and perhaps many more, double the estimated death toll in the San Francisco earthquake and fire of 1906. A massive storm surge driven by the hurricane's winds did much of the damage. The storm was unusually long-lived; it wreaked havoc on buildings in Houston, then moved north. On Sept. 11, winds in Chicago were reported at 80 m.p.h.

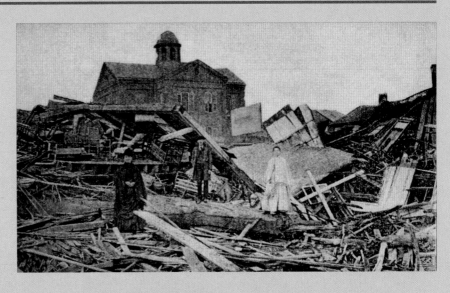

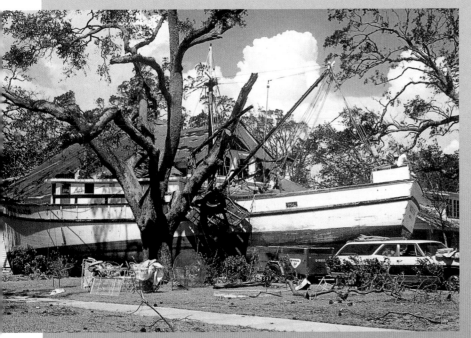

CAMILLE, 1969 Pursuing a deadly trajectory similar to Katrina's in 2005, Camille smashed up against the Gulf Coast in Mississippi and Louisiana on Aug. 17. Dr. Robert Simpson, then head of the National Hurricane Center in Miami, called it "the greatest storm of any kind that has ever affected this nation, by any yardstick you want to measure with." The statement is still valid in 2006. As TIME reported in its Aug. 29, 1969, issue, "Riding waves 22 ft. high, throwing rain hard as bullets on its 210 m.p.h. winds, Camille hurled herself at the Louisiana and Mississippi shoreline, uprooting, ravaging, killing in her awesome kinetic fury. In one fearful night, at least 235 were killed. For a time, the ocean reclaimed as much as six blocks of Pass Christian, Gulfport and other hapless Mississippi towns." At left, a yacht fetches up on land in Biloxi, Miss.

ANDREW, 1992 Ravaging a swath of Florida south of Miami in mid-August, with sustained winds of 142 m.p.h., Andrew left behind an estimated $25 billion in damages. TIME's report at the time seems an eerie forecast of Katrina: "Armed troops patrolled the streets to stop looters, some of whom brought in rental trucks to haul away their booty. The response by state and federal government was slow and disjointed."

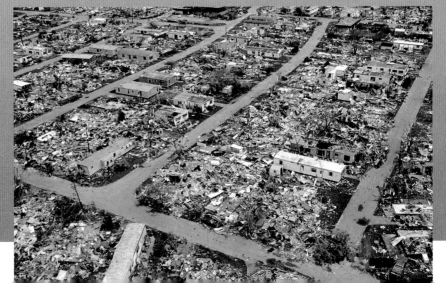

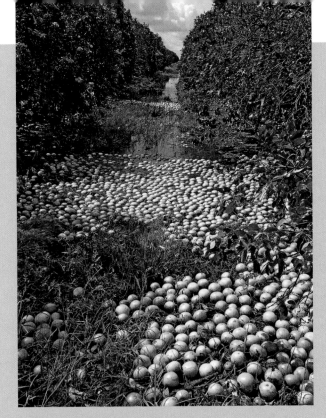

FRANCES, 2004 Floridians will long recall 2004 as "the year of four hurricanes." Over a period of six weeks, a murderer's row of storms took their turn at battering the Sunshine State. Charley struck first, on Aug. 13, smacking into the Gulf Coast 100 miles south of Tampa. Next up was Frances, which made landfall on Sept. 7 as a Category 2 storm just north of Palm Beach, leaving behind ruined citrus crops in its wake, left. Days later, it was Ivan's turn: the big blow smacked into Florida's Panhandle and the coast of Alabama on Sept. 16 Batting fourth was Jeanne, which followed Frances' course, landing near Fort Pierce as a Category 3 storm on Sept. 26. More than 400 miles wide, Jeanne tossed debris and churned up floods from Miami to Daytona Beach. Said Governor Jeb Bush: "This is the price we pay, I guess, for living in paradise."

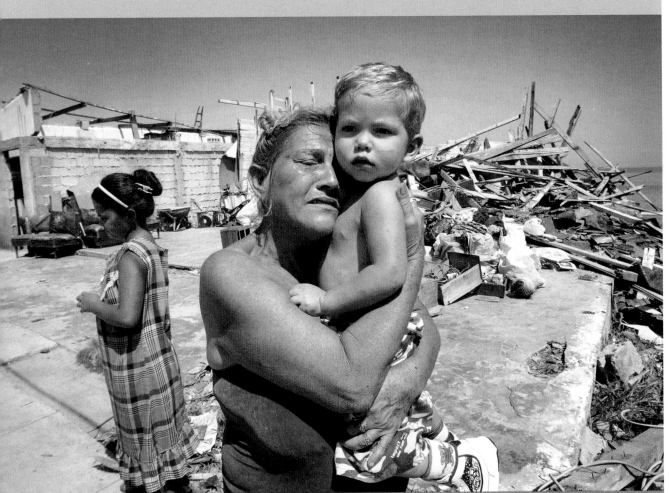

CHARLEY, 2004 The four hurricanes that besieged Florida in 2004 also bred misery on islands across the Caribbean Sea. More than 3,000 people died in Haiti when Hurricane Jeanne caused mudslides. Above, a homeless Xiomara Santamaria weeps while carrying her grandson in Playa Baracoa, outside of Havana, on Aug. 13, a day after Charley hit Cuba.

IT'S A TWISTER!

When a big thunderstorm spins off a tornado, the results can be unpredictable—and deadly

AMERICANS LOVE TO SPIN YARNS, AND when it comes to the weather, some of the best examples of hyperbole involve tornadoes, the devastating storms that are themselves spinning machines of destruction. We've all heard the stories. One twister drove a piece of straw right through a thick fence post. Another picked up a woman who sought shelter in her bathtub, carried her outside and gave her a ride in her ceramic sled right into the woods in her backyard. Then there's the story about the Kansas farm girl who was picked up by a twister and carried to a magical land somewhere over the rainbow. Perhaps you're familiar with that one?

Meteorologists love to swap these stories almost as much as they enjoy debunking them. Take the one about tornadoes driving bits of straw through fence posts. What may actually happen, scientists suggest, is that a sudden drop in air pressure forces the wood to expand, allowing pieces of straw to lodge in newly opened cracks. Trouble is, not all the stories are exaggerated: Betty Lou Pearce, then 64, a clerk from Pilot, N.C., was the recipient of that unexpected bathtub sleigh ride in 1996; she returned from her journey scratched and bruised but otherwise miraculously unharmed.

Sheriff Donnie Joe Yancey of Izard County, Ark., shared his story with TIME, after he tangled with a funnel that rampaged through his section of the state and killed seven people in 1996. On the storm's trail, Yancey was preparing to get out of his jeep, he recalled, when "it got real dark, real still. Then the jeep started rocking and bouncing, I heard a pop, pop, pop, and all the windows blew out." The fierce winds yanked Yancey out of his vehicle, walked him across the road and then, after Yancey anchored himself on some nearby briars, engaged in a tug-of-war for his body and soul. "It was awesome," he told TIME. "I don't believe I ever want to look a tornado in the face again."

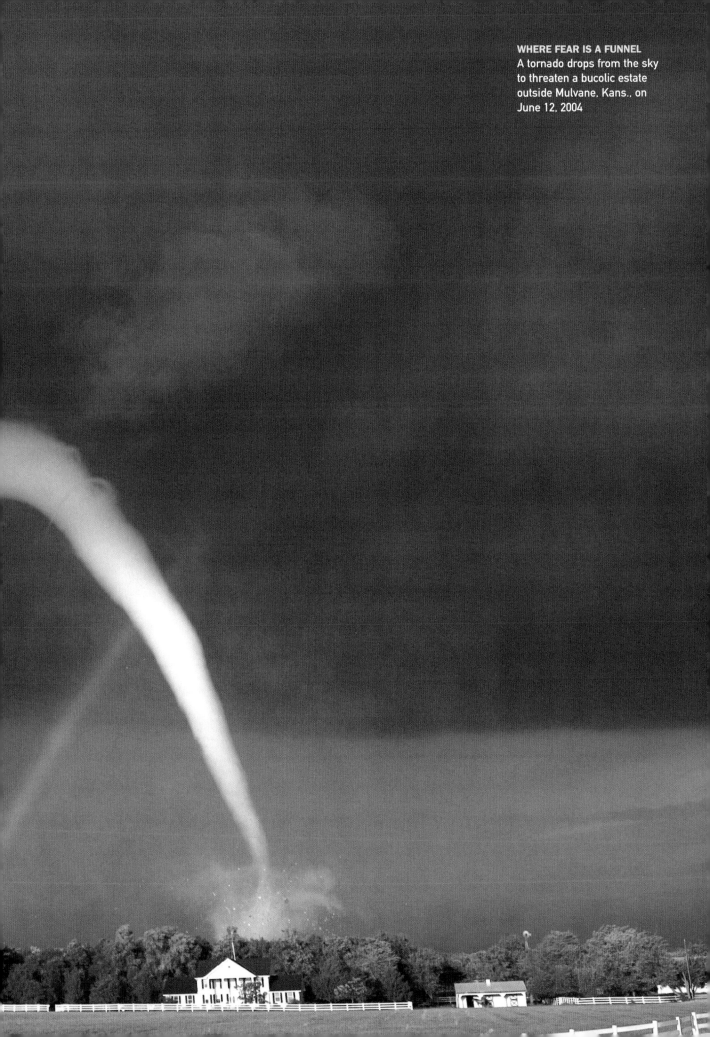

WHERE FEAR IS A FUNNEL
A tornado drops from the sky
to threaten a bucolic estate
outside Mulvane, Kans., on
June 12, 2004

He's not alone. Across the broad swath of the American heartland known as Tornado Alley, no sight is more feared than a funnel-shaped cloud, no sound less welcome than the wail of a tornado-warning siren piercing the unearthly, portentous calm that often precedes a big twister. Small wonder: with winds that can reach as high as 250 m.p.h., tornadoes are serial killers, striking again and again in Oklahoma, Kansas and Missouri and, less frequently, across the Midwest and the rest of the nation. The deadliest tornadoes of 2005 rampaged across a 41-mile front straddling southern Indiana and northwestern Kentucky early in the morning of Nov. 6, killing 23 people and leaving some 200 injured. On average, according to the National Oceanic and Atmospheric Administration (NOAA), 1,000 tornadoes are reported in the U.S. each year, claiming 80 lives and injuring 1,500 people.

WHAT TURNS AN ORDINARY THUNDERSTORM INTO a twister? Tornadoes are most likely to be generated by what is termed supercell storms—towering cloud structures that sometimes top out at 65,000 ft. and concentrate energy in dangerous ways. A supercell typically forms in spring as warm, moist air from the Gulf of Mexico flows north and pushes through colder, dryer layers of air. As it rises, this upwelling of warm air begins to cool off a bit, and the moisture it contains condenses first into cloud droplets and then into rain. At that point, the air—now denser because it is colder—starts to sink. But at the same time, the process of condensation that created the rain releases so much latent heat that the air around it warms up once again and retains its lift.

The collision between warm and cold air masses sets up conditions that favor the growth of big thunderstorms. A tornado, however, requires something else as well: the presence of what meteorologists call wind shear. That occurs when winds in the so-called boundary layer—the part of the atmosphere closest to earth—blow more gently than winds at higher elevations. These two wind streams push on the layer of air that lies between them as though it were an invisible rolling pin. Then, as the warm updraft that powers a supercell shoots toward the stratosphere, it tilts the rolling pin so that it spins on its end. Soon the updraft starts to spin, giving birth to a mesocyclone, a rotating column of air as wide as six miles. Mesocyclones are the broad spinning cloud structures from which tightly coiled tornadoes seem to drop; scientists are trying to find out how one turns into the other.

The simplest explanation is that tornadoes form when a smaller, even more rapidly rotating updraft descends from the mesocyclone like a vacuum cleaner nozzle. To our eyes, that is exactly what appears to be happening. But while scientists agree that the updraft is essential, many doubt that it provides the sole mechanism for tornado formation. Some scientists think the rapid sinking of colder, dryer air near the rear flank of the storm may be key. If that rush of air encounters wind shear on its way down, then it too will start to rotate. In this scenario, a tornado occurs as air from the downdraft nears the ground, swoops out horizontally and—attracted by the zone of low pressure created by the mesocyclone—spirals back into the storm like smoke up a chimney.

MIAMI, 1997 Hurricane-savvy Floridians were startled when a tornado dropped in on May 12; no serious injuries were reported

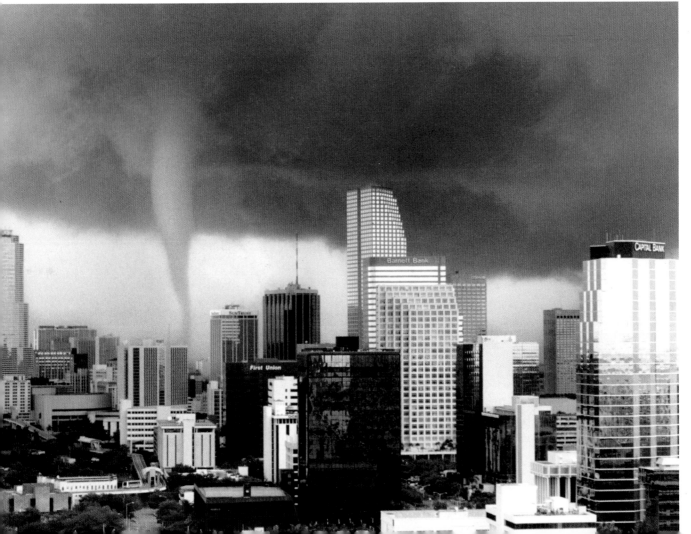

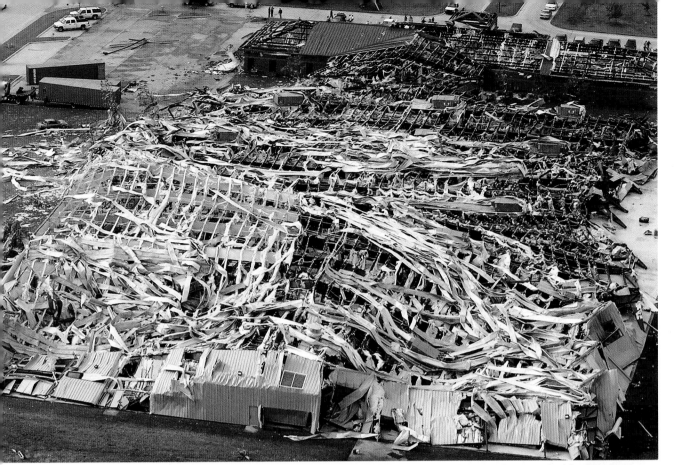

OKLAHOMA CITY, 2003 This factory was leveled by a tornado on May 9; the storm's path of destruction stretched for 35 miles

Another possibility: tornadoes may be similar to waterspouts and dust devils, which build their vortices not from the clouds down but from the ground up. It's possible that tornadoes form both ways, top-down and bottom-up.

As with hurricanes, scientists know they cannot control tornadoes; the goal is to predict their appearance and trajectory more accurately. In 1972 NOAA launched the Tornado Intercept Project, sending storm-chasing scientists right into the storm to provide what radar meteorologists refer to as "ground truth." At the time, NOAA's National Severe Storms Laboratory in Norman, Okla., was developing a radar capable of detecting areas of strong rotation inside big tornado-producing storms. Storm chasers on the ground provided visual proof that particular radar signatures did indeed precede the formation of tornadoes. The new technology, Doppler radar, made use of the fact that radio waves shift frequency depending on whether the objects they bounce off are advancing or receding. In this case, the objects that create the Doppler shift are water droplets inside storm clouds. As the winds inside these clouds begin to spin, the droplets show up on radar screens as tighter and tighter swirls, aiding advance detection of tornado formation—and that can save lives.

The collaboration between radar developers and storm chasers was immensely productive. It led to the NEXRAD (or Next Generation Radar) system, which the National Weather Service installed nationwide, finishing up in 1998. Already NEXRAD has helped extend the lead time for tornado warnings from 3 to 11 min., on average. A more recent project, VORTEX (Verification of the Origins of Rotation in Tornadoes Experiment), again sent intercept teams charging straight into supercell systems to track the development of tornadoes. If meteorologists keep at it, we'll know everything about tornadoes except how all the unlikely stories about them get spun—one mystery even radar can't solve. ∎

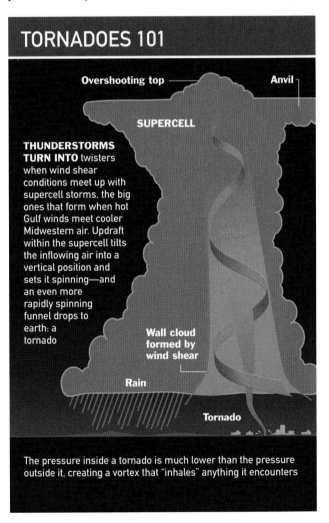

TORNADOES 101

THUNDERSTORMS TURN INTO twisters when wind shear conditions meet up with supercell storms, the big ones that form when hot Gulf winds meet cooler Midwestern air. Updraft within the supercell tilts the inflowing air into a vertical position and sets it spinning—and an even more rapidly spinning funnel drops to earth: a tornado

Overshooting top

Anvil

SUPERCELL

Wall cloud formed by wind shear

Rain

Tornado

The pressure inside a tornado is much lower than the pressure outside it, creating a vortex that "inhales" anything it encounters

FATAL SPLENDOR

Lightning is the No. 2 weather killer in the U.S.

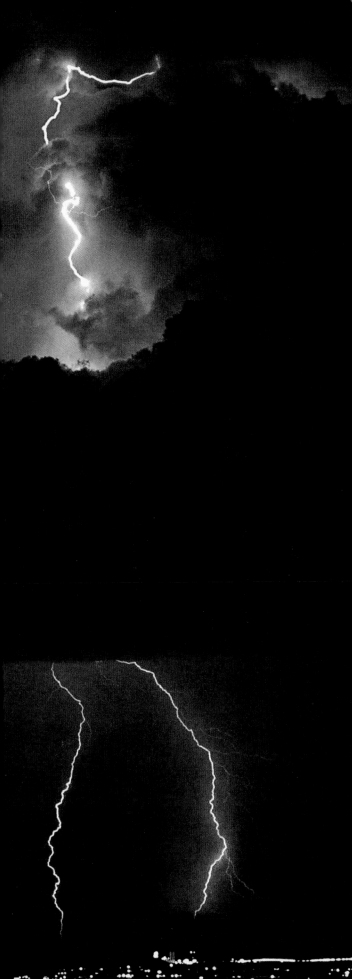

LIGHTNING IS NATURE IN ITS MOST DECEPTIVE GUISE. You know the feeling: your heart does a flip-flop of exhilaration as a jagged surge of electricity streaks across the sky, followed by a peal of thunder, a high-school science lesson illuminated in a burst of glorious power and release. But lightning is not merely a stirring exhibition of son et lumière: it claims more lives in the U.S. each year, just under 100, than any other natural phenomenon, except for flash floods. The obvious reason: unlike a tsunami or a hurricane, lightning is commonplace, the weather hazard each of us is most likely to encounter. Scientists estimate that lightning strikes the ground some 30 million times in the U.S. each year—and there are five times as many lightning flashes that are cloud-to-cloud.

As for the science involved, comic George Carlin wasn't far off when he said, "Electricity is really just organized lightning." Ben Franklin was the first to prove that lightning is electricity and that a lightning strike is similar to (if a bit larger than) the spark you create when you store up static electricity by rubbing your shoes on a carpet, then putting your finger close to metal: ZAP!

You might expect that some 250 years after Franklin's discovery, scientists would thoroughly understand lightning, but that's not the case. We know that cloud-to-ground lightning, the dangerous stuff, originates high in the clouds, 15,000 to 20,000 ft. above sea level, where raindrops begin to freeze. But we're still not certain how this process results in polarization, the separation of cloud particles into two groups, one charged positively, the other negatively. We do have a clear picture of what happens next: a lightning strike is actually a two-part process. First, an almost invisible, negatively charged streamer moves toward the ground at blinding speed, descending in 50-yd. sections called step leaders, seeking a positively charged channel to complete its circuit. When it finds such a channel—a tree, a metal rod, a fence post or a human body—a connection is joined, the current is greatly increased, and sparks fly. This return stroke, far more luminous than the descending stroke, is the one we see. Inside that glowing bolt, the air is heated to about 50,000°F. When this hot air naturally expands, it forms a shock wave: thunder. And as Mark Twain pointed out, "Thunder is good, thunder is impressive, but it is lightning that does the work." Don't let it do its work on you. ∎

TUCSON, 1990

Scientists are now exploring lightning events that happen above the storm clouds, where other discharges occur

BEAUTY AND THE

WILL CIVILIZATION END WITH a whimper? Perhaps, but it seems more and more likely that man's world may go the way of the dinosaurs: with a bang. Most

scientists now think that an asteroid smacked into the planet 65 million years ago, leading to the abrupt demise of *T. rex* and the other big critters so beloved of small fry.

This brilliant theory was first advanced by physicist Luis Alvarez, the late Nobel laureate, who proposed in 1980 that a giant celestial intruder had triggered the dinosaurs' downfall. The clue that inspired Alvarez was found in a thin layer of clay that forms the so-called K-T boundary between the fossil-rich rock of the Cretaceous period, which ended with the extinctions, and the overlying, younger and sparsely fossiled rock of the Tertiary period. When analysis of the clay revealed that it had a far higher content of the rare element iridium, which is ordinarily found in Earth's crust, Alvarez proposed that the element might be of extraterrestrial origin.

Both comets and asteroids, Alvarez knew, are rich in iridium. From that evidence, Alvarez constructed this scenario: some 65 million years ago, a comet or asteroid at least five miles wide struck Earth and blasted out a tremendous crater. The cosmic interloper was completely vaporized, and a great fireball rose into the stratosphere, carrying with it vast amounts of debris. These finer particles remained suspended and were circulated by air currents until they enshrouded Earth, blocking sunlight for months. In the ensuing cold and dark, plants and animals perished. When the dust shroud, including the iridium-rich remnants of the comet or asteroid, eventually settled back to Earth, it formed the telltale worldwide layer of clay in the K-T boundary.

Many scientists, particularly paleontologists, initially scoffed at the Alvarez theory. They argued that gradual climatic change, perhaps brought on by heightened volcanic activity, had caused the worldwide extinctions. But the discovery in 1990 of a long-hidden crater 112 miles in diameter, whose center is below the town of Chicxulub on the northern tip of Mexico's Yucatán peninsula, gave the doubters pause. And the later confirmation of the crater's age—65 million years— led most scientists to jump aboard the Alvarez bandwagon.

Still, problems remained. NASA scientists, for example, suggested that most of the airborne dust from the impact ex-

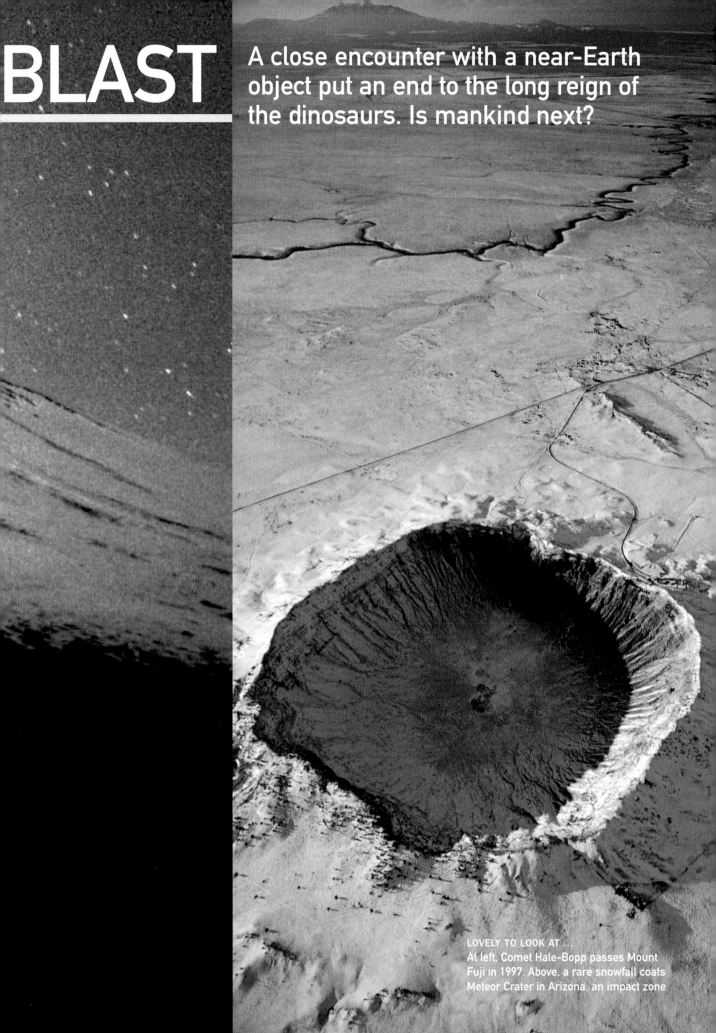

BLAST

A close encounter with a near-Earth object put an end to the long reign of the dinosaurs. Is mankind next?

LOVELY TO LOOK AT …
At left, Comet Hale-Bopp passes Mount Fuji in 1997. Above, a rare snowfall coats Meteor Crater in Arizona, an impact zone

JUPITER, 1994 Two of the 21 fragments of Comet Shoemaker-Levy 9 plow into the giant planet; similar collisions threaten Earth

plosion and soot from fires ignited in forests would have settled back to the ground within six months, far too soon to have caused extinctions.

The NASA scientists offered another explanation, based on the fact that the Yucatán rock around Chicxulub contains abundant amounts of sulfur. The blast must have vaporized the sulfur, they argued, and spewed more than 100 billion tons of it into the atmosphere, where it mixed with moisture to form tiny drops of sulfuric acid. These drops created a barrier that could have reflected enough sunlight back into space to drop temperatures to near freezing, and they could have remained airborne for decades.

Not all scientists embraced this theory: some argued for a "double-whammy" theory that suggests that an impact on one side of Earth could produce massive volcanic activity at the antipode—a point directly opposite on the far side—and that the combined effect would cause disaster. Jon Hagstrum, the U.S. Geological Survey paleomagneticist who co-authored the theory, told TIME in 1995, "This would be the best way to trigger worldwide mass extinctions, because you have both hemispheres affected."

THE ARGUMENT OVER THE MECHANISM BY WHICH A comet or asteroid collision might have sparked a massive die-off of plants and animals on our planet may continue for some time. But events in July 1994 erased any doubts scientists might have harbored about the result of a too-close encounter between a heavenly body and a planet. On July 16, the first fragment of Comet Shoemaker-Levy 9 plowed into the giant gas planet Jupiter with the force of perhaps 10 million hydrogen bombs, lofting a mushroom cloud of hot gas nearly 1,000 miles into space. After a first bright flash, the impact left dark scars on the planet's brightly colored surface. Twenty more hits, some larger, followed; the comet had been torn into 21 fragments by Jupiter's dense gravity as it neared the planet. The impacts rival solar flares as the most violent events man has witnessed in the recorded history of the solar system.

How would such an impact affect Earth, a far smallerr planet than Jupiter? If one of Shoemaker-Levy 9's bigger pieces—say a mile or two in diameter—came streaking in at 130,000 m.p.h., it could tear through the atmosphere and smash into the ground with the force of millions of H-bombs, gouging out a crater the size of Rhode Island and throwing so much pulverized real estate into the stratosphere that the sun would be blocked for months while all Earth went into a deep freeze. If the comet were to hit an ocean, a pall of dust would rise from underwater sediment, and a megatsunami several thousand feet high could race across the sea and hundreds of miles inland, swamping everything in its path.

Science fiction? Not at all. Comets and asteroids have crashed into Earth in the past. Craters marking the points of impact are mostly hidden by vegetation, their edges softened by erosion. But the size of some of the holes suggests that Earth has been hit by intruders at least several miles in diameter, as big as S-L 9 before it broke up.

Indeed, when it comes to asteroids' wreaking disaster on Earth, the real question is not if but when. Two hundred or so large craters and a geological record stretching over billions of years provide plenty of evidence that, time and again, impacts with asteroids or comets have devastated large parts of the planet, wiped out species and threatened the very existence of terrestrial life. Scientists term these up-close-and-personal celestial bodies near-Earth objects (NEOS). Astronomers are all too aware that more of them are out there, hurtling through space, some of them ultimately destined to collide with Earth.

Should we be worried? After all, the most notorious impact of them all, the one that caused the extinction of the dinosaurs, occurred 65 million years ago. Really ancient history. Yet if you want to get contemporary—on a geological scale, of course—it was only 49,000 years ago that an iron

TWIN CRATERS Canada's circular Clearwater Lakes are believed to have been formed by a pair of meteorite impacts some 210 million years ago

A COLLISION IN SIBERIA

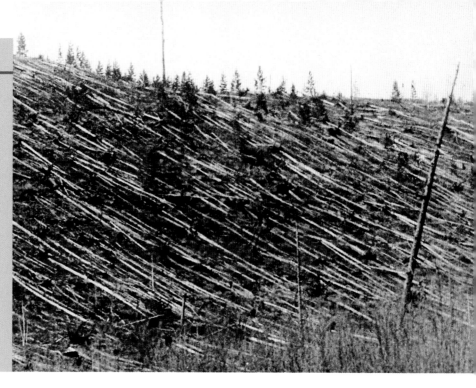

IF THE PROSPECT that a heavenly body might collide with Earth seems a bit far-fetched, think again. The most recent major impact occurred in 1908, in the remote Tunguska region of Russia. Scientists now believe that a meteorite at least 100 ft. in diameter exploded five miles above the ground here. Trees in a 9-mile radius from ground zero were incinerated; those in a 25-mile radius were felled—some 60 million of them.

The region was so remote that the first major scientific expedition did not reach the area until 1927. Geologists found high levels of iridium in the soil—the same clue that was used decades later to assign the demise of the dinosaurs to a similar collision.

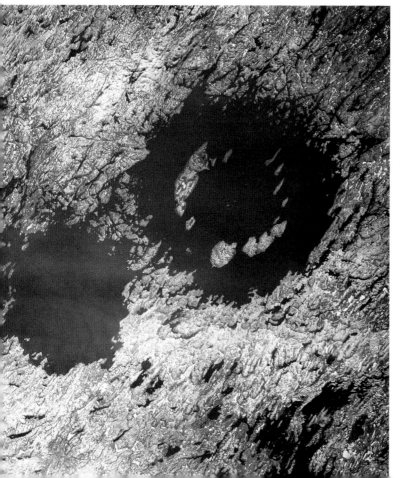

asteroid blasted out Arizona's three-quarter-mile-wide Meteor Crater, almost certainly killing any living creatures for hundreds of miles around. As recently as 1908, a small rocky asteroid or chunk of a comet exploded five miles above the Tunguska region of Siberia. Had the blast from this event, now estimated at tens of megatons, occurred over New York City or London, hundreds of thousands would have died.

And what about near misses? As recently as 1996, an asteroid about a third of a mile wide passed within 280,000 miles of Earth, a hairbreadth by astronomical standards. It was the largest object ever observed to pass that close and, had it hit, would have caused an explosion measuring in the 5,000-to-12,000-megaton range. What was particularly unnerving about this flyby is that the asteroid was discovered only four days before it hurtled past Earth.

Yes, it gets worse. According to NASA scientists, over the past two decades it has become apparent that Earth lies amid a swarm of small rocky bodies, themselves going around the sun, most likely dispatched from the asteroid belt to the inner solar system by the gravitational influence of Jupiter. These bodies vary in size from a few meters to several kilometers. It used to be thought that such objects were rare, much like comets. This view has changed in the light of increasingly sensitive surveys by both spacecraft and observatories on land, which have identified an exponentially increasing number of NEOs, many times more than previously believed. Scientists now term these objects PHAs, Potentially Hazardous Asteroids.

In 1999 scientists unveiled a risk-assessment scale to convey the chance of a collision with a given NEO; it was named the Torino scale, after the Italian city in which it was adopted. The scale takes into account the object's size and speed, as well as the probability that it will collide with Earth. On the scale, very close encounters are generally assigned a value of 7 or 8; certain collisions are 9 or 10. Since its debut, the closest flyby was labeled a 1—good news, but only in the short run.

What can we do to avoid a collision? Scientists and recent Hollywood movies suggest that we might intercept a comet before it hits us, diverting its path. In the first test of man's ability to intercept an NEO, a probe released by NASA's Deep Impact spacecraft collided with Comet Tempel 1 on July 4, 2005, producing the same explosive bang as 4.5 tons of TNT. NASA scientists cheered their feat, although the probe was little more than a bug on Tempel 1's windshield, changing its speed by 0.014 in. per hr. You might call the impact a whimper, but it was a first step in defending mankind's home planet against real-life alien invaders. ∎

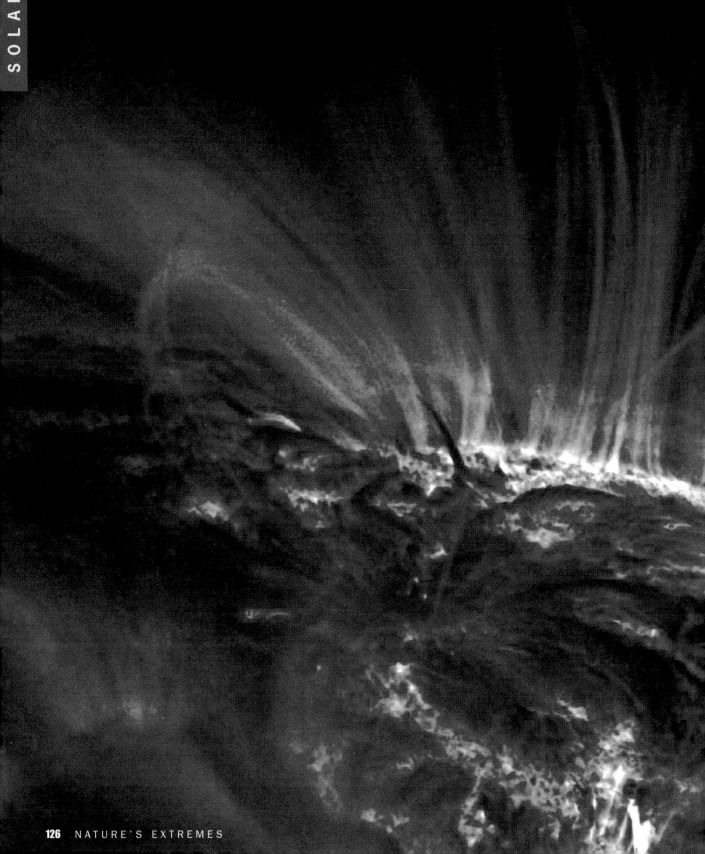

CATCH ANY RAYS?